Secrets of
COSPLAY

CREDITS:

P64-71	Make-up artist & model: Heiyu
P72-77	Make-up artist: Xiao Meng Model: Qudou
P78-85	Prop production tutorial: The Vampire Union
P86-93	Photography tutorial: Zion
P94-105	Photography tutorial: RYO
P106-112	Stage tutorial: Lie, Shifeng & Lengyu, Axiulan
P114-119	Retouching tutorial: Lala II
P120-123	Retouching tutorial: JILL
P126-139	Tutorial: Xiaoxiao Bai & Feimo
P130-131	Sketch artist: Gao Shan
P142-208	Cosers: Tianshui Sanqian, Diyao, Feiyan, Xiyuetu, Liusi, Reika, Tooya, Zangqinwang, Yinchuan Hudiezhu, Kuangjian Xiaoxiao Bai

SECRETS OF COSPLAY

Authors: Tooya, Wang Ying
Commissioning Editors: Guo Guang, Mang Yu, Wang Ying
Translator: Ling Yan
English Editors: Dora Ding, Jenny Qiu
Copy Editor: Bethany Anne
Book Designers: Tang Di, Sun Sujin

First published in the United Kingdom in 2014 by CYPI PRESS

Add: 79 College Road, Harrow Middlesex, HA1 1BD, UK
Tel: +44(0)20 3178 7279
Fax: +44(0)19 2345 0465
E-mail: sales@cypi.net editor@cypi.net
Website: www.cypi.co.uk
ISBN: 978-1-908175-50-2

Printed in China

Secrets of
COSPLAY

Tooya Wang Ying

CYPI PRESS

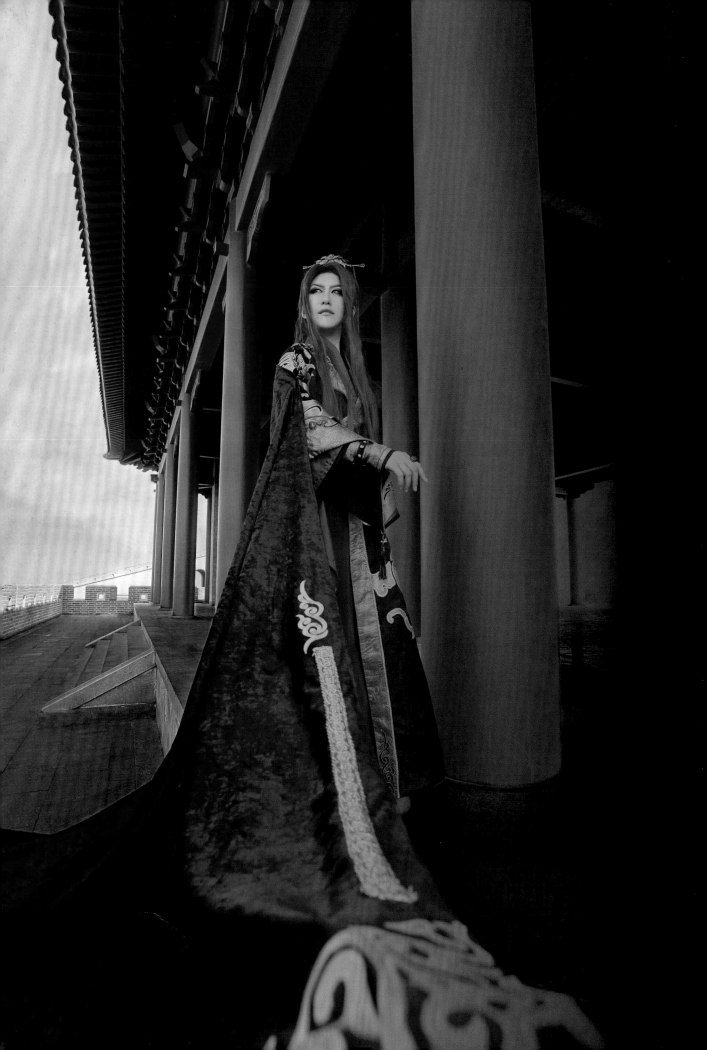

Preface

Wang Ying

As animations and games gradually come into vogue, there are increasingly more anime and manga lovers that instill personal feelings into roles and plots. This promotes the economy; manufacturing specialty products like materials, scenery, props and make-up for cosplay and its related industries, such as toys, models and doujin books (fan-fictions). The word "cosplay" is the abbreviation of "costume play" or role play. It usually refers to the impersonation of virtual anime and manga roles with reference to costumes, ornaments, props and makeup. The person who participates in cosplay is called a cosplayer or a coser.

Given the many unknowns and challenges in the three-dimensional world, cosers often express and represent the psychological world and worldview of the roles in a creative way. Through a combination of human models, materials, posing and performances, cosers would incorporate their own ideas into the original work in the transformation from 2D images into 3D figures.

Cosplay today is no longer restricted to human roles in anime and manga; rather, games, movies, TVs and novels have also become sources of prototypes. Meanwhile, food, animals, machines, zodiacs, blood types, celestial bodies, even metro stations, tourist resorts and countries can all be personified for cosplay. There are even cosplays of celebrities in the real world.

Cosplay parties can be held as masquerades, at which a group of people of the same interest gather around and dress like their favorite roles to their heart's content. This fantasy world may be exactly what today's young people, with their focus on individualism, are craving for and it helps constitute the inherent driving force for cosplay.

Cosplay is also known for enhancing participants' abilities to make, create, perform and coordinate with team members, building leadership. Throughout the entire process of cosplay, it is imperative that cosers communicate with others, pose in preset manners, give performances and engage in photography. In this regard, cosplay strengthens human interaction and promotes individual initiative. In this sense, cosplay also assumes a sense of responsibility, which is one of the reasons that cosplay fans are so fascinated by it.

Every year, a number of cosplay competitions or conventions of various subjects and scales are held in countries including America, Japan, Germany, China, Russia and South Korea. They possess varied characteristics in different countries: American cosplay works are very trendy with highly exquisite details and overall innovative modeling completeness; the Japanese works are mostly from animation works from their own country with emphasis on representations of the entire modeling; Chinese cosers usually excel in team performances, which is rarely seen elsewhere.

This book incorporates delightful tutorials and photo gallery of fine cosplay works, enabling cosplay lovers a comprehensive understanding of cosplay. It expounds on the procedure of cosplay in line with its categories, delves deeper into difficulties and key points of each stage and provides detailed dos and don'ts of each key point shared by excellent cosers in that specific area of cosplay. The latter part of the book constitutes a photo gallery of classic works by outstanding cosers from countries around the world. Now let's indulge in the fantastic world of cosplay!

03 Case Study:
Cosplay of "Lord Shen" from
Kung Fu Panda 2 125

04 Photo Gallery 141

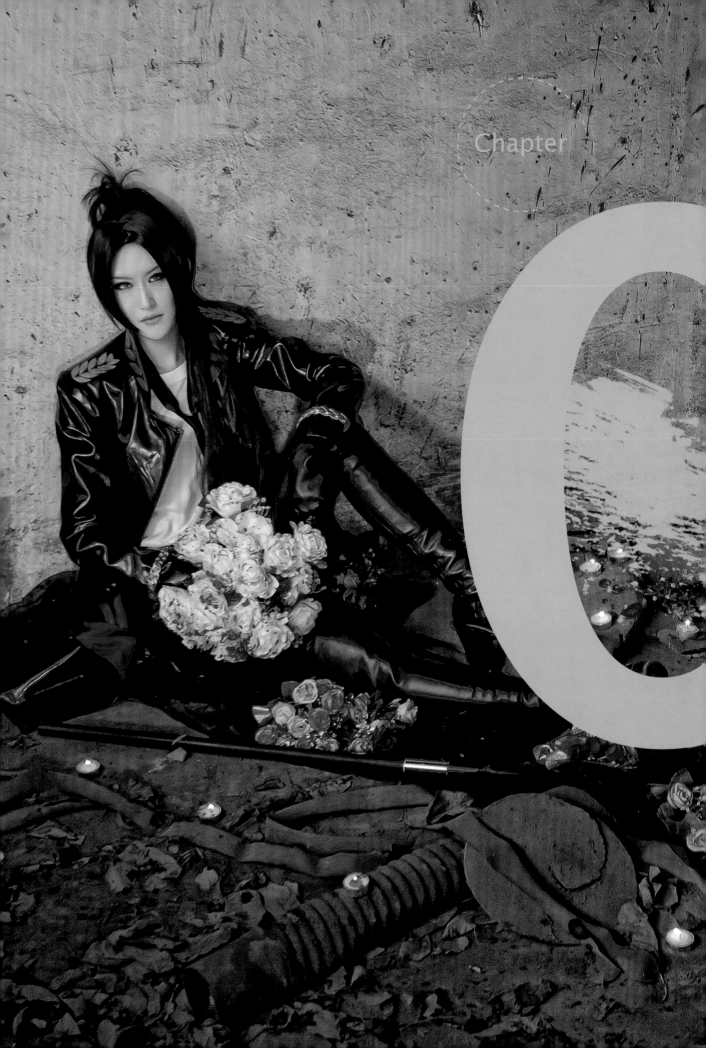

Introduction
to Cosplay

I. Cosplay Conventions

Cosplay is the abbreviation of "Costume Play". It usually refers to the performance of roles in animations, games and other works through costumes, adornments, props and corresponding makeup. The term "coser" is coined to refer to those who give cosplay performances. Let's take a look at a few competitions and exhibitions across the world to gain an insight at the fantasy world of cosplay.

1 Cosplay exhibitions

• World Cosplay Summit, Japan

Abbreviated as WCS, World Cosplay Summit, is an international competition initiated and proposed by Japanese Aichi TV and attended by world cosplay enthusiasts. Since its successful debut in October, 2003, it has gradually developed into one of the most influential competitions around the world. From October to June of the next year, all participating countries organize tryouts. Winners are selected as national representatives for finals in Japan.

• Cure Cosplay Festival, Japan

Hosted by the popular cosplay website "Cure", the Cure Cosplay Festival is one of the top-class cosplay exhibitions in Japan. Over the years, it has become the shrine for cosplay fans to exchange ideas and interact with each other. At the exhibition many fans will present an array of live cosplay shows of games and animation characters.

• Golden Mask Award, China

Held in July annually in Beijing, China, the Golden Mask Award has become a global competition featuring young comics lovers participating in reality shows of animation dramas. The competition aims to realize every comics lovers' optimum dream by building the most professional stage conditions, the most creative stage art effects, and the most exquisitely arranged shows with strict procedure management.

2 Major conventions with cosplay gatherings

• Tokyo Game Show (TGS), Japan

The Tokyo Game Show is an international video game convention held twice every year in Makuhari Messe (Japanese Convention Center) in Chiba, Japan. Attracting hundreds of thousands of game lovers every spring and fall, the convention features all kinds of video game consoles, recreational software, computer games and peripheral products. Some game players bring their own costumes and present cosplay shows after the exhibition while some simply attend the exhibition to give cosplay performances.

• Comic Market (Comiket), Japan

Commonly known as Comiket or CM, the fair is organized by Comic Market Preparation Committee twice a year, and has become the world's largest fair to display and trade doujinshi (self-published works including magazines, manga and novels). Many amateur comic fans, professional cartoonists, and even game companies attend the activity. The summer fair is usually held from the second Friday to Sunday of August each year while the winter fair is held from December 28th to 31st at the famous Tokyo's Big Sight in Koto, Tokyo. The fair would set up a Cosplay Square outside for cosplay fans to take photos.

• China International Digital Entertainment Exhibition (ChinaJoy)

ChinaJoy is held in Shanghai every year in July. It selects over 20 cosplay teams from hundreds of candidates across the country to participate in the finals. It encompasses China's overall cosplay proficiency and gives an overview of the regional variations in the performance styles of the participating teams, especially between northern and southern associations. In general, ChinaJoy favors cosplay of games over other categories.

Below right: image from stage tutorial by Lie

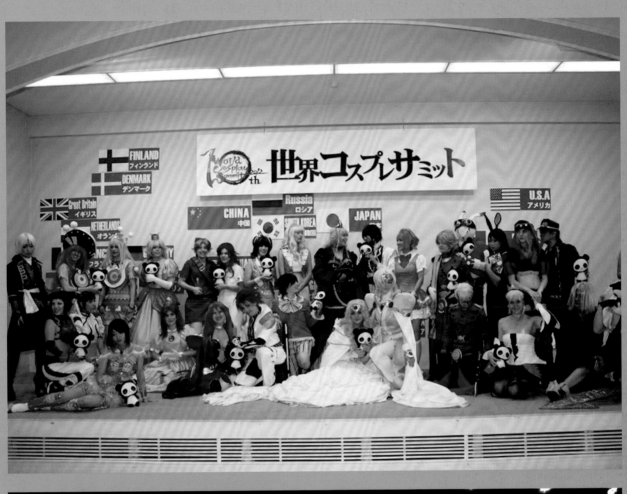

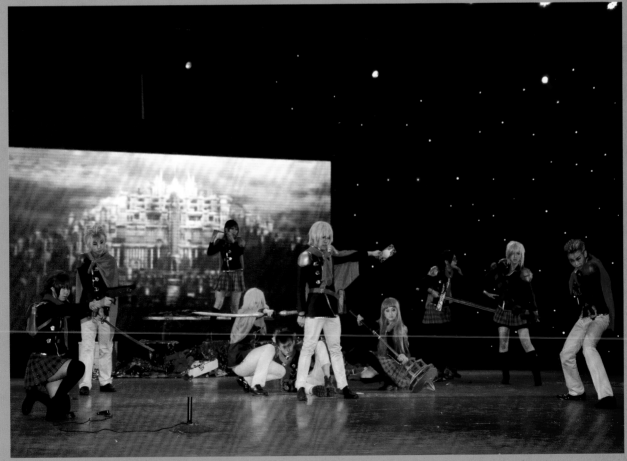

• Anime Expo (AX), USA

Centering on animations, cartoons and games, Anime Expo is the largest anime and manga expo in North America with its turnstile attendance over 220,000 in 2014. Popular large events include the Masquerade, Anime Music Video Contest, Concerts, Battle of the Bands, and the AX Fashion Show. Anime Expo is a 24-hour convention that offers late-night activities. Many of the attendees cosplay while attending the convention with their own designs, making the convention a big gathering of creativity.

• Electronic Entertainment Expo (E3), USA

E3 is the world's premier trade show for computer and video games and related products, and the third largest convention on entertainment. At E3, there are all sorts of excellent cosplay artists-in-residence. The expo requires participants to be 18 years or older to attend.

• Gamescom, Germany

Gamescom is Europe's largest trade fair on interactive games. It is used by many video game developers to showcase their upcoming games and game-related hardware. Together with E3 in America and Tokyo Games Show in Japan, Gamescom is listed as one of the three largest interactive entertainment exhibitions. At this expo, cosers and game players are invited by game companies from around the world to give performance of role cosplay.

• Frankfurt Book Fair, Germany

An international book fair held in Germany, FBF is the largest and most renowned book fair in the world with the reputation as "the Olympic Games for World Publishers". Every year at the fair, there will be a cosplay assembly at the general hall, at which attendees are able to view brilliant roles in all anime and manga works.

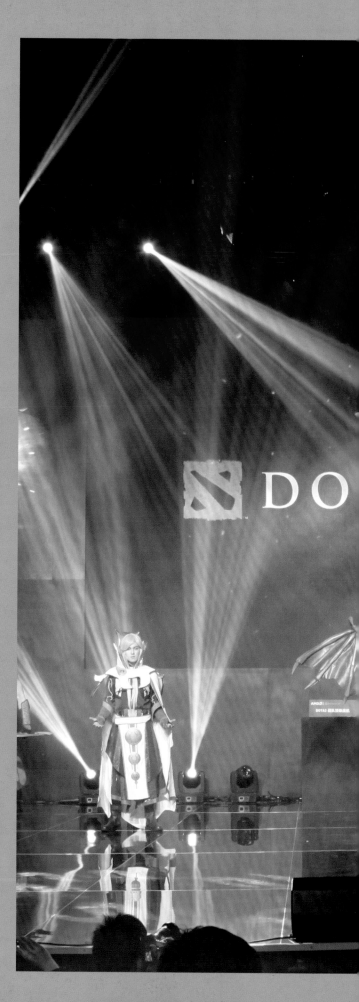

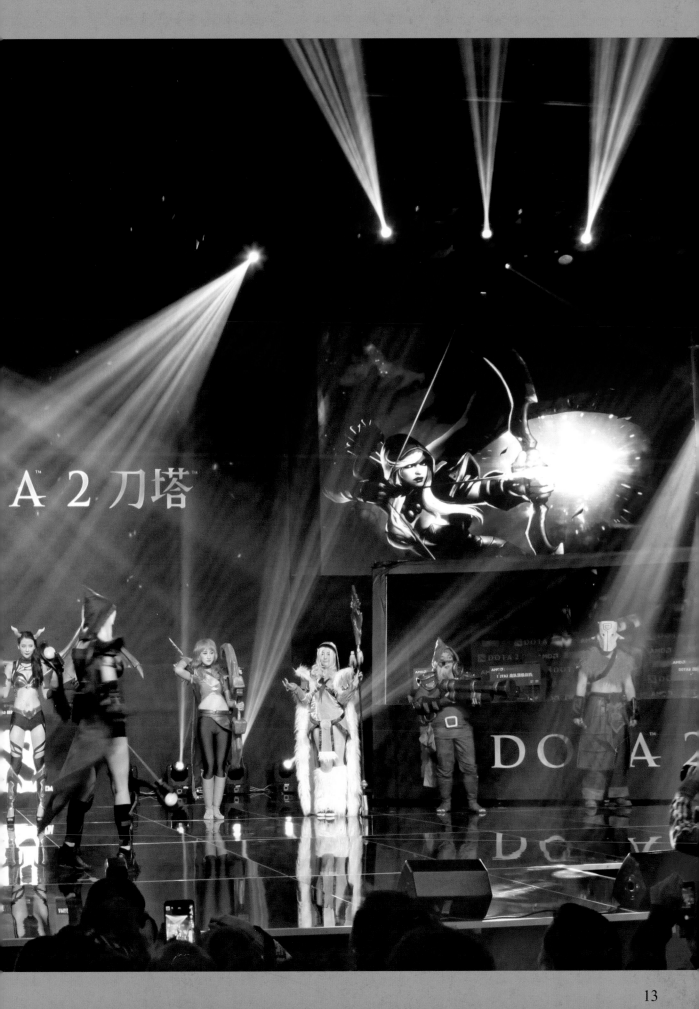

II. Interviews of Cosers

TOOYA

China

- One of the first official spokesmen for Chinese original animation
- First personal photo album *Anarchy in the NIPPON* published in 2011; the book combines cosplay photos with proses to express the cultural creativeness in cosplay
- Editor of *Secrets of Cosplay* (published in 2011), the first professional cosplay tutorial in China
- Curator of various animation exhibitions
- Senior makeup artist
- Freelancer

Q: What features of cosplay have attracted you?

A: Cosplay is the link between the two-dimensional and three-dimensional worlds. It turns beautiful fantasies and dreams into concrete forms, which I find very appealing. From costume styling to photo shooting, retouching, and to stage performance, you are allowed to engage yourself in the whole process and express your own thoughts. Such kind of self-fulfillment is intoxicating. Even more, cosplay can tap deep into your potential and provide you with the most straightforward and the most desirable sense of self-identity.

Q: What is the greatest pleasure that cosplay can bring to you?

A: Cosplay always enables me to discover something new, and has left me so many precious memories. It allows me to realize that it doesn't matter if I'm not the most beautiful or the most professional, but a pursuit of perfection can always bring something even better.

Q: What do you usually do besides cosplay?

A: Apart from being a coser, I am also a curator for animation conventions. I prefer to extend my interests into various fields. Likewise, I am also a professional makeup artist, which I can use to my advantage in cosplay performances.

Q: How Long have you been involved in the field of cosplay? Do you need to constantly go over the characters and movements of the role every time you set out for photo shoots? And could you offer some tips on preliminaries for cosplay?

A: I have been in this field for 11 years. Usually I will collect materials for all the roles in advance and study cosplay works of these roles done by other cosers, and then I practice the poses repetitively in front of a mirror to find out the best angle for the role. Prior to photo shootings, we need to check if we've got all the costumes and props; do makeup trials; communicate with the photographers; check weather forecasts; have a clear vision of the shooting process and draw storyboard accordingly; and finally, prepare auxiliary props for the shooting process.

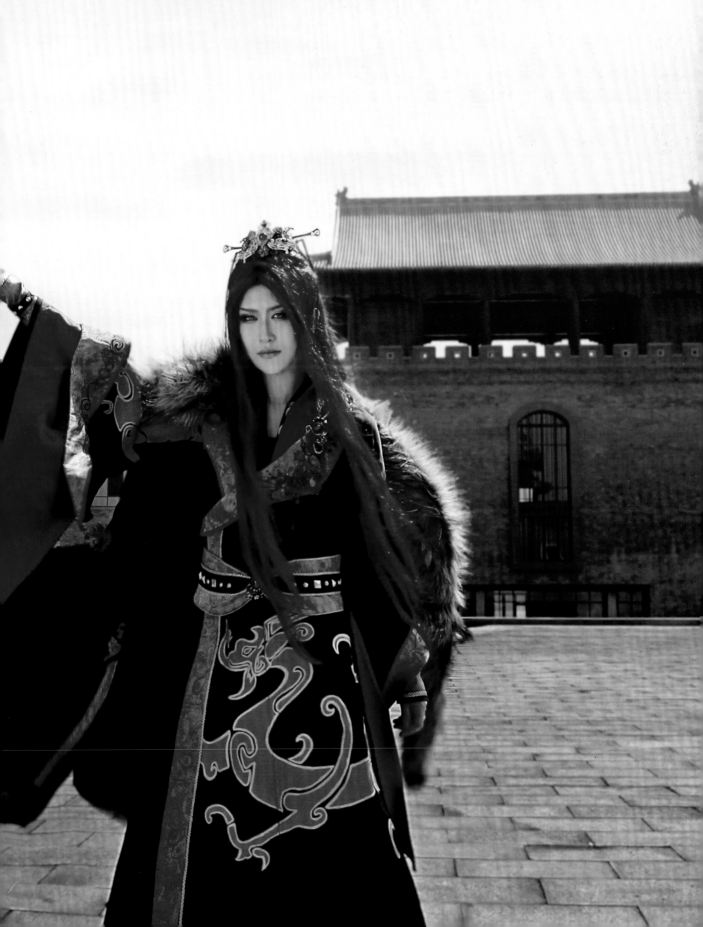

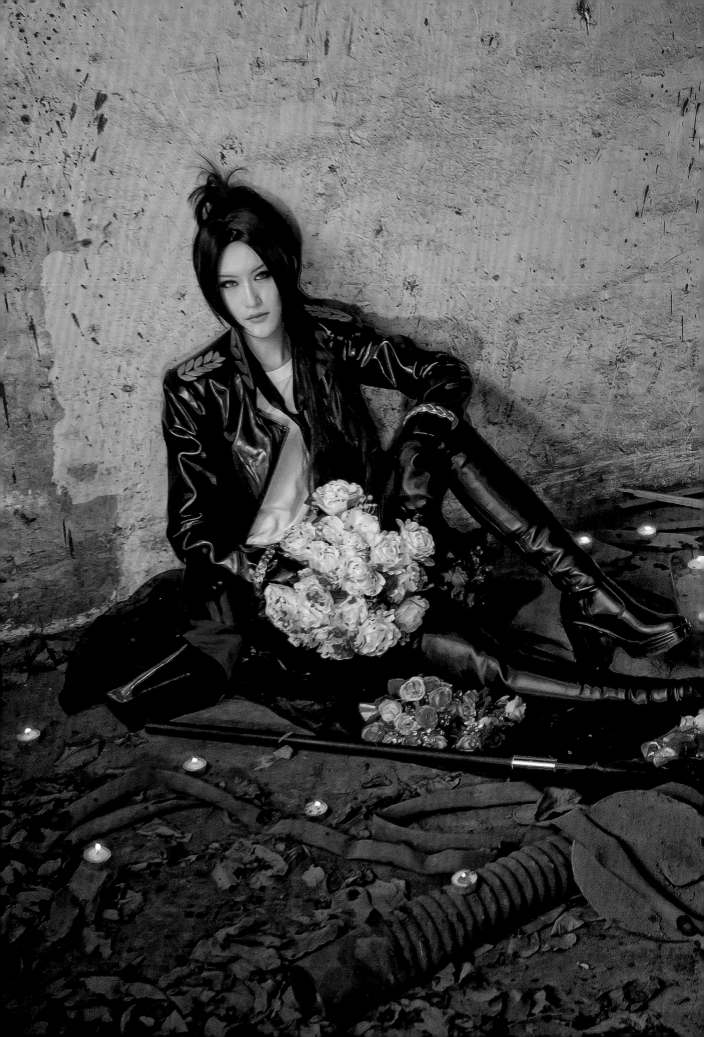

Reika
Japan

- Renowned Japanese coser with diversified and handsome styles
- Member of the cosplay team "Inazuma Eleven"
- Actively engaged in large-scale Asian anime and manga exhibitions

Q: How long have you been engaged in cosplay? Do you make costumes yourself?

A: I have been in this field for 19 years and I made almost all costumes myself. The more elaborate the costumes, the more devotion needed. Disorganized operations may ruin the attire. Therefore, each step needs to be conducted with scrupulous care, as if handling a piece of art.

Q: Can you brief us on the situation of cosplay in Japan?

A: Cosplay in today's Japan, in my view, is kind of reclusive. Some activities in Japan resembles photography gathering and are in dire need of exchanges, which I find regretful. Many activities in Japan have neither stages nor matches. Comparatively speaking, outdoors photo shoots is a popular choice as they can offer delightful atmosphere.

Q: What kind of roles would you cosplay?

A: I only cosplay the roles I favor. The meaning of cosplay must not rely on earning popularity, but on personal expression; therefore the key is to show your love, just like children put on masks and helmets to impersonate heroes they admire. Only in such a way can you truly touch the chord of yourself and in others.

Q: Could you give us a general introduction to cosplay around the world?

A: Different countries vary in their cosplay activities. In America and Europe people usually put on costumes to play for entire nights, just like attending school celebration festivals. Such activities lighten up the spirit and entertain everybody. In contrast, Asian cosplay activities usually set up a festive stage and everybody performs individual shows on it. This way is also agreeable as it enables more exchanges and opportunities for improvement. As there is barely a stage in most cosplay activities in Japan, I tend to think that activities elsewhere are more popular than that in Japan.

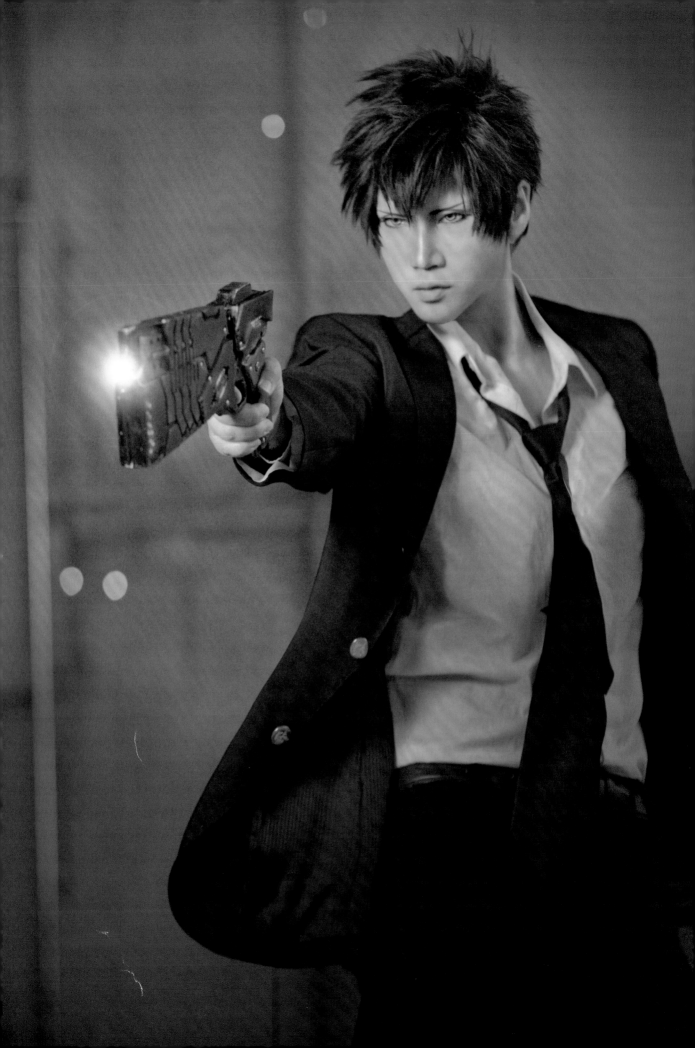

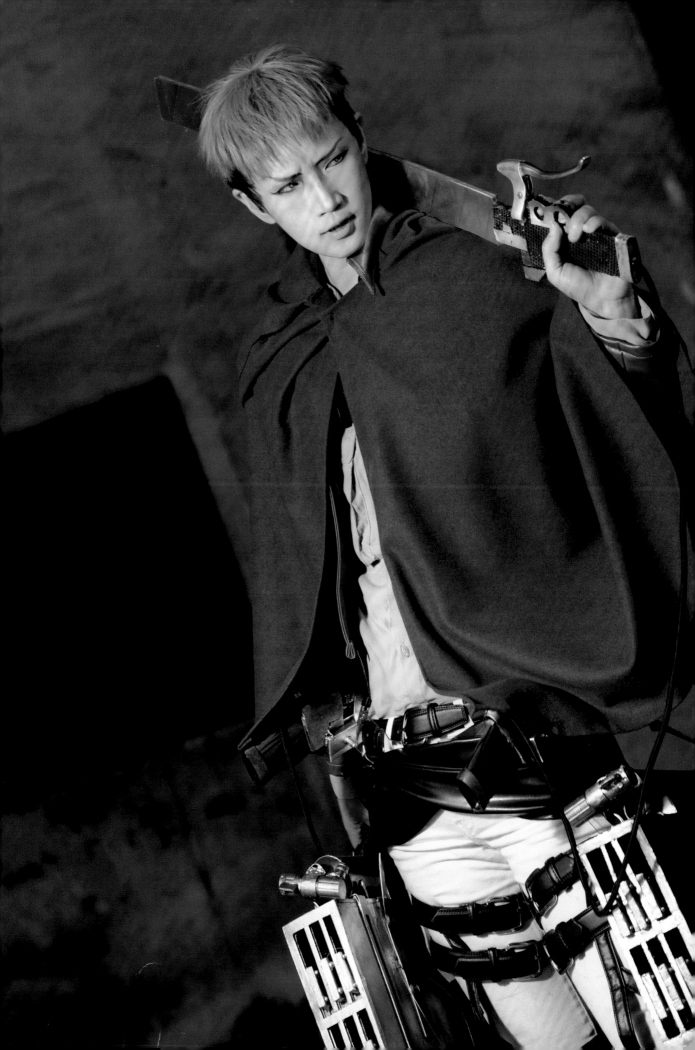

Gesha
Petrovich

Russia

● Champion of 2014 Russian Animatrix
National Cosplay Photography Competition

Q: Are there many animation festivals in Russia? What are they like?

A: In Russia, Japanese animation and cosplay came into vogue in 2000. Before that, there were no more than ten large-scale animation galas and game festivals in the capital, along with smaller specialized venues in other areas. Now according to statistics, there are animation-related celebrations of all forms every two to three weeks.

Q: When did you start to fancy animation? How did you start to cosplay?

A: When I was little, I was really into the animation called *Pretty Guardian Sailor Moon*, but the series stopped airing shortly after. Then every year I was sent to my Grandma's for summer, and there I met a girl who was learning Japanese style caricature and she told me a lot about Japanese animation. When watching *Angel Sanctuary*, I joined an animation club, where I made friends with many people of the same interest. Later on, I moved to Mosque, where I discovered many animation festivals and cosplay performers and all sorts of animation clubs. Gradually I've become part of the cosplay world.

Q: How long do cosplay photo shoots usually take?

A: It depends on the costume and venue. In terms of costumes, if they are simple and light in texture, photography usually only takes two hours; however, in cases of heavy and elaborate costumes, it may take an entire day. But these estimations are also subject to team coordination.

Q: What kinds of roles do you usually choose to cosplay? What are your criteria for a good cosplay photo? And what is your favorite animation work?

A: I usually impersonate dangerous roles or antagonists. I prefer gloomy, dark scenes that are full of action. In my mind, such styles boast a supreme effect in photos. My type of animation works are mostly from Japan, such as *Angel Sanctuary*, *Berserk*, *Hunter × Hunter*, and *Attack on Titan*, etc. As a matter of fact, each cosplay style brings delight, and that is why I would like to try inclusively.

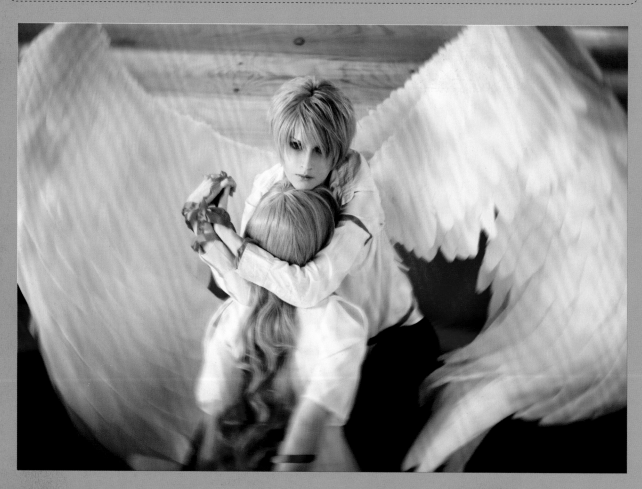

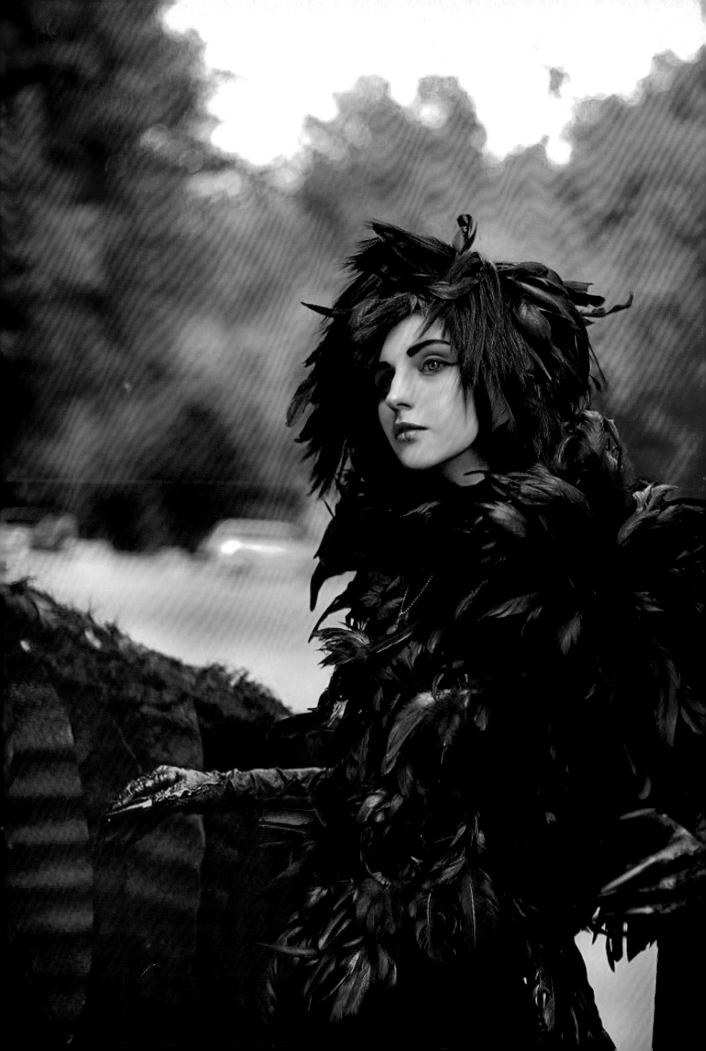

Yuegene Fay

Thailand

- Senior popular Thai coser specialized in prop and costume making and retouching
- Attended WCS on behalf of Thailand in 2007 and 2009, and was invited to participate in activities held in Japan and South Korea

Q: How long have you been engaged in cosplay? How many roles have you performed? What is cosplay like in Thailand?

A: I made my first foray into cosplay in 2000. I haven't calculated how many roles I've performed but I hope to try as many as possible. Thailand doesn't place much emphasis on animation and cultural industries. Current large-scale cosplay-related activities are mostly held in Bangkok; it's barely popular in other cities.

Q: Do you make your own cosplay costumes? What kind of roles do you favor?

A: Yes, I made my own costumes. In cases of being fully occupied, I'd ask for help from my friends; yet I tend to all the details in person. I like many kinds of roles, and what really fascinates me is the story behind the role and its relationships with other characters.

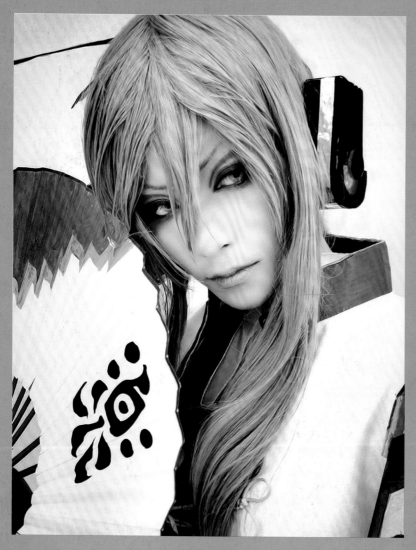

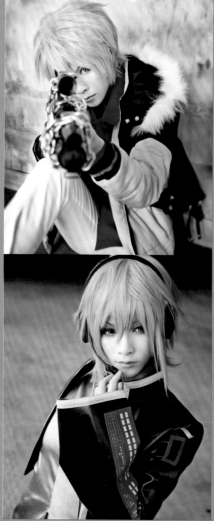

Krishna

China

● Experienced Chinese cosplay studio consists of senior cosers including Allen, Xiao Meng and Shasha

Q: Can you share with us some anecdotes and difficulties you encountered in your photo shoots?

A: When taking cosplay photos, the primary concern is weather conditions. For instance, when we were shooting *Antique Sword 2* in Cambodia, it was hot with intense sunlight and the temperature was at about 40°C. All day long, the coser didn't take in anything except for water and was surrounded by onlookers. There we've also had problems in communication. Staff members at that scenic resort couldn't speak English well and we had difficulties understanding each other.

Q: What kind of cosplay do you prefer? What preparations do you make before outdoor photo shoots?

A: Personally I prefer to cosplay roles from novels, as there is vast room for creation. The preparation works differ from case to case. For example, if we are going to shoot death and corpse scenes, we need to prepare blood plasma or simulations. In outdoors photo shoots there may occur all sorts of emergencies, so we usually would bring mosquito-repellent liquid, band-aids, and common medicines as backup. In these cases, I will make a comprehensive check list beforehand so that everything would be organized.

Q: How many works have you completed so far? Which is the most satisfactory one?

A: Krishna Studio has completed a few dozens of cosplay works so far, and as for the most satisfactory of all, I would always say the next one. At present I am relatively more satisfied with the three works including 2013, Peacock's Crave for Light (Peacock King/ Spirit Warrior) and The Grave Robbers' Chronicle.

Q: How do you coordinate with your team members? Do you make your own costumes and props?

A: There are not many people in our team, usually around ten. However, each member is versatile. I am in charge of producing and photography, Xiao Meng is responsible for make-up and modeling; Caicai for monitoring costumes, and we have specialized makeup assistants and photographer assistants as well. Also, everyone is able to do retouching with Photoshop. We don't make costumes and props ourselves; instead, we have collaborated with tailors and prop masters, but we provide input and will help making minor adjustments.

Coser: Xiaomeng

26

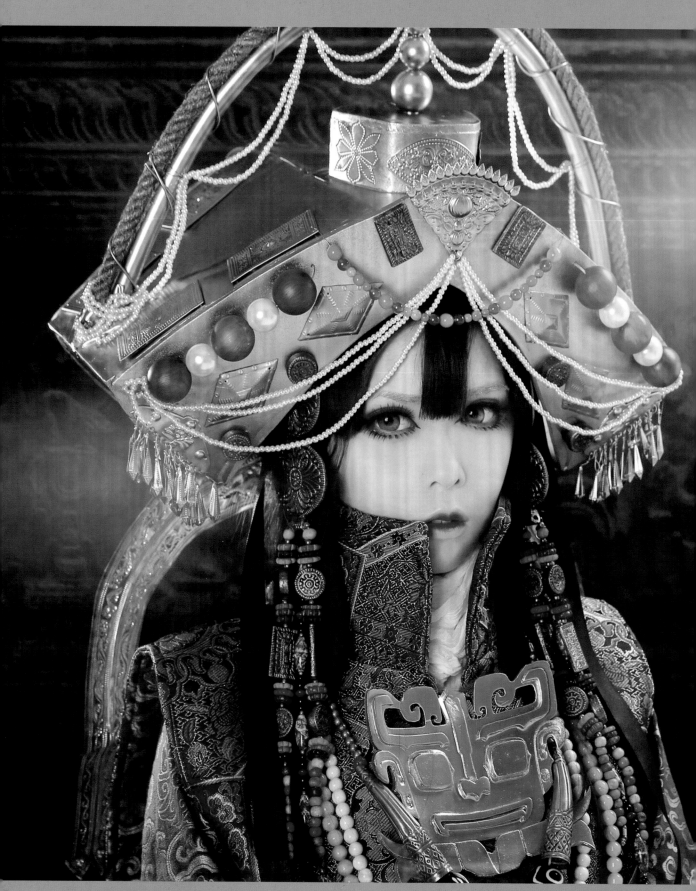

Coser: Xuan Xiaomianbao

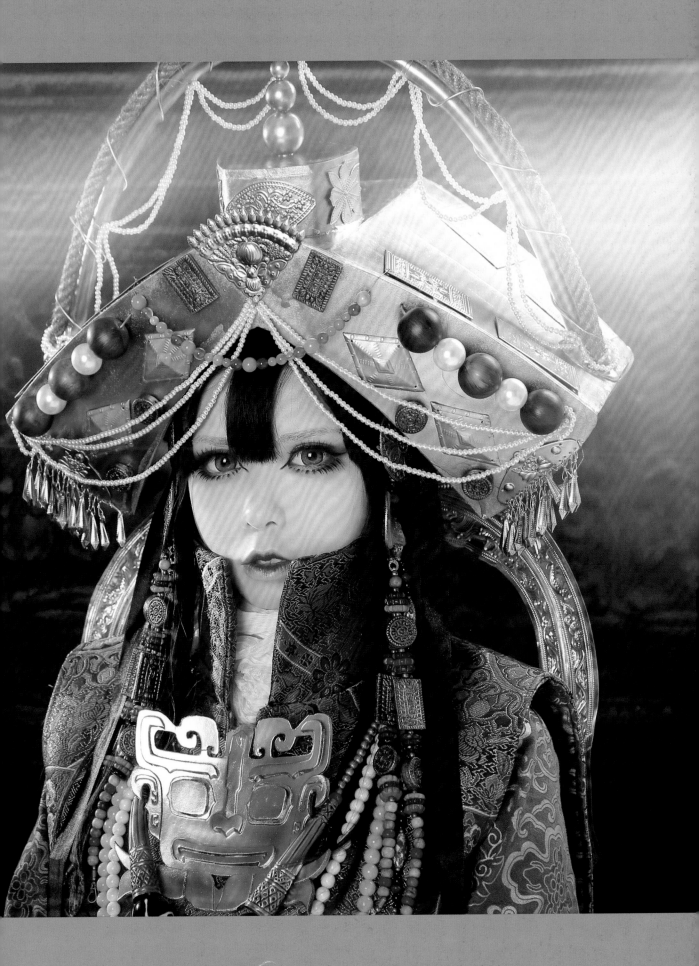

Xiaoxiao Bai

China

- Renowned Chinese coser, professional judge at many large-scale anime and manga competitions
- Official coser for various online games

Q: What is the usual time span of cosplay competitions at present?

A: The time span of cosplay competitions depends on their nature. Usually small activities last for two to three days, and the first three winners will then be chosen from the participating individuals or teams. There are also regular annual competitions, for which the organizers would always try all means necessary to extend the time span for the sake of best marketing results and attracting people's attention. Therefore, these competitions are divided into preliminary matches and finals. Candidates are selected gradually from each round of various competition sectors before they vie for the finals.

Q: What are the criteria for a good performance in cosplay competitions?

A: The judges give their scores based on compition's rules as well as their personal preference, and both standards and preferences are subject to changes for different competitions and judges. Therefore, the results are not of much importance. The essence of competition rests within exchanges of ideas and learning from each other. Generally speaking, the basic key factors for competitions include costumes, props, makeup representativeness, stage effect, choreography, teamwork, expressiveness of facial and body language, highlights of the performance, and the audience's reactions, etc. It is pointless to try and decipher the question relating to which factors are the most important for certain competitions since all aspects must be superior to achieve a high score.

Q: Could you give some advice for team and individual candidates from the viewpoint of a professional judge?

A: Different judges vary in their technique and tastes, including me. I just simply express my own opinion. For team competition, it's crucial that the cosers be fully committed and their temperament complies with the roles. It is necessary to make story explicit to the audience and it is even better if the performance can attract the audience to the original works. Stage catwalks need to be diversified to avoid monotony. What's more, teamwork is very important in team competitions. A relatively big yet well-organized team will be very impressive. In solo competitions, although at present many solo cosers tend to show their talents, such as singing, dancing, martial arts and magic, I personally still hold the view that cosplay should focus primarily on self-made costumes, props and the technique of how you impersonate the role you play. For instance, if the role is good at dancing, it feels odd if you sing on the stage. Therefore, it is equally important to find the right role according to your advantage. Never show your talent for its own sake.

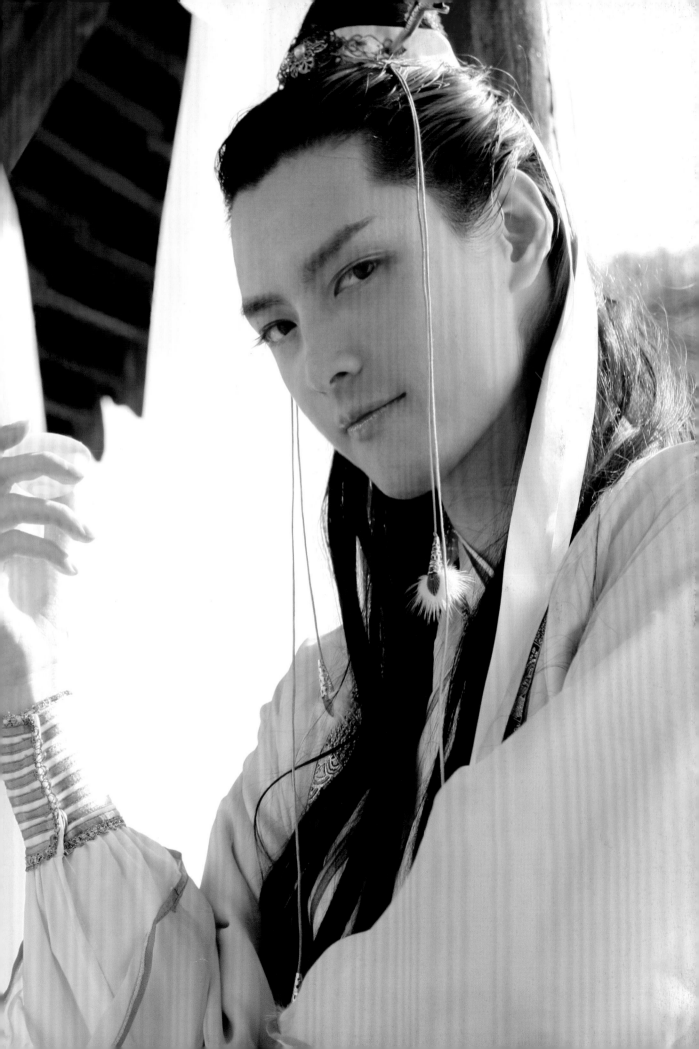

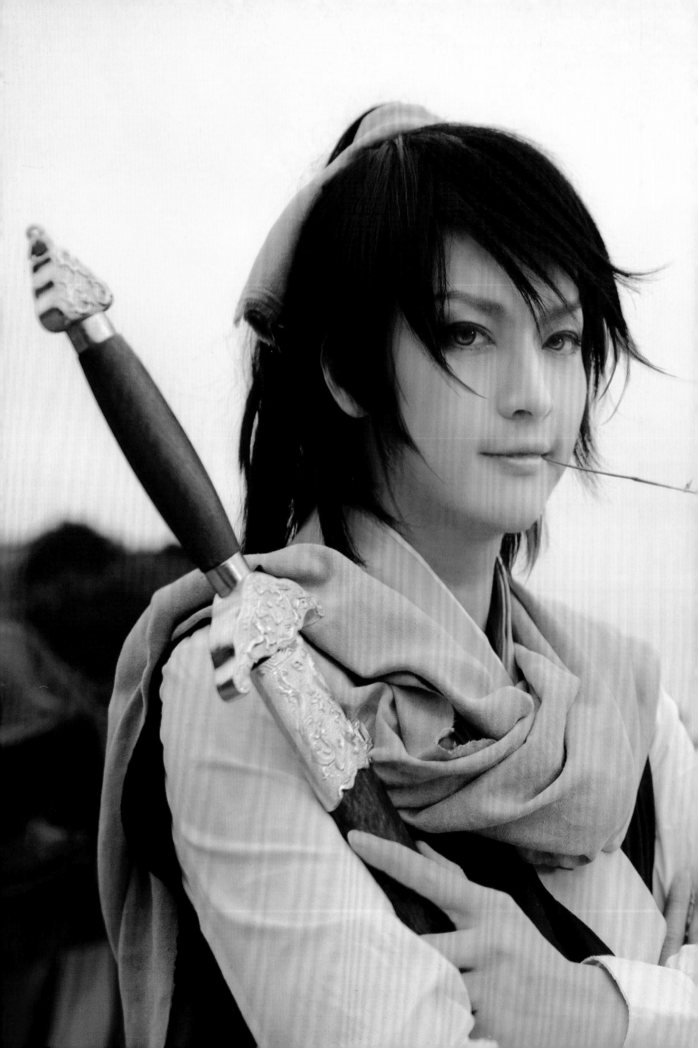

AINO

South Korea

● National representative of South Korea at WCS in 2012

Q: Do you make your own cosplay costumes?

A: I make my own costumes and sometimes I make costumes for others. In South Korea, many people produce their own attire since they can produce better than those sold in shops. However, there are still quite a number of people purchasing from stores, who are usually young students without adequate time to make on their own.

Q: How long does it usually take to prepare for a set of cosplay photos?

A: The preparation takes at least two to three months. It is subject to specific situations like the number of members and the level of intricacy of costumes. If we choose to manufacture the costumes ourselves, it means we need to coordinate each member's time. A group must find a time for every member to be at the same place picking out materials and everything. Therefore, it takes a longer time for a group of people than that for an individual.

Q: Could you tell us what cosplay is like in South Korea?

A: Cosplay in South Korea today has enjoyed better opportunities for development than before, yet it is far from enough. A large number of people have no interest in animations, games or even cosplay, which has hurt the feelings of many cosers. Even so, there are still quite a few people who are fond of animations and cosplay, including a growing number of junior and senior high school students. We have our own "Comic World" where every coser would go for appreciation of cosplay.

Q: Would you like to say something to other cosers?

A: Hello to everyone, I am a coser from South Korea. I wish to have more communications with friends from other countries. Although we are from different countries, we share the same passion for cosplay. I hope and encourage more people to show their love and join the big cosplay family.

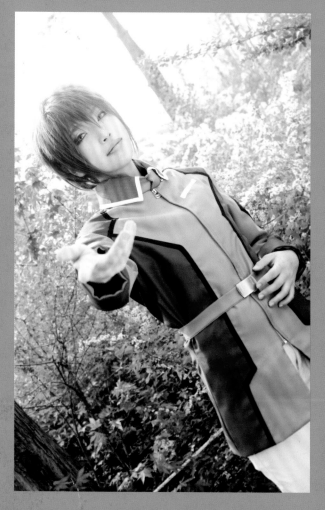

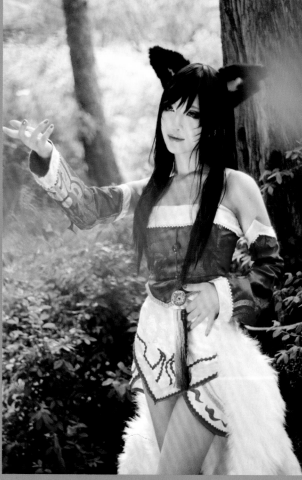

34

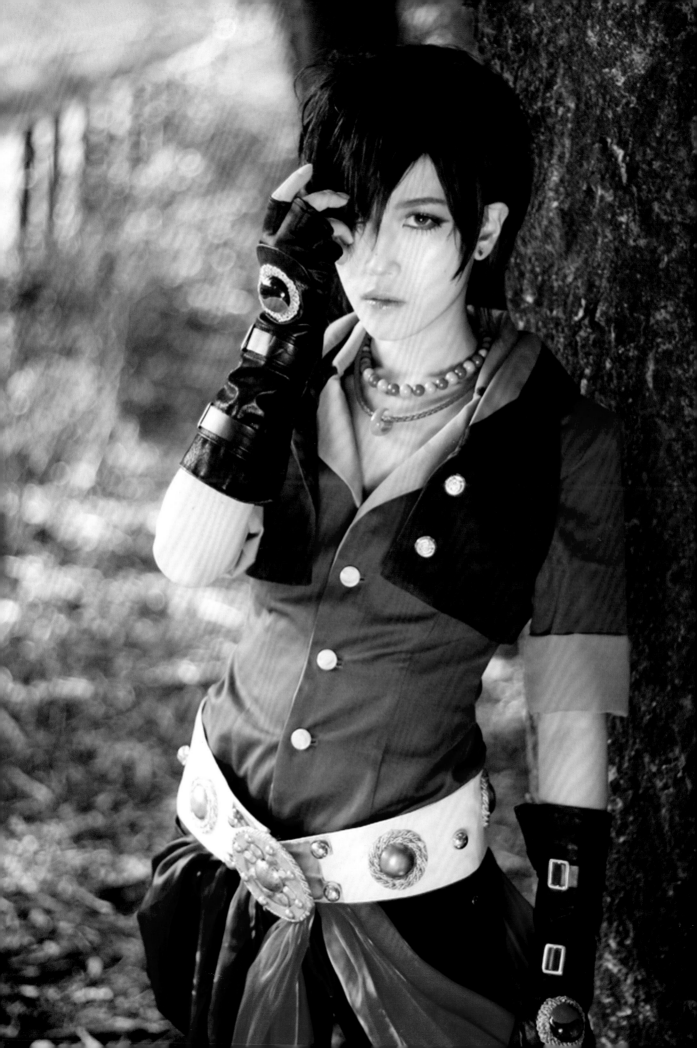

Nevan

China

- Judge for various professional cosplay competitions
- Mainly cosplay roles from games with self-made costumes and props
- Specialized at adding surprising effects to photos in retouching

Q: Could you give some advice to team candidates from the viewpoint of a professional judge?

A: For cosplay teams, whatever the topic is, confidence and coherence is the most important. Cosplay teams need to be fully committed, yet also maintain a relaxed demeanor. Many teams tend to analyze previous award winners and current trendy forms; though it is necessary to do so, it doesn't warrant too much attention. In competitions judges attach more importance to teamwork, plot arrangement, costumes and props.

Q: Could you give some advice for individual candidates as well?

A: For individual cosers, it is easier to prepare the performance, yet requirements for them are much higher. Team competitions bear the advantage that, with more people, even if lapses occur, they are quickly covered by other teammates. On the contrary, in solos, there is no one else to serve as a distraction and all the attention of judges and the audience is focused on the coser, which could magnify even a small error. Solo performance is suggested to be concise so it serves the audience's content just adequately. Moreover, cosers need to understand the difference between stage cosplay and cosplay photos. The former is not just about choosing a costume or modeling and posing for a nice photo. Don't risk difficult performances; if you are not ready, they may harshly expose your shortcomings.

Q: Could you share with us your experiences in stage performance and competitions?

A: First and foremost, be confident of yourself as well as the team. Secondly, keep good command of emotions. Although cosers may not be able to guide the audience's feelings like professional actors do, many do manage to influence them. The command of emotions is reflective of the proficiency of the coser. Some cosers might tend to exaggerate their performance and indulge in themselves so much that they ignore cooperation with their team members, but as a matter of fact, neither howling, roaring, wounding nor bleeding could ensure a good performance. Stage performance is an interactive art that involves the audience's appreciation.

Q: From the viewpoint of a judge, what situations and practices are fatal in competitions?

A: In recent years many cosplay clubs prefer to use large but clumsy props, which may hinder the cosers from walking with ease, let alone delivering a successful performance. Insufficient preparation of specialties also lowers scores. For instance, a dance show with incomplete choreography or out-of-rhythm movements is unquestionably disappointing. Finally, practices of going cross the line or even using immoral actions to attract attention would definitely bring down the score. This is definitely unacceptable.

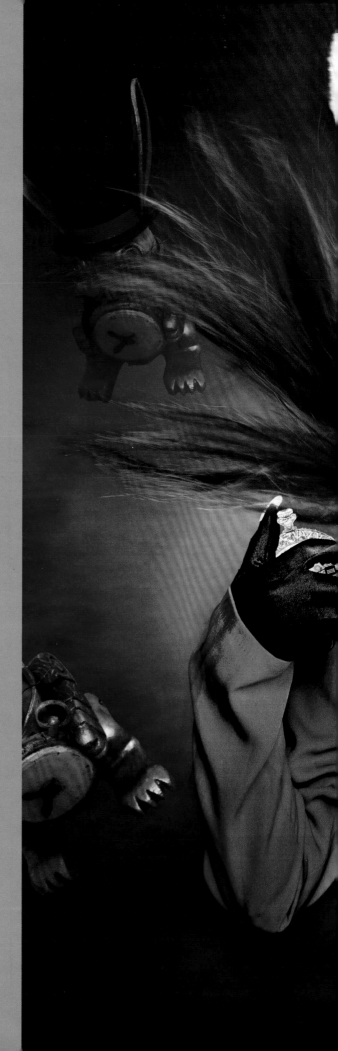

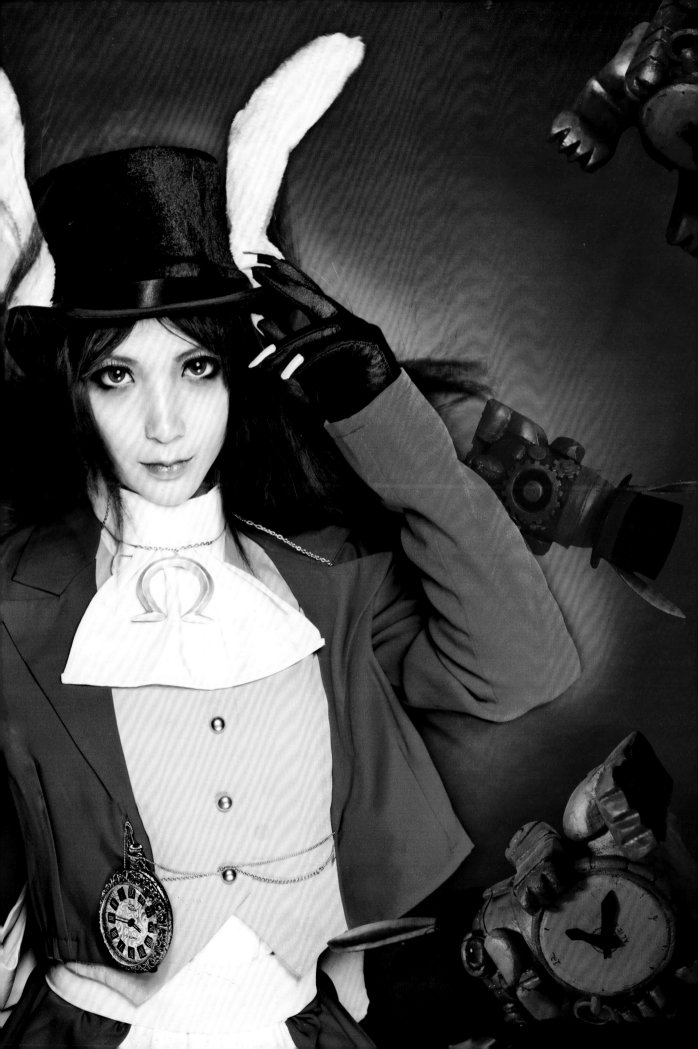

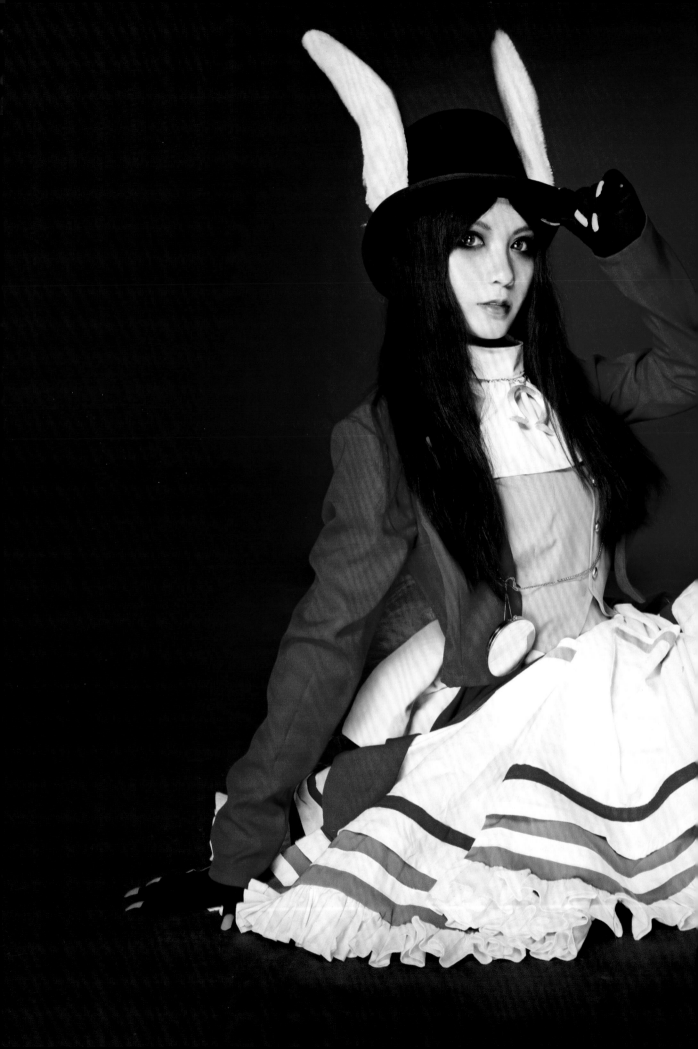

III. Categories of Cosplay

Cosplay brings fantasies on graphic animations and games into reality through costumes, styling, props, and make-up. Throughout the process, cosers' amazing performance enchants numerous animation and game lovers. We can classify the connection of reality and fantasy into two categories in line with its demonstration method.

1 Two categories of cosplay

• Photo shoot

There are two forms of photo shoots: one is an individual practice initiated by personal interests of a group of people as they take cosplay photos for personal appreciation or commercial usage; the other is a commercial activity organized by sponsors to produce advertisements for animations, games and other products.

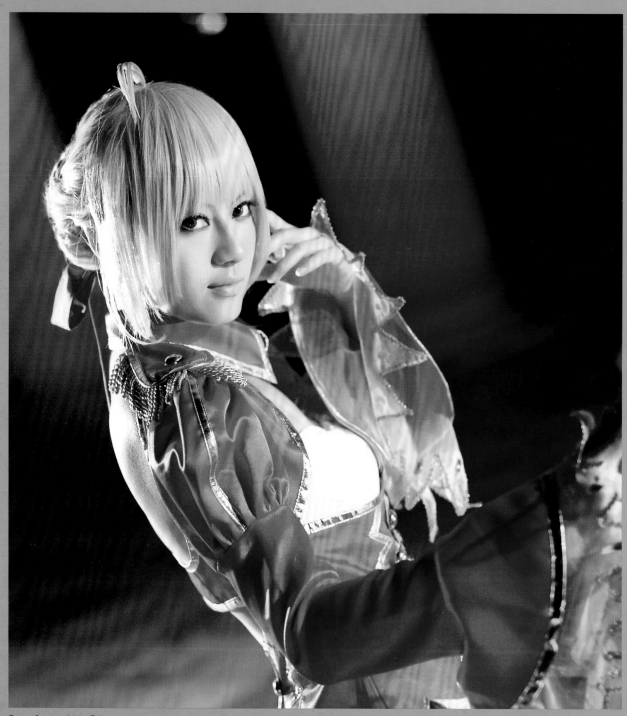

Coser & retouching: Feiyan
Photographer: Yangguang

• Stage performance

Cosplay performances on stages are organized by sponsors and equipped with lighting, sound and other facilities. Stage performances are usually live competitions with audiences and judges. Normally the categories include solo, duet and team competition.

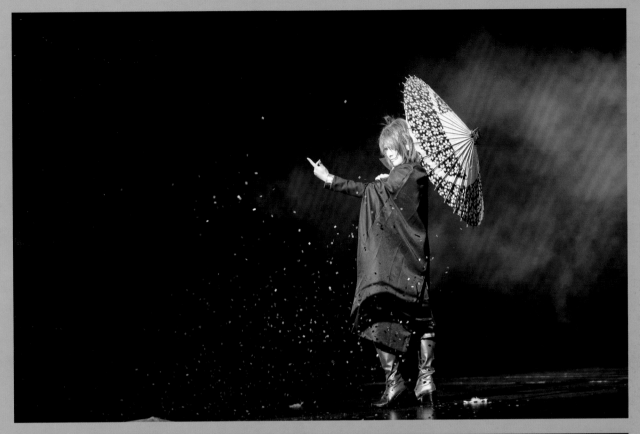

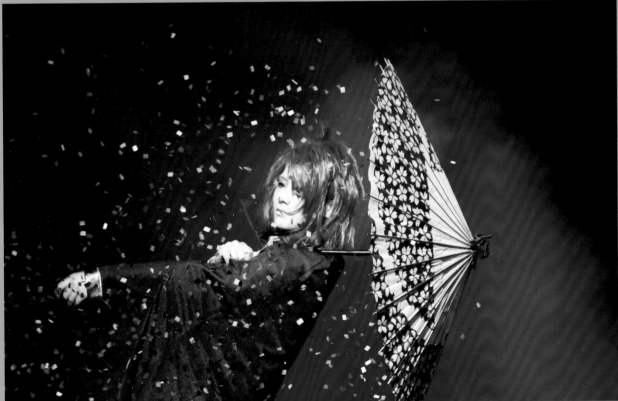

Image from stage tutorial by Shifeng & Lengyu

2 Procedures of cosplay

The following diagrams illustrate clearly the detailed procedures and key points of each of the two categories of cosplay, i.e. photo shoot and stage performance. The two categories shares some basic steps but varies in execution. In practice, these procedures may be simplified or combined according to specific needs, and some steps could be carried out simultaneously. The following diagrams are only for references.

• **Procedure for cosplay photo shoot**

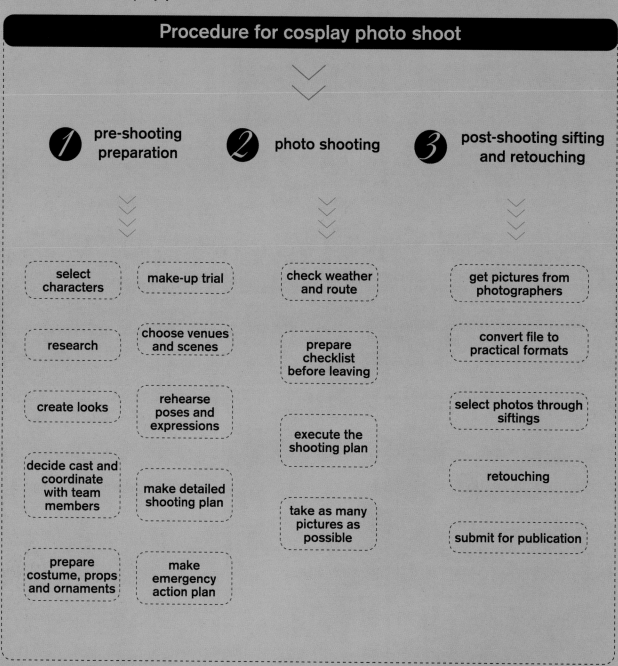

Procedure for cosplay photo shoot

1 pre-shooting preparation

- select characters
- make-up trial
- research
- choose venues and scenes
- create looks
- rehearse poses and expressions
- decide cast and coordinate with team members
- make detailed shooting plan
- prepare costume, props and ornaments
- make emergency action plan

2 photo shooting

- check weather and route
- prepare checklist before leaving
- execute the shooting plan
- take as many pictures as possible

3 post-shooting sifting and retouching

- get pictures from photographers
- convert file to practical formats
- select photos through siftings
- retouching
- submit for publication

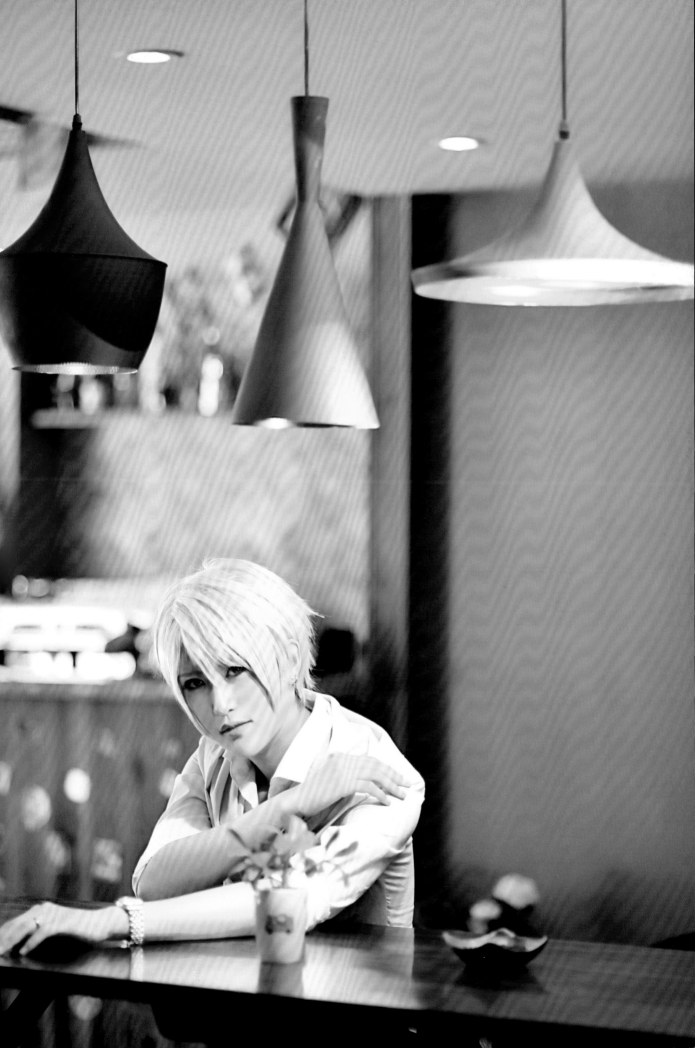

• Procedure for cosplay stage performance

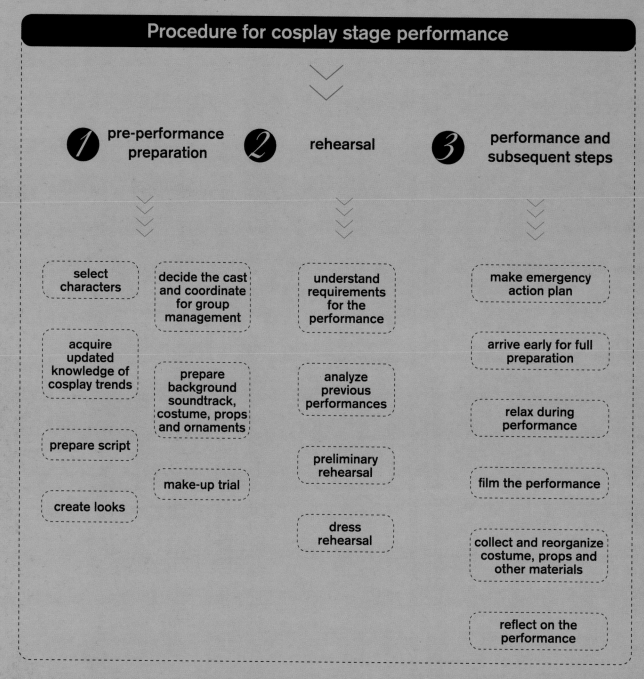

Procedure for cosplay stage performance

1 pre-performance preparation

2 rehearsal

3 performance and subsequent steps

1 pre-performance preparation
- select characters
- decide the cast and coordinate for group management
- acquire updated knowledge of cosplay trends
- prepare background soundtrack, costume, props and ornaments
- prepare script
- make-up trial
- create looks

2 rehearsal
- understand requirements for the performance
- analyze previous performances
- preliminary rehearsal
- dress rehearsal

3 performance and subsequent steps
- make emergency action plan
- arrive early for full preparation
- relax during performance
- film the performance
- collect and reorganize costume, props and other materials
- reflect on the performance

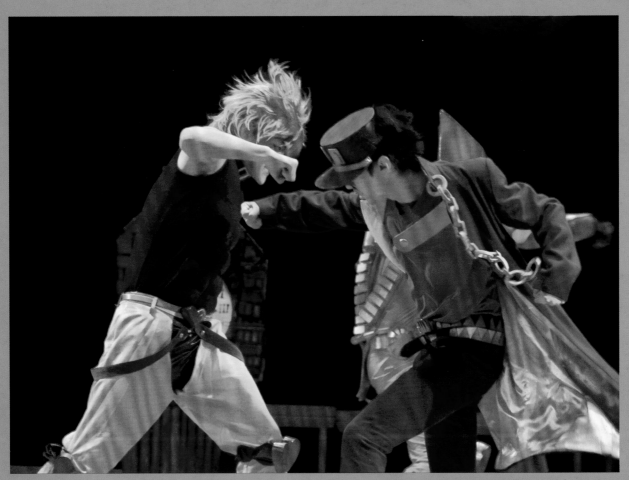

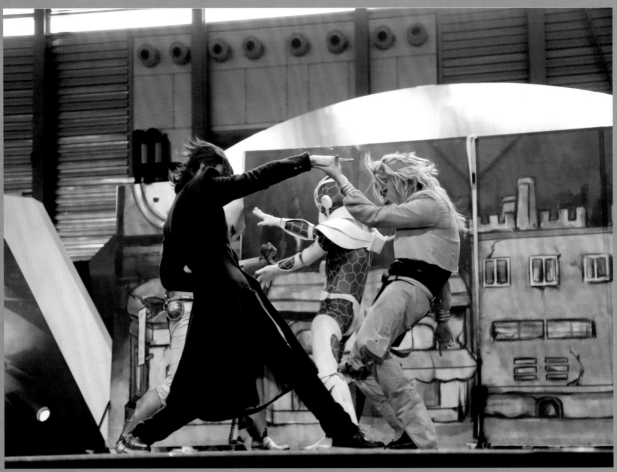

Key Steps in Cosplay

I. Research of roles

Cosplay is a role-play performance, which transfers linear visual images into amazingly tangible three-dimensional figures, conveying texts and feelings in visual forms. Before such transformations, it's essential to have a comprehensive and thorough understanding of the roles and stories behind. We need to find their features that are suitable for three-dimentional presentation, review previous cosplay images to study possible outcomes, analyze how to maintain the original characteristics while achieving the desired effect.

1 Figuring out the type of roles

Thanks to years of development, the roles adopted in cosplay extended from animations, comics, games to novels, movies and television. In this process, cosplay has generated many role types of its own, such as Lolita, Super-sister, Queen, Shota, and Schemer just to name a few. A full understanding of the characteristics of each type can help us visualize them precisely in terms of costume styling, expressions, movements and acting and so much more. Here is a brief account of the characteristics of some popular role types.

• Lolita

The term "Lolita" originally refers to the 12-year-old heroin in the novel *Lolita* by Russian-born American writer Vladimir Nabokov. It has become the official appellation of young girls or things related in the animation, comics and game culture (ACG). Girls of this type are endowed with inherent nobleness and appears polite, smart, adorable, sweet and naïve; they are constantly dreaming about knights and princes coming to their rescue. Styles for this character include: classic Lolita, sweet Lolita, and Gothic Lolita, among which the last style embodies less childlike innocence and more dark elegance – they usually paint fingernails with black nail polish and wear a cross, disguised with a sense of mystery and sweetness.

Lolita

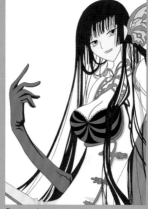
Super-sister

• Super-sister

Super-sister used to be a respectful reference to "sister", over time the concept has developed into females of approximately 20 to 32 years old with an elegant image, mature personality and sexy appeal. They are proud, ambitious, assertive, introspective and seasoned with experiences, all of which demonstrate their accountability. They usually wear mature and sexy clothes with elegant demeanor and their actions are deliberately slowed to achieve a purposeful and appealing visual tempo.

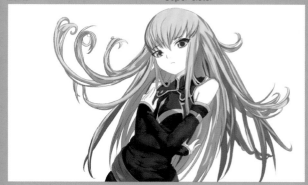
Queen

• Queen

A Queen is born of aristocratic European style, presenting a dominating and supercilious sense of affluence with an air of powerfulness. They tend to boss others around and are usually arrogant. Queens possess many traits of a Super-sister, but not all Super-sisters can deliver the presence of a queen.

• Tsundere

Characters of this type are unyielding with an arrogant, competitive and somewhat cold attitude towards

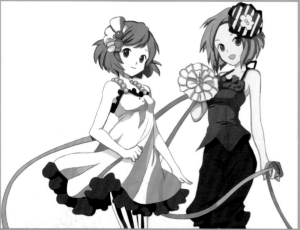
Natural dullness & Muteq Pou

everything in life, and they have a relatively mean tongue. They usually appear aloof in relationships but are in fact passionate inside and seldom concede in front of a rival. They may seem indifferent to friends, but they'll always step up when friends are in danger.

• Natural dullness

"Natural dullness" refers to characters with an unvarnished, adorable dullness that they would involuntarily fall into a state where they make silly actions with absurd and grotesque ways of thinking, which in turn generates hilarious and comedic effects. The style of this role is more or less disheveled to a certain extent.

• Mushins

Mushins (literally translated as "three-fold void") refer to the silent girls with no facial expressions and unfathomable and relatively reclusive inner thoughts. The "three-fold void" refers to their lack of speech, emotions and expressions. They barely talk except only when necessary; they seal their feelings inside and no one else is able to perceive their changes of inner feelings; there is no facial sign of emotions and no clue to sorrow or joy, as if they are indifferent to the outer world. However, Mushins are not entirely without a soul; they are just cold beauties.

• Muteq Pou

Muteq Pous (meaning buoyant but reckless) are a kind of impetuous and presumptuous female characters with little consideration of consequences. They are energetic, seemingly carefree, sanguine and courageous without fear. Their optimism usually helps clear others' minds of doubts yet they keep on doing stupid things without knowing. Therefore, they always serve as the role of "fool" in animations; but endearing and lovely once they set their heart at something or become upset.

• Doji Kko

Doji Kkos refers to clumsy girls who are always making "lapses with no serious consequences". They usually embody diligence, simplicity and candor, rising up after they fall. However, due to their sloppiness and lack of luck, they may continue to make mistakes one right after another. Doji Kkos are worthy of compassion not only in that they have to make apologies to others owing to mistakes, but also because of their toughness and tenderness, fortitude and independence. Doji Kkos are never reckless.

• Shota

In anime and manga, boys less than 12 years old with innocence, coyness, handsomeness and shiny eyes are called Shota. They often wear school uniforms, brace shorts and marine shirts.

• Otokonoko

Otokonoko refers to male characters with pseudo female tones, beautiful features with tall, thin, supple and graceful shapes. They are attractive both to men and women.

• Schemer

Schemers refers to those amicable in appearance while devious and calculating in heart. They may not be dark or malicious and their overall personality is positive. There are both female and male schemer roles in animations.

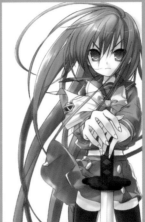

Tsundere

Mushins

Doji Kko

Shota

Otokonoko & Schemer

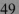

2 Research for the transition from 2D to 3D

Before transforming a graphic image into a figure in the three-dimensional world, we need to acquire background knowledge such as the animation related to the role, its profile and previous cosplay works of the role, etc. The appeal of cosplay lies in discovering and tackling the many problems along the way. Now let's take a look at what preliminaries are needed for the research.

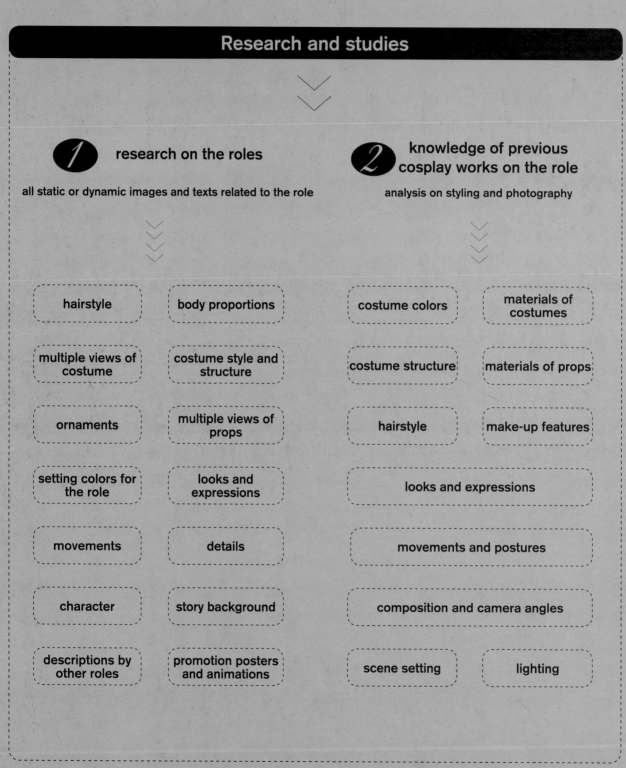

Furthermore, we also need to know in advance how to make full use of the textures and features of each material to bring the role into reality.

Static images help us gain a better understanding of the details of the styling, as well as the characteristic expressions and poses of the role, which would become very helpful in photo shoots.

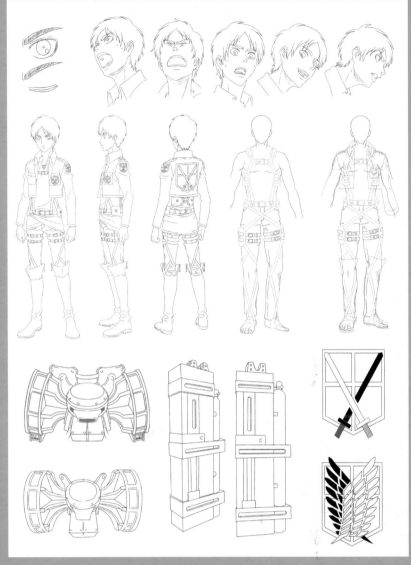

Dynamic images present to us the "feel" of the costumes, props and hairstyles – feelings for such as thickness, weight, toughness, etc. Animations provide us with visual and audio insights and enable us to gain a comprehensive understanding of them, so as to make the cosplay portrayal of the roles better conform to the original art.

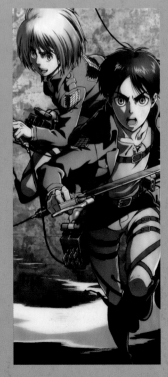

To study existing cosplay works, we mainly look at two aspects: modeling and photography. Modeling includes body shape, hairstyle, hair color, expressions, poses, textures of costume materials and refining props. Photography encompasses the angle of shots such as upward, downward, panorama, feature, close-up and middle, along with lighting and the surrounding environment.

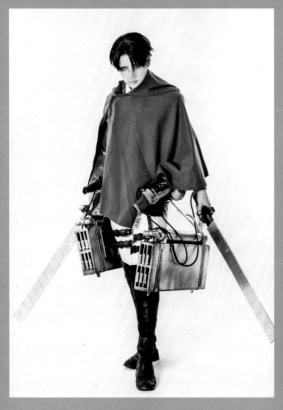

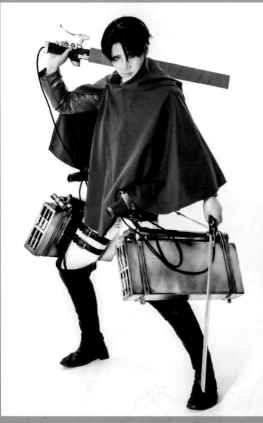

Expressiveness of materials is of the upmost importance in cosplay; therefore, before we transfer the role into 3D, we are obliged to understand the unique characteristics of common materials.

Coser: Reika

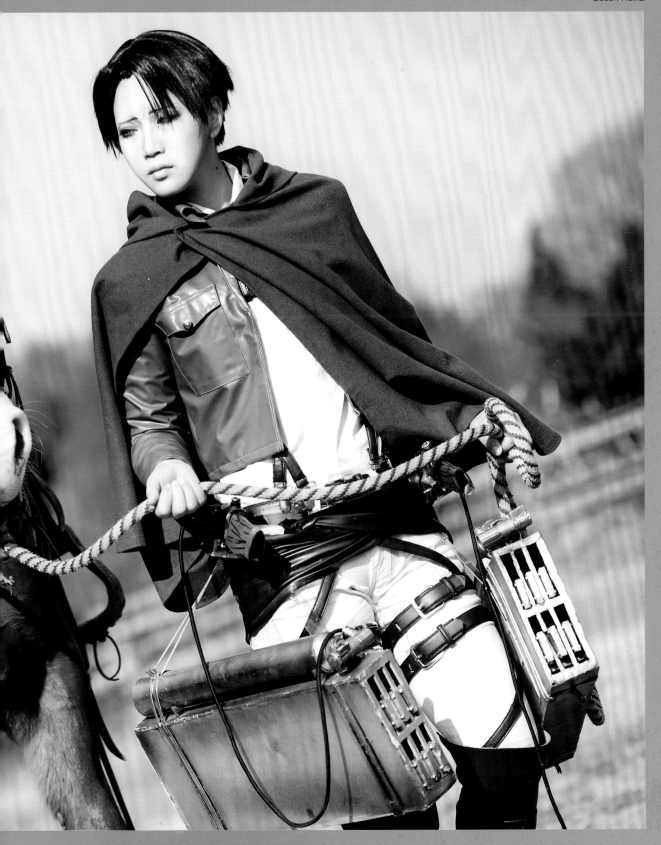

3 Creation based on prototype

Even though it is said that cosplay should conform to the original art, the three-dimensional world bears so much uncertainty that many cosers are fascinated with representing the original work in their own creative ways. As a matter of fact, it is almost impossible to achieve identical exterior environments compared to the original. This, in turn, demands cosers to exert more imagination to find and build proper settings.

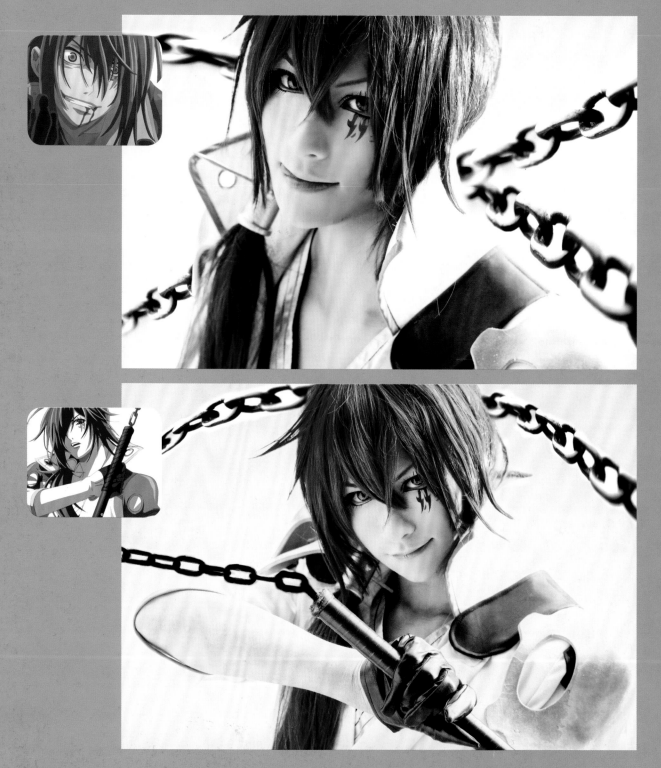

Studying into previous works allows us to draw
inspirations from their experience in all aspects and help
us make our own design.

II. Cosplay Make-up Styling

Makeup styling is the highlight and essential key point of cosplay styling. In this section, we'll give a detailed explanation on primary contents such as makeup procedures, tools, and color selecting, facial effects with makeup on, eye makeup types and other tips.

1 Tools in the cosplay makeup kit

• Brushes

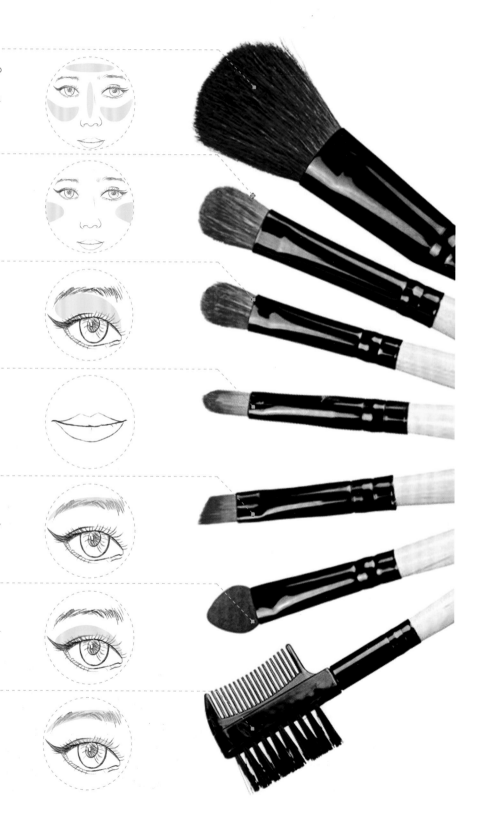

Face powder brush

Using the brush to apply face powder to the primed face to achieve a softer and more natural look than doing that with a powder-puff.

Blush brush

The blush brush is flat and smaller in size compared to the face powder brush. It has a semicircular head.

Eye shadow brush

Eye shadow brushes can incorporate eye line and eye shadow sufficiently to smudge and create gradients.

Lip brush

Lip brushes can define the lip line and blend the color of lipstick evenly. It is suggested to choose lip brushes with relatively stiff bristles and moderate volume.

Eyebrow brush

Use an eyebrow brush to wipe the dust off the eyebrow before trimming or penciling. After penciling, comb it gently so as to make the color consistent.

Eye shadow stick

It is the tool used for upper eye shadow application. Usually it gives a deeper and darker eye shadow than using other tools.

Brow & lash groomer

This type of brush can remove extra brow powder and mascara so as to define the lashes and groom the brows.

• Accessories

Powder puff

Powder puffs, usually made of cotton or velour, are used to apply powder to your show glamor. Common types are dry puffs and wet puffs. They come in various shapes. Triangle ones are suitable for eye corners and wings of nose; round or rectangular ones facilitate patting powder on large areas. Make sure to clean it and maintain it with gentle care.

Artificial eyelashes

Artificial eyelashes are not to be used in its complete form but need to be trimmed and glued where necessary to extend your own lashes naturally.

Eyeliner

Eyeliner can transform shapes of the eyes to make them more visual and versatile. It is a personal choice to choose eye pencil or eyeliner. Practice is needed to apply eyeliner more efficiently and effectively.

Mascara

Mascara thickens and curls your eyelashes. Aritificial eyelashes, eyeliner and mascara share the same function of adding definition to the eyes for attention.

Eye shadow

Eye shadow is the makeup for the area around the eye. It makes the eye more stereoscopic through color choices and brightness. On normal occasions, one dark color, one light color and one main color are adequate. However, as cosplay involves various roles and diversified styles, much more colors are required.

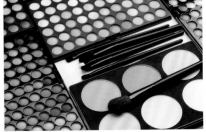

2 Restyle the natural canvas: the face

A thousand people have a thousand faces, yet not everyone's face shape conforms to the aesthetic standards. The purpose of "makeup" is to make up for facial deficiencies and follow trends, which can also build confidence. Here are the keys on how to "reshape" different face shapes.

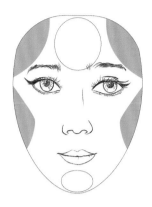

Inverted triangle face

Key: narrow down the perception of the middle and upper parts of the face

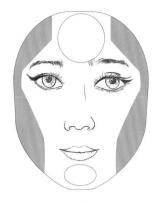

Round face

Key: weaken the outline with shadows to guide the attention to the center

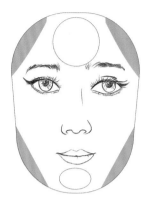

Rectangular face

Key: weaken four corners of the outline with shadow

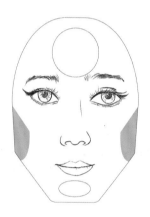

Face with edges

Key: add shadows to both sides of the face to make it appear narrower

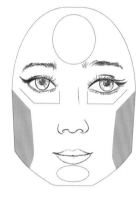

Inverted-heart-shaped face

Key: place shadows on the sides of cheeks so as to make the face more gentle and graceful

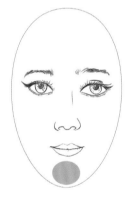

Long face

Key: put some shadows on the chin for the purpose of shortening the face

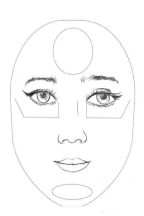

Oval face

It's a pretty face with no distinct deficiency, apt for all styles of make-up.

> **After remedying defects of the various face shapes, makeup will lend itself to a more glamorous appeal.**

3 Color combination

A full understanding of basic features and properties of colors enables a better use of them. There are no ugly colors, just bad combinations. Sometimes choosing from an abundance of eye shadow colors can be difficult, but as long as you follow the color classification diagram below, you'll find it is easier to make a choice.

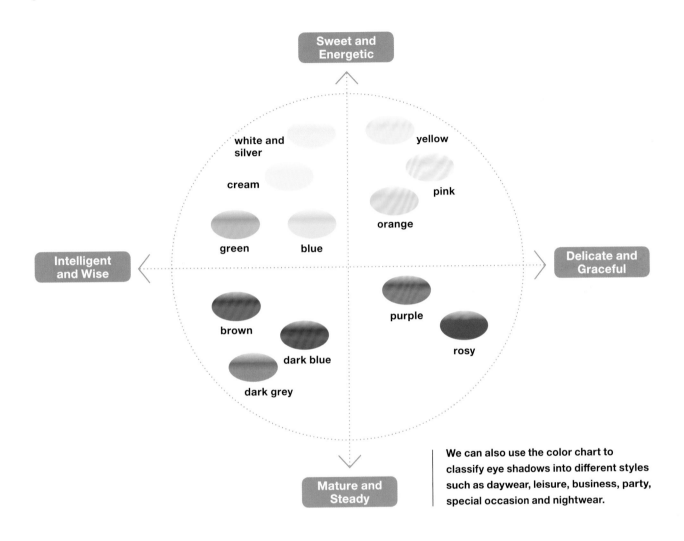

We can also use the color chart to classify eye shadows into different styles such as daywear, leisure, business, party, special occasion and nightwear.

Here are a few eye shadow combinations for your reference. Understanding of implications of eye shadow colors facilitates more accurate conveyance of intensions and accelerates our choices of them when needed. It is advised to collect and sort out such color combinations in daily life and make small color cards, which may help avoid possible make-up slips in case of emergency.

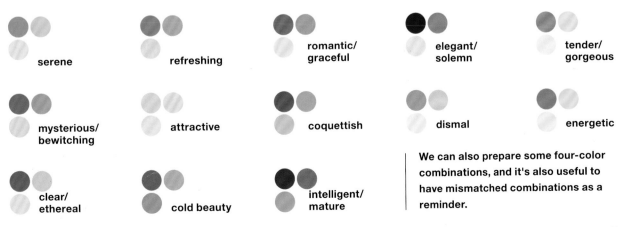

We can also prepare some four-color combinations, and it's also useful to have mismatched combinations as a reminder.

4 Various forms of eye make-up

It's important to research the role in advance and understand the characteristics of every style of eye make-up. This gives room for creating the right look and brings confidence during performance.

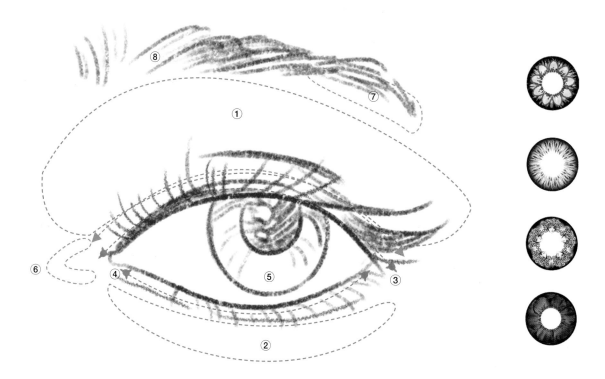

Areas 1 and 2 are for eye shadow. Eye shadow should be applied around the eyes to give a three-dimensional look. With combinations of colors, a good eye shadow can add to the facial expressiveness. Areas 3 and 4 are for eyeliner, which can magnify the shape of eyes and perfect the outlines. Area 5 is for cosmetic lenses, which can make eyes bright and luminous, a must-have for cosers on stage. However, make sure to choose quality lenses to protect your eyes and the right color and shape to match the make-up and costume.

Areas 6 and 7 are outer eye corners and the area below the end of eyebrows. Attention to details in these area can make the finished look more polished and refined. Area 8 is the eyebrow, which can intensify facial expressions. There are various fashionable styles of eyebrows, each exerting specific impressions.

Bare eyes
We can always make rectifications to compensate for imperfections of the eye shape with the help of eyeliners.

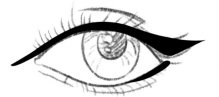

Long-eyed effect
suitable for narrow and long eyes
suitable for elliptical and V-shaped faces

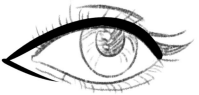

Bring eyes closer
suitable for wide-set eyes
suitable for all face shapes

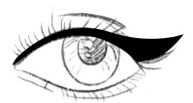

Rising effect
suitable for almond and oval-shaped eyes
suitable for elliptical faces

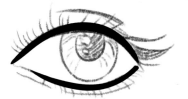

Falling effect
suitable for relatively round eyes
suitable for round and elliptical faces

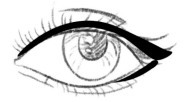

Pushing eyes apart
suitable for close-set eyes
suitable for all face shapes

60

Classic

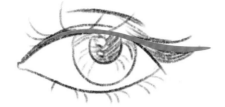

Feature: refined long lines bring out a sense of orient
Tip: use vermilion eyeliner on the upper lid; pay attention to the subtle variations in thickness

Bewitching

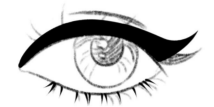

Feature: also called cat-eye makeup, which has many variations and gives a sense of keenness and cunningness
Tip: add a cute, catlike rising tail to the thick line on the upper lid to avoid the sense of heaviness

Cold beauty

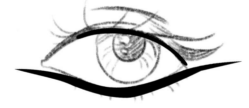

Feature: elegant, yet also extudes a sense of distance
Tip: sharp tips at each end of the lines on the lower lid is the key; it has to be done in one dexterous stroke with no extra modifications

Geometry No. 1

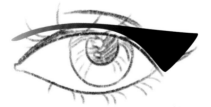

Feature: geometrical color patches convey a sense of roughness; the pointed lines are very suitable for round eyes to achieve enlarged effects, as this strengthens the sharpness of the look, yet maintains femininity
Tip: the outer edges of the lines should be exquisitely drawn to create intensity

Geometry No. 2

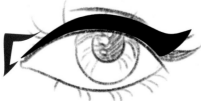

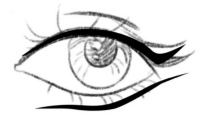

Enlarged

Feature: eyes are perceived as much bigger than usual, which creates a dramatic appeal for stage performance

Tip: pay special attention to the distance between the line and the lower eyelid

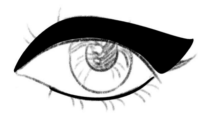

Smoky

Feature: it blurs the distinction between eye line and eye shadow. The eye shadows in the sockets are smudged to acheieve the effect of diffusing smoke, which earns itself the name

Tip: use paler foundation to give way for the smoky eye; smudge the shadow layer by layer to create a gradual, hazy effect

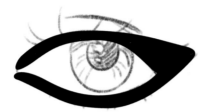

Queen

Feature: the upper line, fused with eye shadow, looks thick and bold, extruding a sense of queenly dominance

Tip: be careful with the outline of the makeup around the eyes; and be terse and distinct at turnings

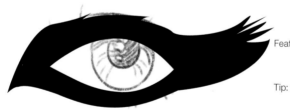

Black swan

Feature: as an imitation of black swan, this look features exaggerated effects and imparts a sense of arrogance and mystery

Tip: be careful with the proportion of the outer contour of the eye as compared to the entire face

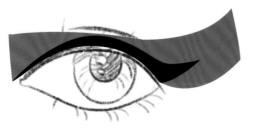

Oriental

Feature: combining Chinese and Japanese makeup characteristics, it depicts roughness amidst tenderness, emitting luscious and charming appeal

Tip: pay attention to the thickness of the eye lines against the red shadow above; be careful with the shape of the red shadow

62

Elegant

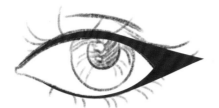

Feature: suitable for daily wear; especially good on almond-shaped eyes, as it can visually elongate the eye and give a refreshing look

Tip: lines on the upper and lower eyelids are equally important; too much attention on the upper eye line will result in an impression of overloaded upper lid

Rakish

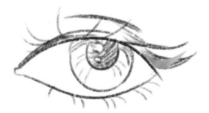

Feature: a sweet and exquisite look with a small "finishing touch" at the outer corner of the eye, which illuminate the entire face

Tip: the focus is to depict in detail how the two colors fuse into each other on the upper lid; remember to emphasize the sweetness and charm in the shape

Winglike

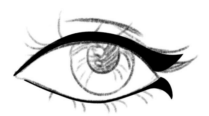

Feature: amiable innocence with darling ladylike temperament

Tip: pay attention to the depiction at the eye corner; dark colors shall give way to sweet candy-like colors

Sleepy

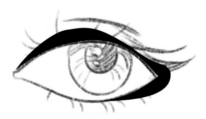

Feature: it expresses a sense of lethargy, leisure and drowsiness

Tip: the thick lines on both upper and lower lids are essential in successful portrayal of this look

Waterdrop

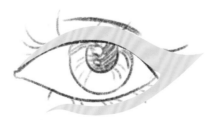

Feature: without heavy eye shadows, this look gives a sense of naivety and pureness, creating the effect of amiability and innocence

Tip: the key is not to enlarge eyes, but rather to alter the eye shape

Case study I: make-up for Poker Face of GUMI

Before designing makeup, analyze and the characteristics of the prototype. Then design proper makeup for the coser in accordance with the coser's facial features.

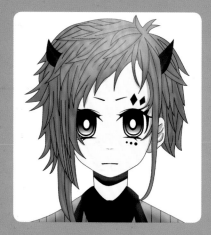

Key features

- big eyes
- thick eyelashes
- short eyebrows which are a bit far from the eye
- Shapes like "◆" and "●" appear above and below the left eye

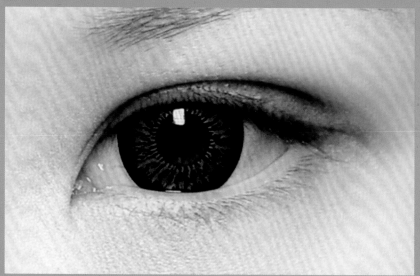

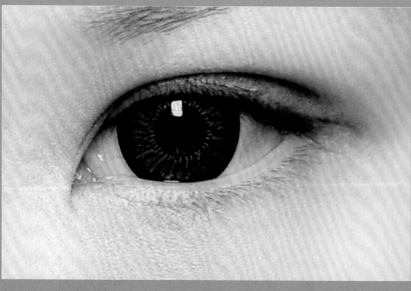

01 Eyelid tapes are adopted to emphasize the size because thick eye lines will hide the coser's double eyelids. This step is subject to individual coser's situation.

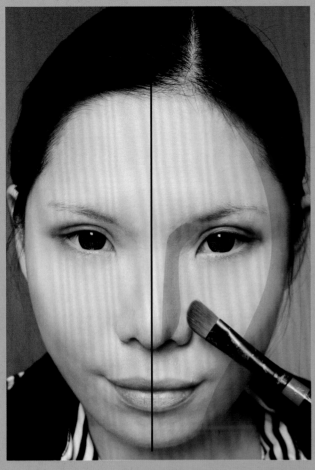

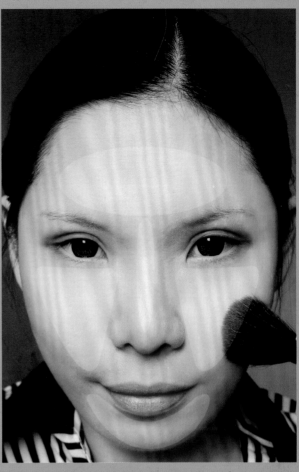

02 Female roles are not expected to have definite stereoscopic facial features, so shadows are applied as needed.

03 The coser's face shape is elliptical, so we are free to add highlights in large areas.

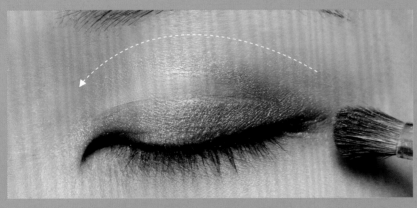

04 Apply turquoise shadow to the outer corner of the eye, then use golden tones for the inner part, smudge to create stereoscopic blending effect.

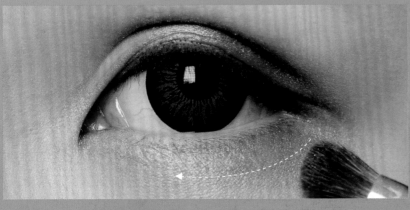

05 Apply red shadow from the lower outer corner of the eye toward the middle which grows gradually thicker and then becomes thinner again.

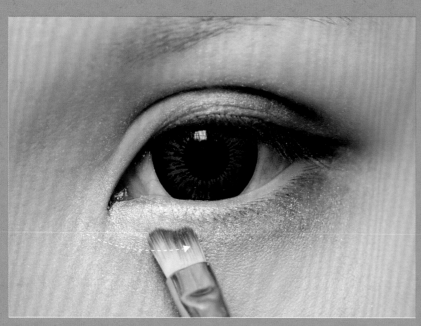

06 Apply a thin layer of white eye shadow starting from the inner corner of the eye, and make sure that the two colors blend together.

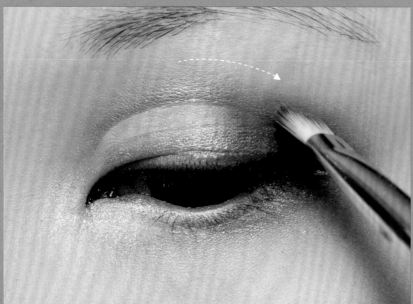

07 Dab some dark brown eye shadow and press it above the creases of the eyes. Ask the coser to open her eyes occasionally to ascertain that it is visible.

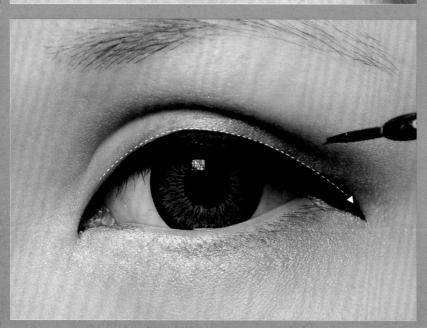

08 Define the eye with black eyeliner. Pay attention to the thickness of the line. It should be half of the width of the double eyelid. Extend and thicken the lines at the end of the eye.

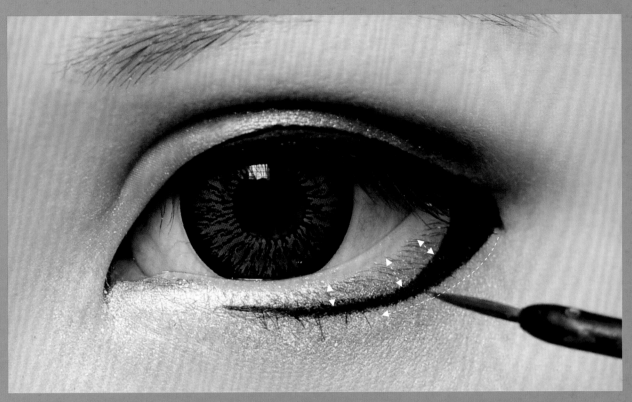

09 Draw a dark line on the lower lid from the outer corner inward and from thick to thin. Keep in mind the contrast between the radian and the thickness, and leave little space inbetween.

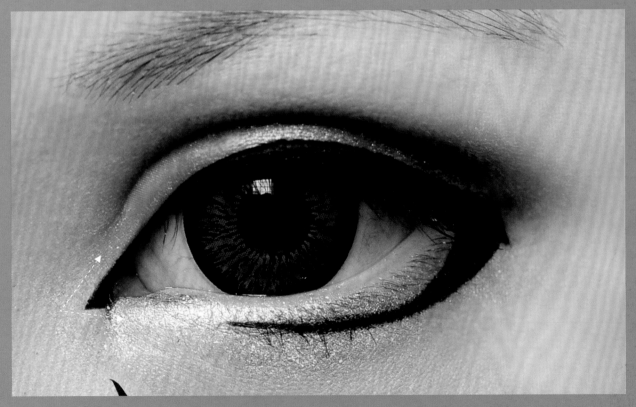

10 At the inner corner of the eye, draw a half triangle shape "∠" with the eye shadow to bring the upper and lower lids together, but remember to keep it consistently thin. However, if the eyes are already closely set, no such work is needed for the inner corner.

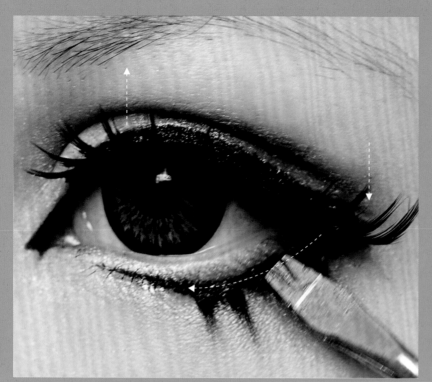

Here a thick type of eyelash is used. Cut it into halves with one part for upper lashes and the other for bottom lashes.

upper lashes

bottom lashes

11 Paste the artificial eyelashes. Align the eyelashes to the radian of the eye line and press downward at the end of the eye while push upward above the iris. Then apply extra eyelashes at the tail of the lower eye lids in the same manner.

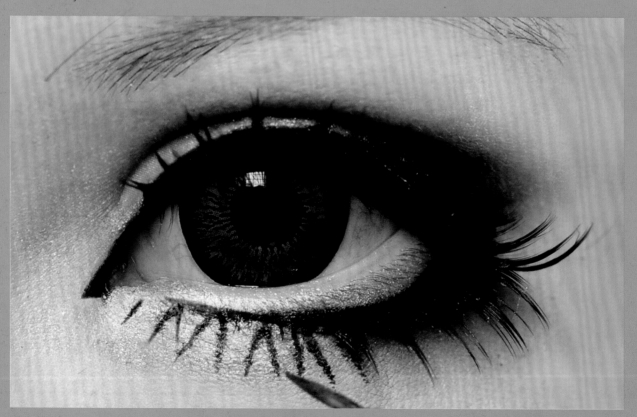

12 Wiggle mascara for parts without artificial eyelashes. You may insert some scattered artificial eyelashes as an alternative, but here no such type of eyelashes is acquired. Hence the use of mascara.

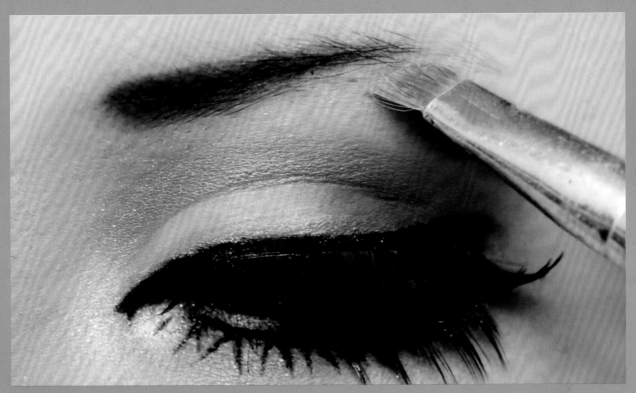

13 Draw green eyebrows. If the eye shadow doesn't appear prominent enough, use greasepaint. Here the eyebrow is drawn thick and long for the sake of appropriate proportion of the whole look, but if you prefer the prototype's eyebrows, you can leave them thinner and shorter.

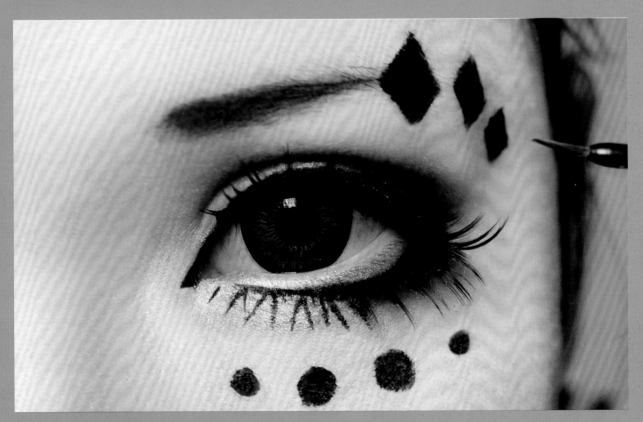

14 Finally draw shapes of "♦" and "●" one by one following the prototype and pay attention to the size of each shape.

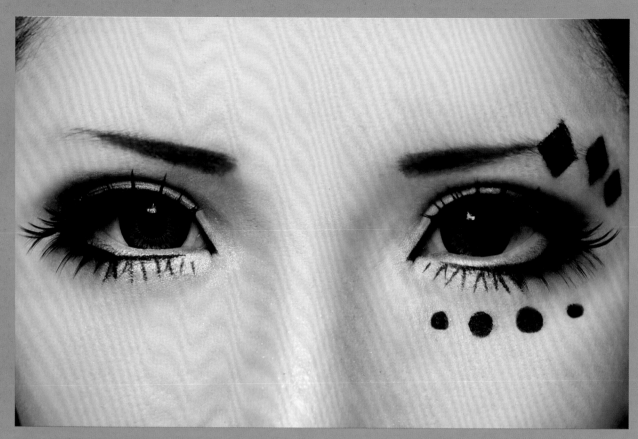

15 Finished look of Gumi's Poker Face

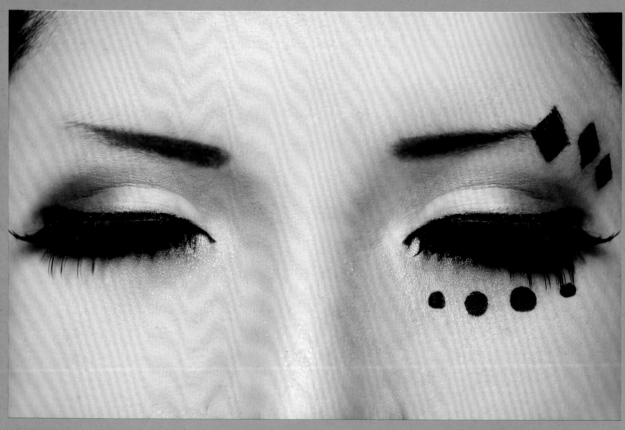

16 With eyes closed

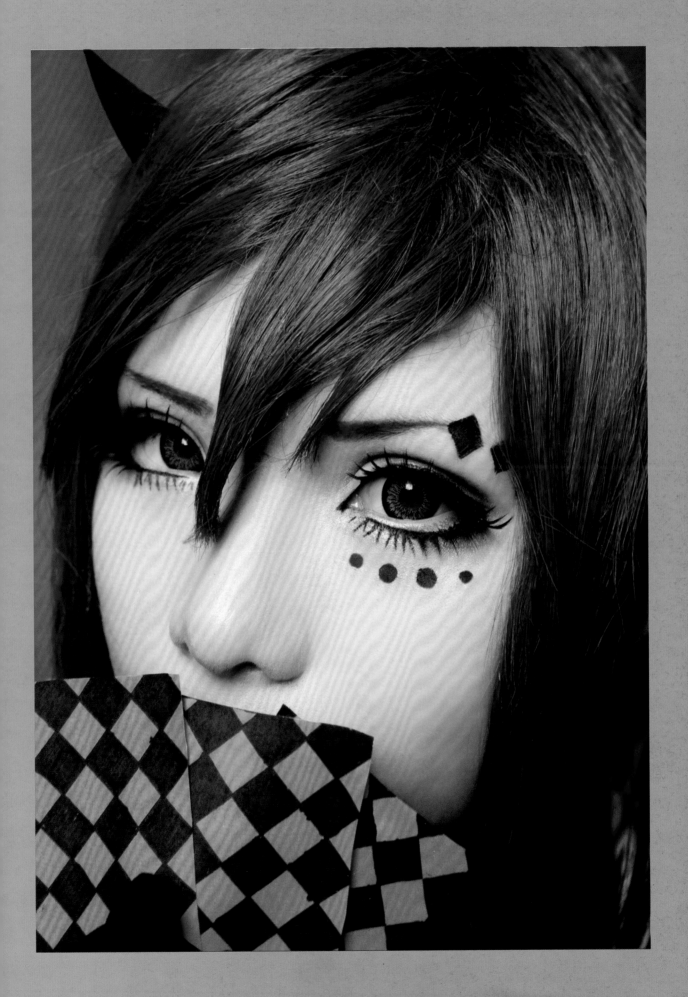

Case study II:

make-up for Little Red Dragon by Xiao Meng

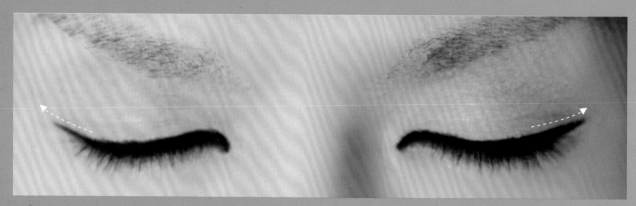

01 Apply eyeliner as close to the lashes as possible and extend it to the outer corner of the eye. Make sure that the lines are thicker in the middle and turns thinner at the end.

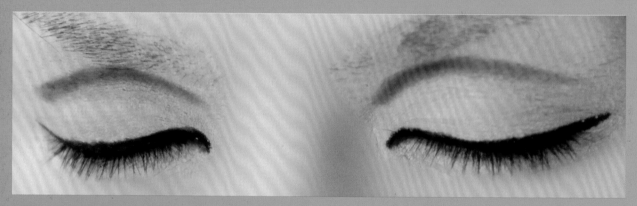

02 Draw fake double eyelids in the sockets with a brown eyeliner to enhance the final effect of the eye makeup.

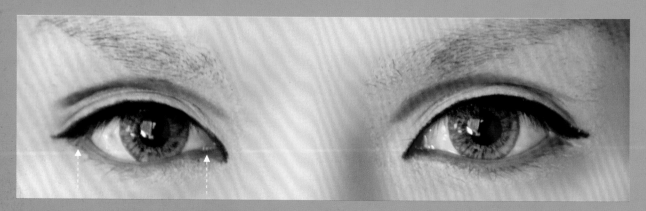

03 Draw lines on the lower eyelids with brown eye shadow. Make the lines thicker at both inner and outer corners of the eyes to form a sense of shading.

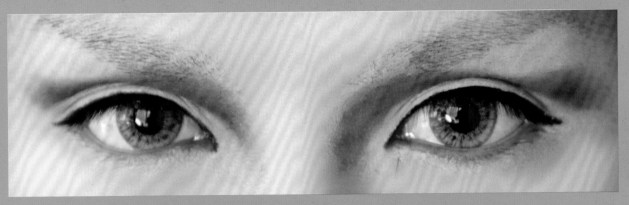

04 Darken the socket with brown eye shadow, which covers the entire area stretching from the sides of nose bridges to the ends of the eyes. Pay attention to the gradation of the color shades.

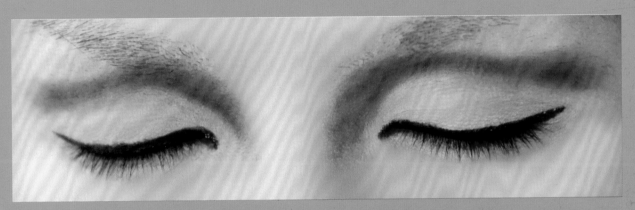

05 Check the effect with eyes closed. Make sure edges are blended naturally.

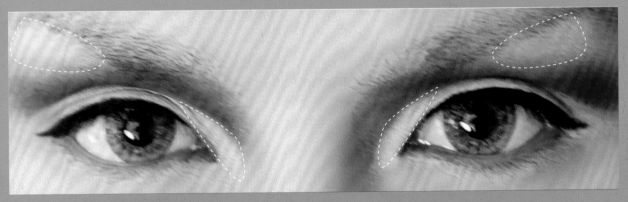

06 Lighten up areas above the inner eye corner and below eyebrow ends with silver eye shadow. For eye corners, apply more to make the effect even more illuminating.

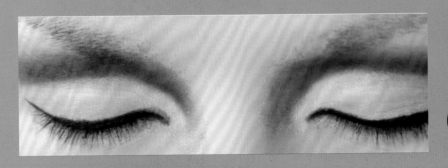

07 Extend and blend the silver eye shadow over to the whole upper eyelid.

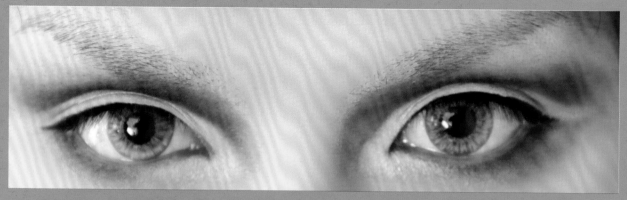

08 Strengthen and blend the lower eye lines with reddish brown eye shadow and apply more at the ends of the lower lid.

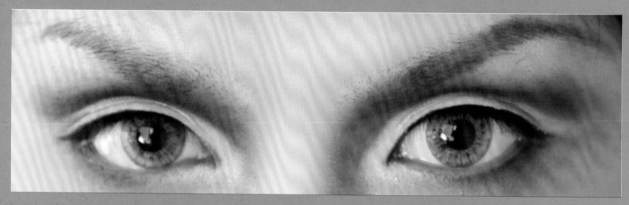

09 Sketch eyebrow shapes with wine colored eye shadow. Observe the variation of dark and light, thick and thin.

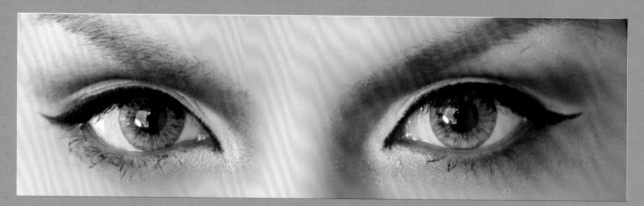

10 Now it looks as if the original eye lines are slightly out of proportion; therefore, darken and further elongate the lines at the outer corner of the eye, following its own trend. Then wiggle your eyelashes with a bristle-fibered, Z-shaped mascara brush.

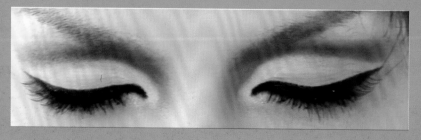

11 The effect with eyes closed

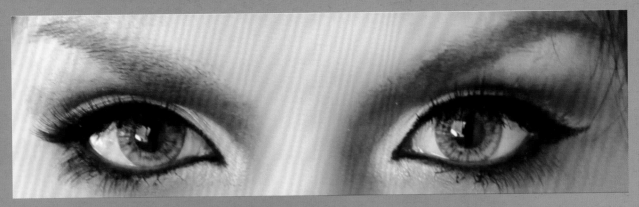

12 Paste both upper and lower artificial eyelashes, being mindful not to smudge the makeup applied previously.

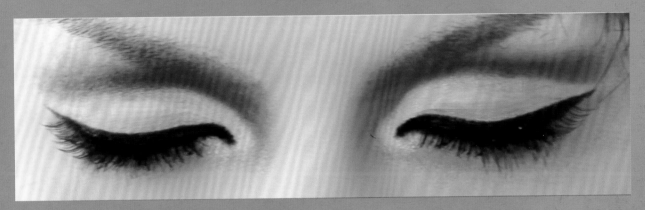

13 The effect with artificial eyelashes and closed eyes

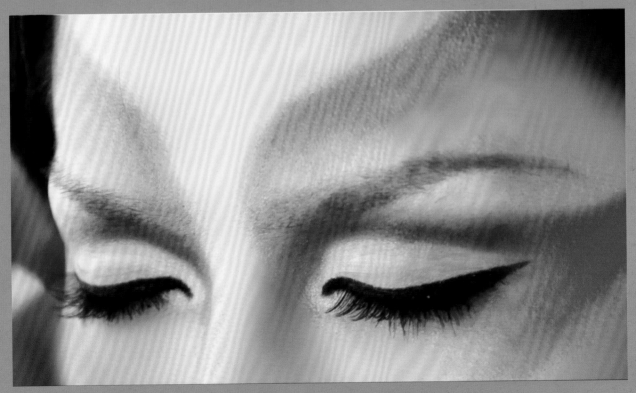

14 Paint shapes with red eye shadow above the eyebrows, paying attention to the thickness and tone variation of the color.

15 Dab your finger into the golden eye shadow and press it little by little inside the area outlined in the previous step.

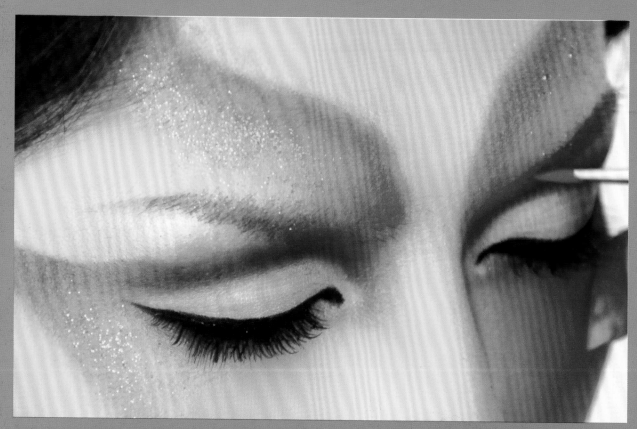

16 Reiterate the shape of the eyebrows as the finishing touch.

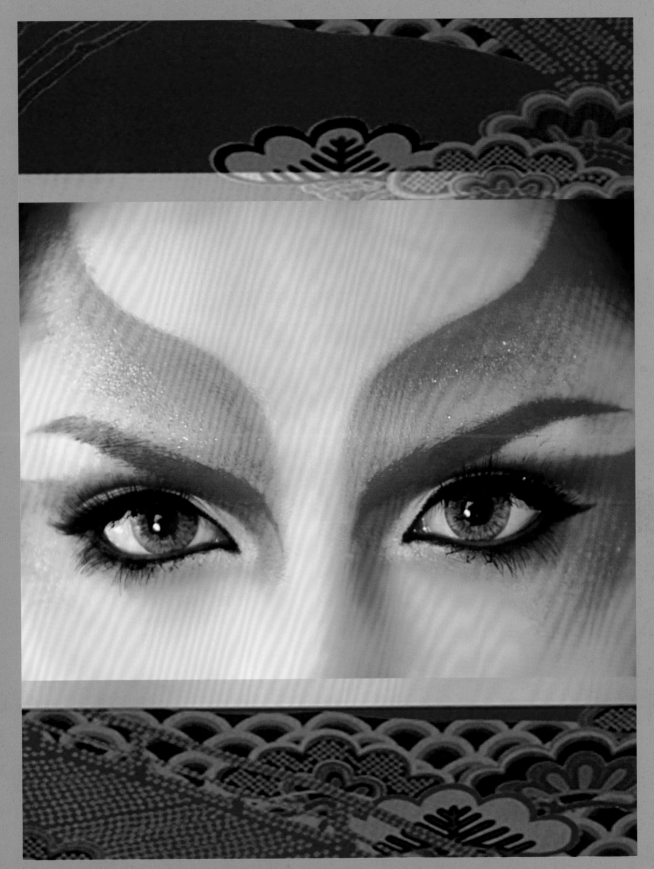

Final effect

III. Case study of costume styling: female Arthas in WoW

Usually cosplay costumes are eccentric and weird, which yields itself barely accessible for purchase. Therefore, they are usually made in the style of DIY (do it yourself). Although the process requires intricate work and devotion and lends itself to all sorts of challenges, it produces extremely joyful and fruitful results!

The armor of female Arthas assembles that of Arthas' in most parts except for the breast plate, waist plate, thigh plate and shoes. However, the armor of Arthas has a variety of versions in the original paintings and 3D models; and its looks in *Warcraft* series and *World of Warcraft* are also different. After discussion with the team, the CG version of *Warcraft III: Frozen Throne* is used as the reference and inspiration for the costume.

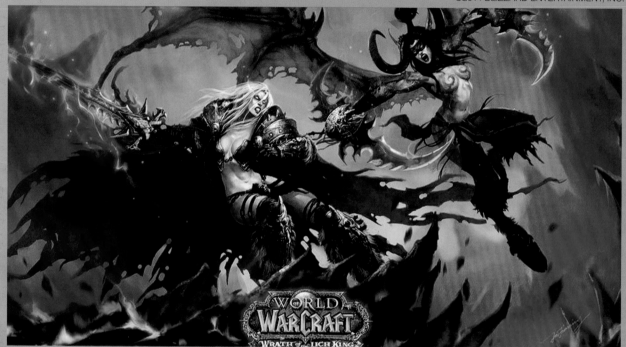

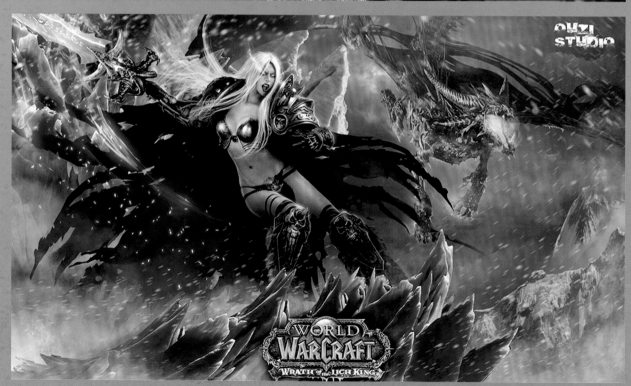

Parts needed to make the armor include: cuirass, two shoulder armors in different forms, gardebras for upper arm and forearm, elbow guard, hand armor, calf guard, shoes, and the cloak and cloth for the waist. The making of the armor is supposed to start from the cuirass as this defines the size of the armors for shoulders, arms and hands. After that, the size of the armor parts for the lower half of the body can be determined. This order ensures that every part is proportional and coordinated as a whole.

In female Arthas' armor, the thigh plate is changed into a belt to help reduce weight for the waist to reveal the female body shape; other parts retain the heftiness of the original to make the entire suit sexy in its appeal without losing the magnificence and toughness of European armor. In this design, the shoulder armor and arm armor follow the style of vanity and roughness in its full regal glamour. Here are explanations of some parts for further understanding.

[**Materials**] 3mm and 5mm EVA boards, 10mm belt and belt fastener, thermo-plastic glue, light clay, wide elastic, thick glove, high-heeled long boots, copper buttons and steel buttons, buckskin, velvet and fur

[**Tools**] 502 glue, transparent tape, knife, tape measure, ruler, cardboard, paper, pencil and gel pen, scissors, compasses, carving knife, propylene and spray paint

• Right shoulder armor

Split the armor into four identical parts

Right shoulder armor

The round skull plate at the front of the shoulder armor

① Pay attention to the radian at the sides

② Connect the two base models

② Scoop out rounded shapes

④

① Start by separating the piece into four identical parts. Cardboard is used to make the base model. Trace the lines and use 5mm EVA board to make the base model. Make sure the surface has a gentle arc shape.

② Adhere the EVA base models together. If the radian on the sides are correct, the four identical pieces will make a slick base model of shoulder armor in a nicely curved shape.

③ Make two more base models with 5mm EVA boards, and glue them above and beneath the original base model to make base model 15mm thick. Scoop out round shapes in the outer layer for copper buttons.

④ Add a trim. First glue two 5mm EVA boards together horizontally to make a long strip; then use knife to cut slant ridges along both sides of the strip; lastly, paste the edges of the board onto the armor.

⑤ Draw skulls at the right positions and then glue curly patterns onto the armor by referring to the original picture.

⑥ Make the innermost layer of the armor in the same way as stated above and render it protruding as the brim of a hat. This layer is embedded only with one 5mm EVA strip with a single-sided slant ridge.

⑦ Constructing the inner armor. Use cardboard to make a paper model half the size of your own shoulder, and then make an EVA base model in accordance. Glue it to the base model in the previous step, then to the previous shoulder armor.

⑧ Cover the shoulder armor with a thin layer of light clay and carve out the details of a skull with an engraver. Air-dry before painting.

⑨ Make the round skull plates. First make the paper models, then fabricate the base model of these plates using 5mm EVA board.

⑩ Make plate trims with 5mm EVA board and inset copper buttons. Fashion skulls with light clay. Then polish and color them for the effect of iron. As the final step, stick one of the skulls onto the right shoulder armor.

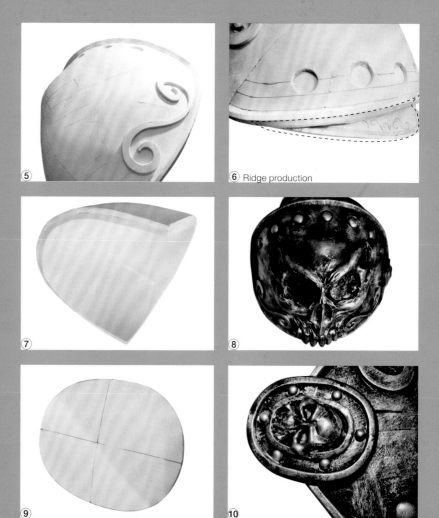

⑤

⑥ Ridge production

⑦

⑧

⑨

⑩

• Left shoulder armor

Split the piece into two halves

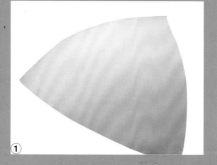

①

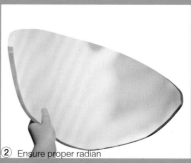

② Ensure proper radian

① ② The main part of the left shoulder armor is symmetrical with the shoulder line as the axis. With similar steps as used in making the right shoulder model, create four identical base models with 5mm EVA boards.

③ Glue four base models into two identical pieces. Attach great importance to the radian of each side as this affects the smoothness of the finished piece. Then stack and glue these two pieces together to create a 10mm base model.

④ The rising part is symmetrical as the main part, so same methods are employed to make a double-layered base model using 5mm EVA.

⑤ Make the bulge part by using half of it as the prototype. Make sure that the bulge is well pasted and in coordination with the radian of the shoulder armor.

⑥ Make the ridges of the left shoulder armor, glue and extend the boards to make a 10mm thick EVA strip. Depict ridges on both sides and paste them along the edge of the armor.

⑦ ⑧ Engrave intricate patterns with a knife on a relatively thinner EVA board of 3mm, and then cover it on the bulge which boasts a trim made with a 5mm thick EVA board. Determine exact positions for the copper buttons.

⑨ Carve out patterns around the copper buttons.

⑩ Inscribe flowery patterns for the rising part.

⑪ Create thorns. Gather five base models of 5mm EVA boards and make an isosceles triangular body. Chip it with a blade into a cone and polish it sleek, complete with a "pedestal" pasted at the bottom.

⑫ Stick five thorns onto the right positions. Cut off the tip of one of the thorns to produce the effect of fracture.

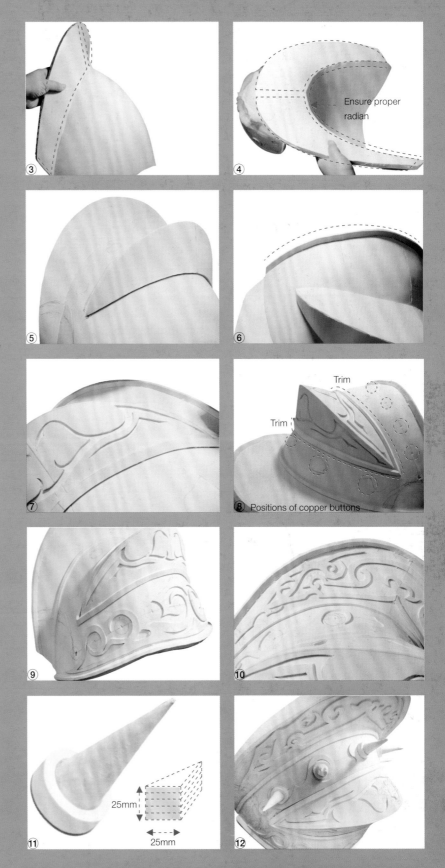

③

④ Ensure proper radian

⑤

⑥

⑦

⑧ Positions of copper buttons — Trim — Trim

⑨

⑩

⑪ 25mm 25mm

⑫

⑬ Fabricate the inner armor with double layers and stick it with the left shoulder piece completed in previous steps.

⑭ Paste ready-made round skull plates onto the armor and paint them in colors to achieve the effect of iron and metal. You now have the visually impressive left shoulder armor.

⑬

⑭ Skull plates

• **Finished pieces of other structures**

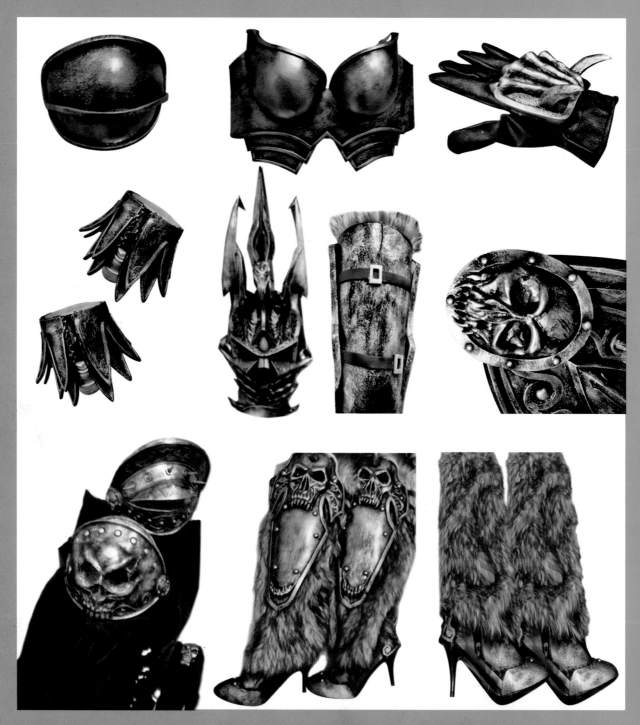

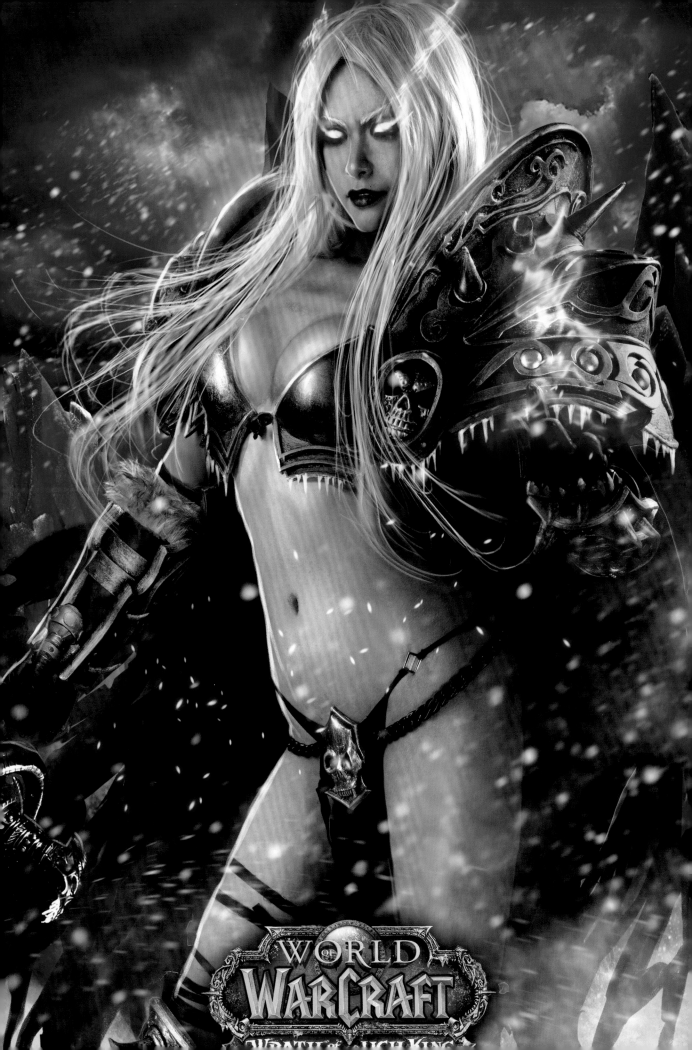

WORLD
WARCRAFT
WRATH

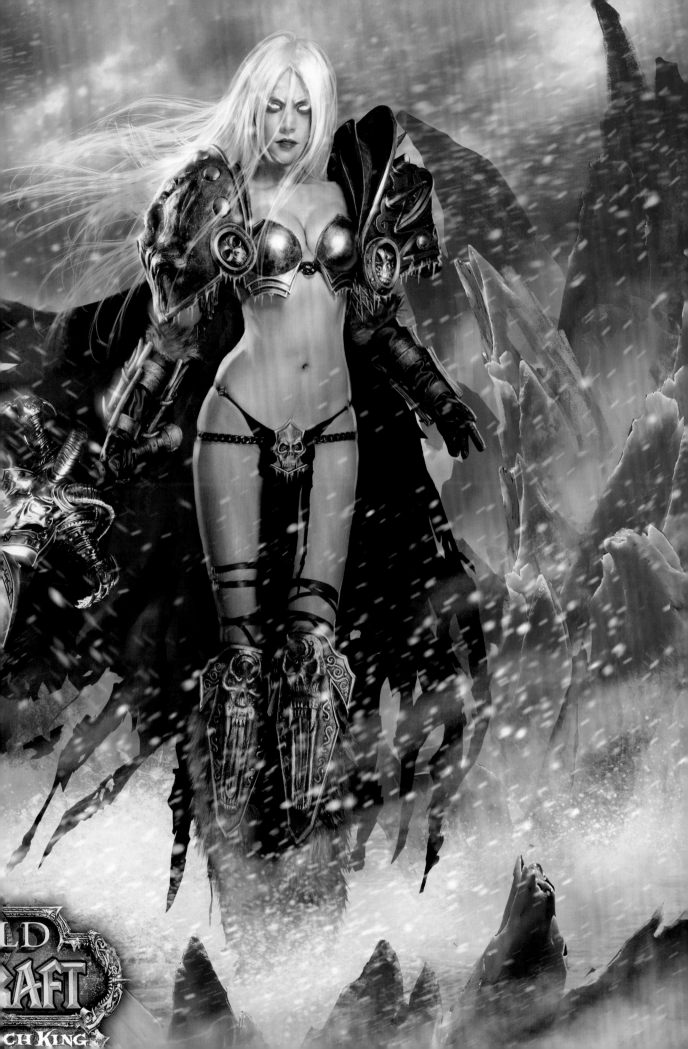

IV. Lighting, Composition and Photography

Photo shooting is an enormous task warranting full preparations before executing. This section will offer you insiders' knowledge such as how to communicate and how to take beautiful pictures with available resources. Here various styles of cosplay photographs are provided from the perspective of the photographer.

1 Basic lighting skills and composition

Proper and competent use of lighting and picture composition can contribute to an incredibly amazing effect of cosplay photos. Specific examples below allow us to have an in-depth look.

1) Lighting in night views

The principle for shooting night view pictures is to outline the backdrop to provide focus on the figure. For creating night atmosphere, it is advised not to use flashlights if possible. Try to achieve the desired effects using the least amount of equipment.

• Making use of ambient light

The advantage of using ambient light provided on the scene is that what you see is what you get. The fewer variables involved in shooting, the more natural the photo will be. The photographer for the picture on the left chose not to use flashlight in this scene with strong and bright light. The background shows the effect of being veiled in cold LED light. The street lamps offered a warm yellow light to brighten up the foreground. The photographer set the focal length at 35mm to deepen the view, and the final picture is unbelievably fantastic.

• Shooting with a single flashlight

Flashlight is easy to use, and it gives a straightforward and distinct delivery of the subject.

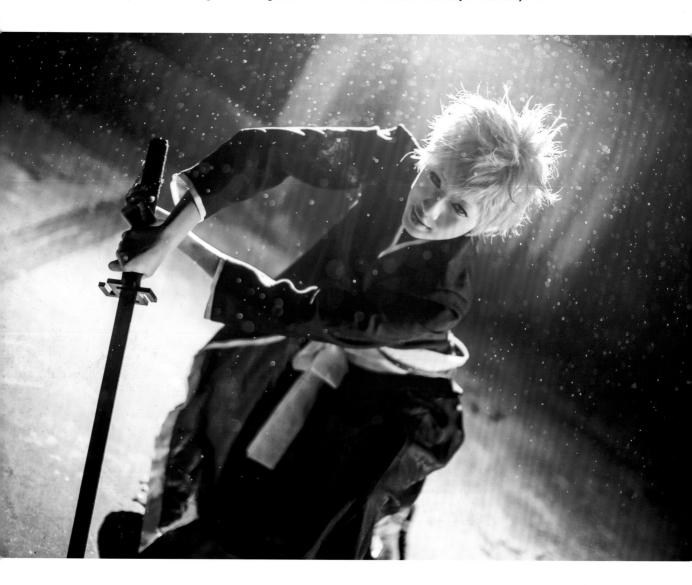

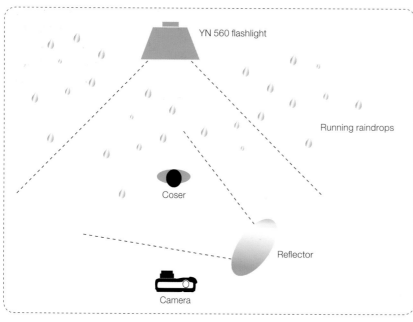

This scene is set at a platform with a single flashlight at the back of the coser as the main light source. A reflector is used on one side to illuminate the coser's face. It was raining during the photo shoot, and high shutter speed is perfect for capturing the running raindrops still in the frame, producing a very special effect.

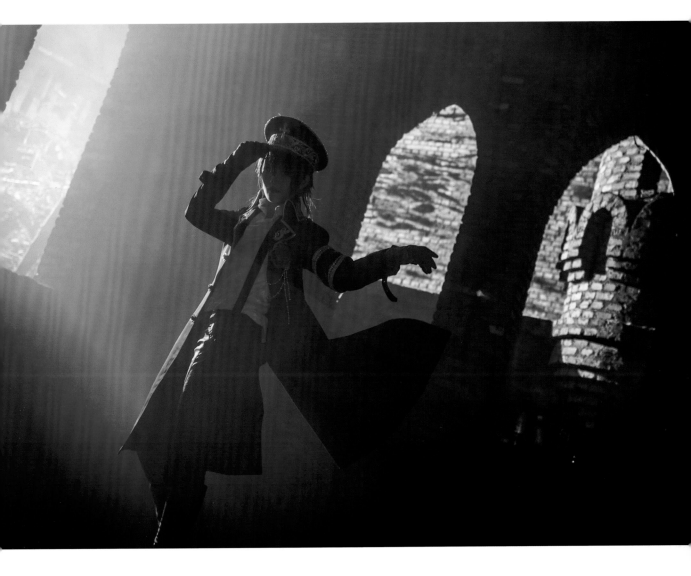

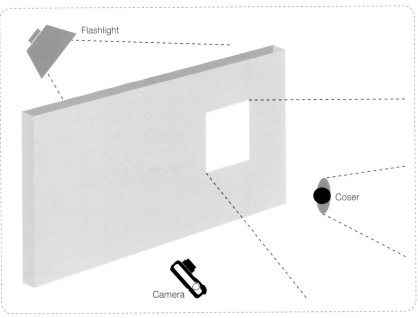

Flashlight

Coser

Camera

This picture is shot in a dilapidated old castle. In order to produce a mysterious atmosphere, a flashlight is set up at the outer layer of the castle to outline the coser, creating the Tyndall effect.

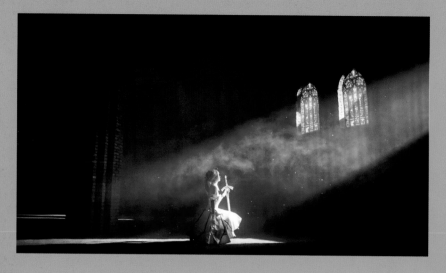

This photo is shot in a spacious church. A flashlight equipped with a concentration tube is employed to simulate the feeling of the moon shedding light through the window onto the ground.

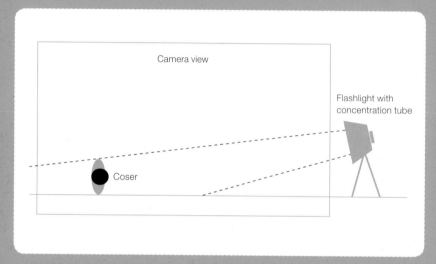

• **Multiple lights and mixed lighting resources**

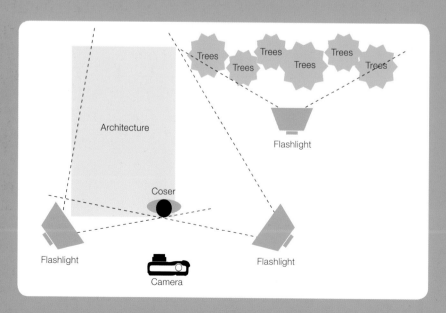

If the environment requires a conveyance of multiple layers while there is not adequate environment light, multiple lights are required. First define the exposure of the environment, then decide how to fill the light for the character and lastly locate the main light resource. Arrangement of multiple lights for the photo on the right are as shown in this picture. It's advised to take separate photos to confirm the effect for each individual lighting source before shooting for the final.

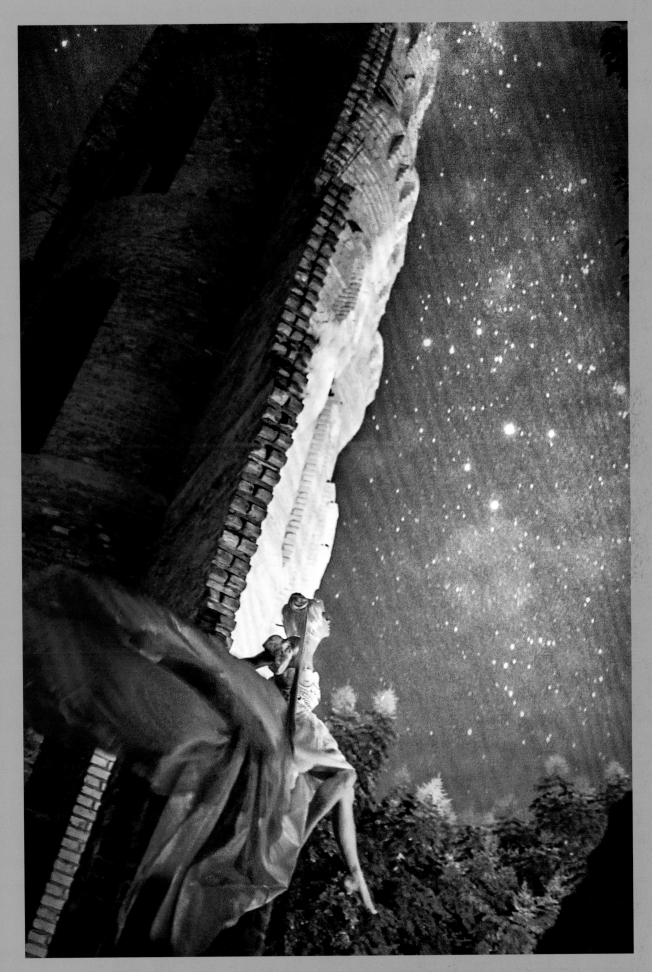

2) Basic compositions

There are only two basic classifications when it comes to the composition method: the Rule of Thirds, and the Diagonal Rule.

The Rule of Thirds: divide the image into nine equal segments by two vertical and two horizontal lines, then place the main subjects around the intersection points (A, B, C, and D).

The Diagonal Rule: cross section the picture with two diagonals, place the main subjects on the lines and make sure directions of the main subjects follow the path of the diagonals.

Here are two examples of the combination of both rules.

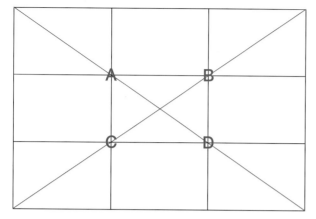

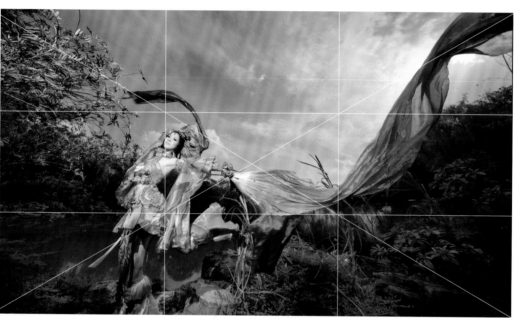

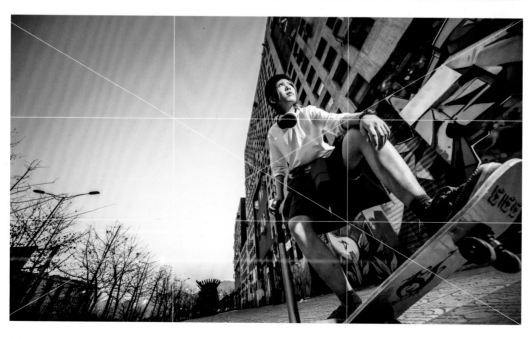

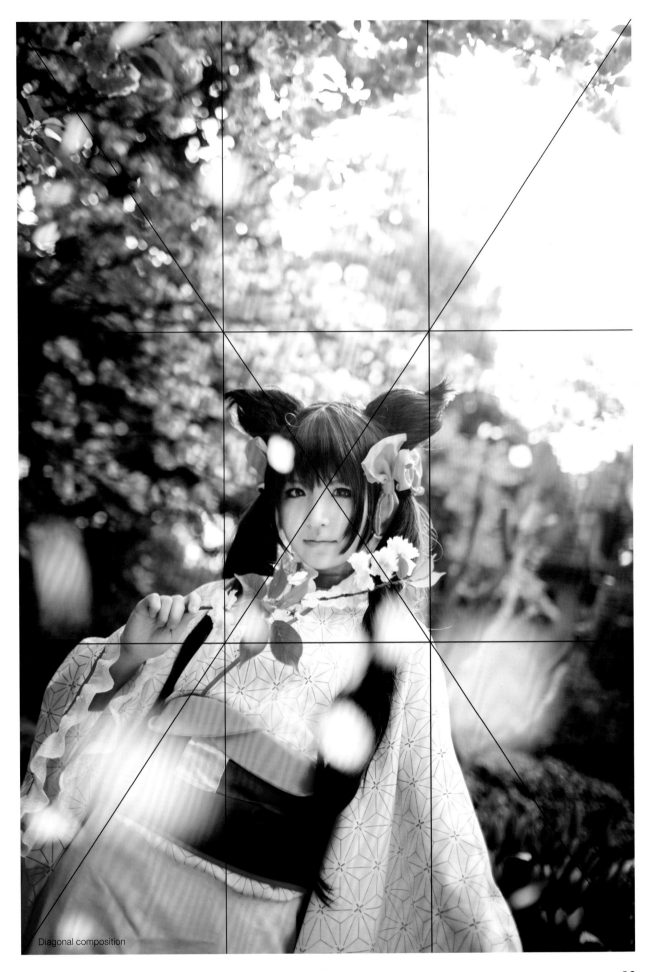

Diagonal composition

2 Cosplay photography

1) Prior to cosplay photo shoot

Photography is the art of light and shadow, and cosplay photography aims at turning a two-dimensional world into a virtual one. Apart from conveying the behavior, experiences and even inner feelings as normal photography does, cosplay photos need to mimick a two-dimensional world that has a unique atmosphere of fantasies. Usually cosplay photos are divided into single shot and sequence shots.

Single shot usually captures a specific moment pictured in the original work. An excellent single shots can grab our attention at first glance.

Sequence shots tell a story or a represent classic scenario with a sequence of photos. There can be a few or even dozens of photos under one theme. They draw inspiration from comic and animation and the set is vibrant in terms of visual expressiveness and story plots.

For both single shots and sequence shots, photographers need to be prepared to shoot dozens to hundreds of photos. Before shooting, photographers are expected to familiarize themselves with the content of the original work. They should participate in the decision-making process including role analysis, selection of shooting site, props and equipment, and communication with other members on the team. After these steps, photographers will have a clearer picture of the final result, which will facilitate the shooting process.

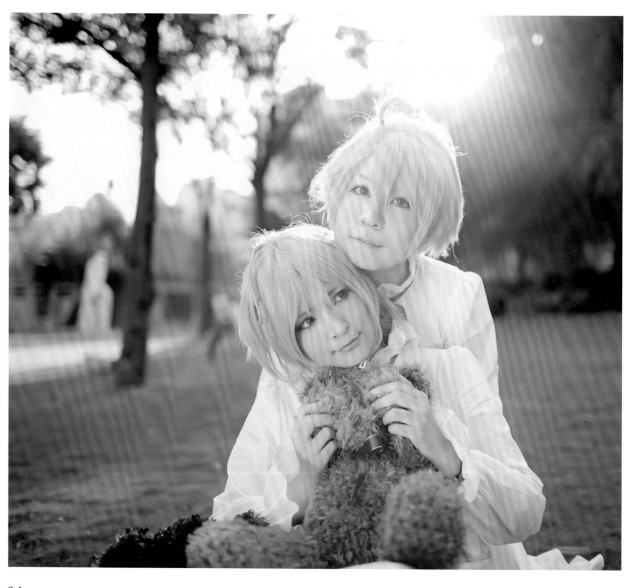

2) Lighting in photo shoots

Together shadow and light are magical in the undeniable effects of setting off certain atmospheres and serving as an instrument for human emotions. A good combination of light and shadow can add life to the otherwise ordinary pictures, exerting three-dimensional effects while maintaining the flavor of anime and manga. With the sea of literature on the use of light and shadows in photo shoots in the market, here we focus on how to create a two-dimensional atmosphere with light and shadow from the viewpoint of a cosplay photographer.

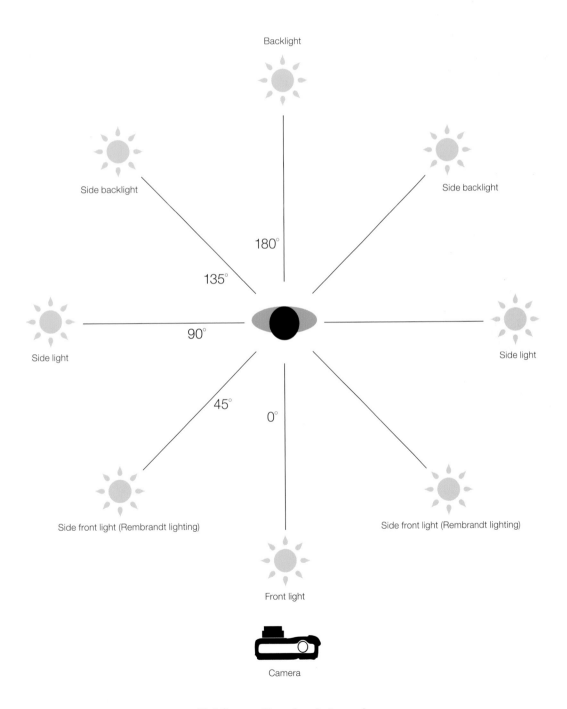

Lighting positions for photography

• Elementary lighting: refreshing sight in the sun

For outdoor shootings under the sun, simply bringing your camera, lens and reflectors will be adequate. While taking photos, watch the direction of natural light and use your reflector to capture a nice degree of lighting.

Sunny fairy tale

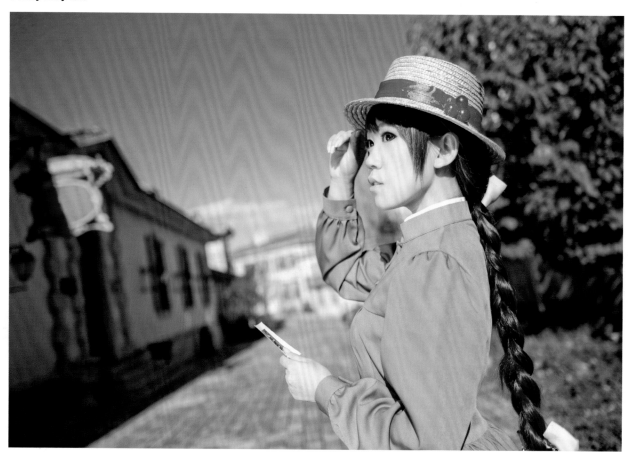

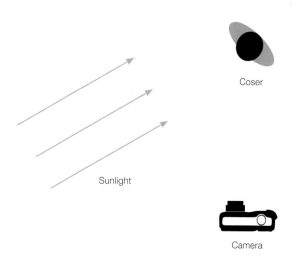

Coser

Sunlight

Camera

Distinct and refreshing colors in full bright sunshine, classic low-rise buildings, the blue sky and green trees, combined with pretty "Sophie" performed by Sakina, this photo is typical of Hayao Miyazaki's world of fairy tales. With a bit more attention to the sunlight, the angle between the camera and Sakina's face, and shooting in conformity with the light direction, an excellent piece of work is done with ease.

Haul's Moving Castle
"Sophie" cosplayed by Sakina

Camera: Canon 5D MARK II
Focal length: 35mm
Aperture: f/2.5
Shutter speed: 1/1600
ISO: 100
Color temperature: 6700K

Another application of the reflector

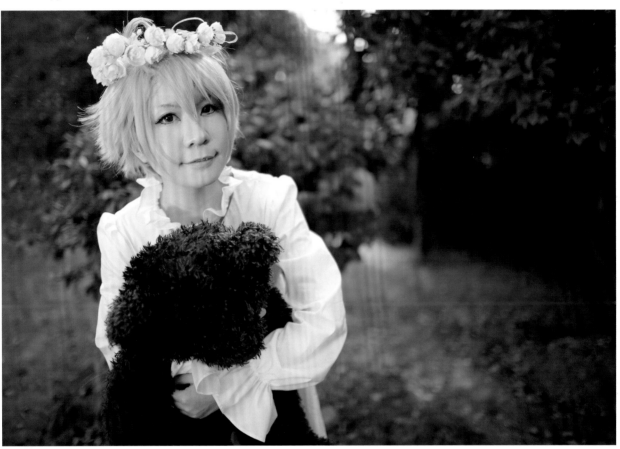

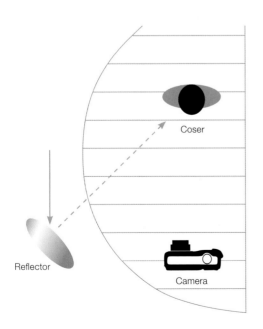

If the sunshine is too bright, the coser cannot be directly exposed to the sun; otherwise the photo would be overexposed causing serious detail neglect in the picture. A more effective practice is to have the coser stand in the shade of a tree and use the reflector to transfer the sunlight onto him/her. The reflection of the sunshine is the main source of light while environment light makes the model's face fairly bright, achieving a subtle balance between light and shadow.

Hetalia: Axis Powers
"Alfred F. Jones" (America) cosplayed by Qi Shun

Camera: Canon 5D MARK II
Focal length: 35mm
Aperture: f/1.4
Shutter speed: 1/640
ISO: 100
Color temperature: 5500K

• Intermediate lighting: outdoor shooting with flashlight

Flashlight is considered the most common auxiliary equipment used in photo shoots where the ambient light is neither too strong nor too weak. Here are some specific examples on how to use flashlight.

Creat tension in cloudy days

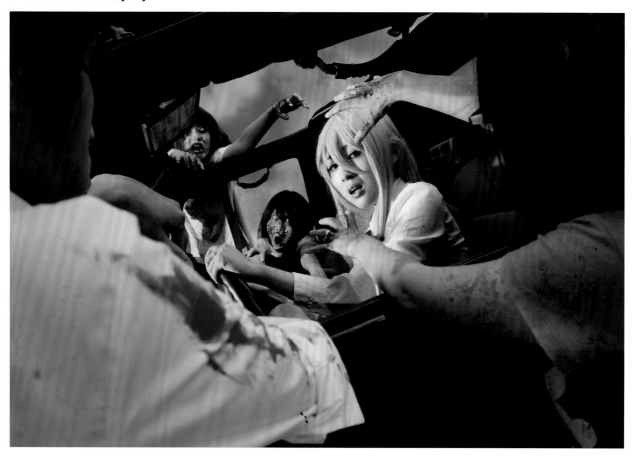

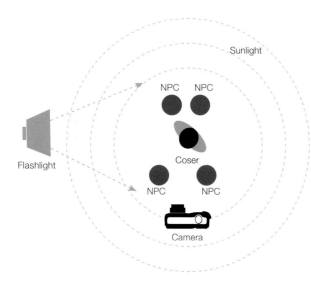

In cloudy days it looks like the sun is veiled in a vast diffuser, which renders all light rays in the open air mild and soft. In this photo a high-powered flashlight with no diffuser as the main light source is adequate enough to brighten up the whole scene. Proper shutter exposure makes the entire picture fairly bright with the differentiation between light and shade distinct with adequate details. Combined with grey clouds gathering overhead, the picture vividly depicts an intense and breathtaking atmosphere of the original work.

High School of the Dead
"Shizuka Marikawa" cosplayed by Ting Xue

Camera: Canon 5D MARK II
Focal length: 24mm
Aperture: f/6.3
Shutter speed: 1/100
ISO: 250
Color temperature: 7100K

Imitate natural light by using subdued light

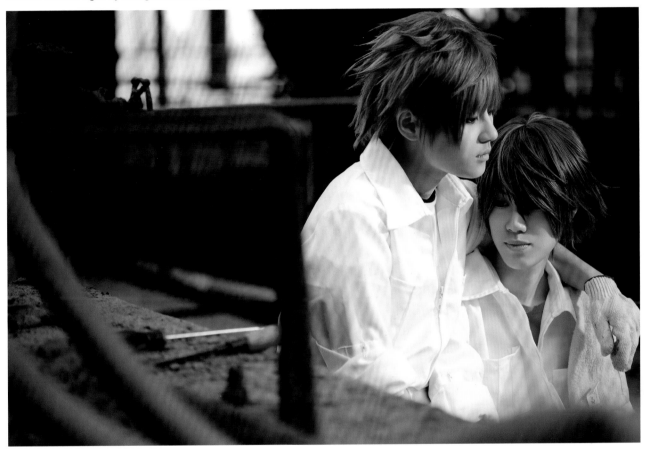

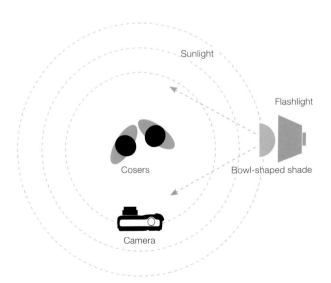

Sunlight

Flashlight

Cosers

Bowl-shaped shade

Camera

Here a shade is added to the flashlight to make the light soft to simulate natural light. Set the capacity at a low level to make the exposure a little bit brighter than natural exposure. Use light meters to test accurate levels if applicable. Alternatively, you may try a few test shots until you feel satisfied with the result. In order to make the flashlights effective, shutter speed must be kept within 1/160 second. However, if environment light is too weak, you can still try to lower the shutter speed.

True Blood ADV
"Keisuke" cosplayed by Fei Yan
"Akira" cosplayed by Shang Ye

Camera: Canon 5D MARK II
Focal length: 100mm
Aperture: f/2.8
Shutter speed: 1/30
ISO: 160
Color temperature: 7000K

Combine flashlight and reflector to supplement light

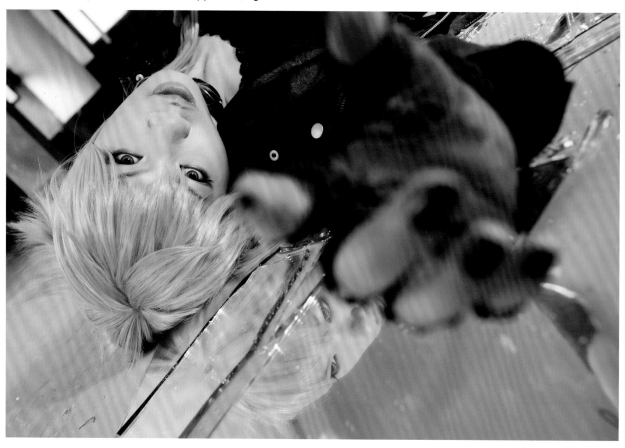

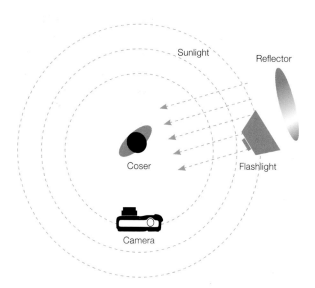

Flashlight is also used in indoor photo shoots, because indoor daylight is only as good as natural light on a cloudy day. In order to make the light extend further with milder rays, the combination of flashlight and reflector are employed. Reflected light can supplement light for the coser's face and the ground around him.

True Blood ADV
"Gumi" cosplayed by Red Master

Camera: Canon 5D MARK II
Focal length: 40mm
Aperture: f/7.1
Shutter speed: 1/125
ISO: 160
Color temperature: 5700K

Use back light to create literary and artistic scenes

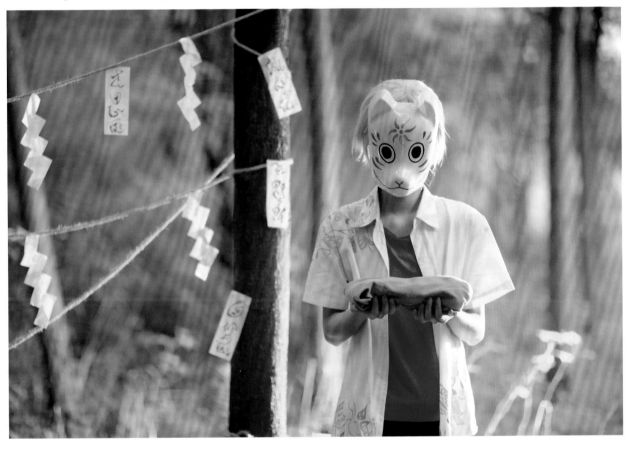

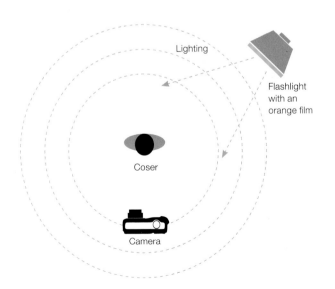

Lighting

Flashlight
with an
orange film

Coser

Camera

In *Hotarubi no Mori e* (lit. *Into the Forest of Fireflies'
Light*), every time Gin and Yuki part each other, it is at
sunset. Fair, refreshing summer days and scenes of
two lovers reluctant to say goodbye to each other have
left deep imprints on the hearts of the audience. It was
cloudy when this photo was taken. In this scenario, a
flashlight with an extra orange film was placed with an
angle at the coser's back so that the coser and all the
plants around him were cloaked in a golden veil. This
creates an almost genuine sunset effect.

Hotarubi no Mori e
"Gin" cosplayed by Shang Ye

Camera: Canon 5D MARK II
Focal length: 85mm
Aperture: f/1.6
Shutter speed: 1/125
ISO: 500
Color temperature: 6800K

• Advanced lighting: two flashlights for outdoor shooting

Two flashlights are easy to fit into a backpack yet adequate enough for most shooting tasks, including some night views. Even when it's in full darkness, photos using this method may still be unexpectedly brilliant. However, too many lights will weaken your control and render the picture chaotic.

Match the ambient light to the character

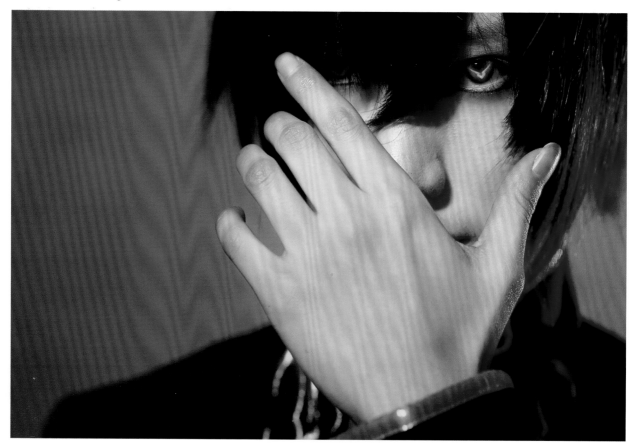

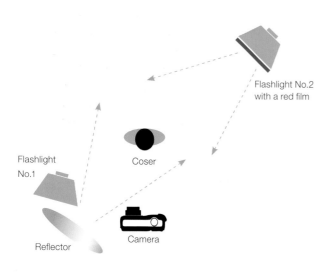

This photo was shot in a newly built room. The best advantage of shooting indoors is that the walls can act as mild reflectors for the red rays from the second flashlight. Apart from serving as supplementary light, the reflected light actually brightens up the entire scene. This is how ambient lighting works. When the power of "Geass" is activated, Lelouch's left pupil shows a flying bird with wide-spread wings. The color complements and matches exactly the environment color, beautifully demonstrating the effectiveness and irresistibility of "Geass".

Code Geass : Lelouch of the Rebellion
"Lelouch" cosplayed by Shang Ye

Camera: Canon 5D MARK II
Focal length: 100mm
Aperture: f/2.8
Shutter speed: 1/125
ISO: 500
Color temperature: 6800K

Create the impression of blazing bonfire at night

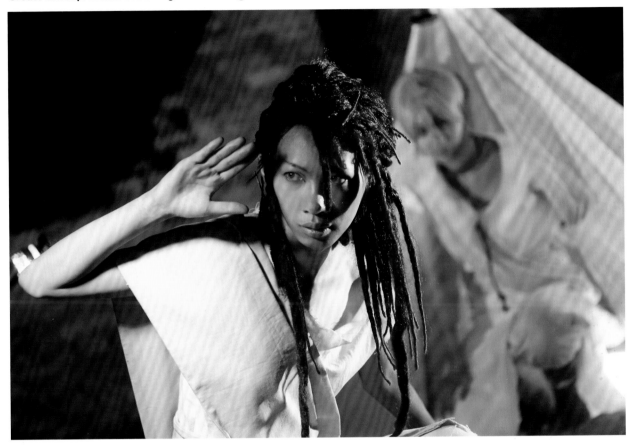

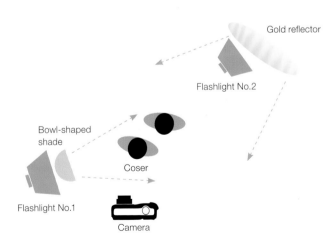

Gold reflector

Flashlight No.2

Bowl-shaped shade

Coser

Flashlight No.1

Camera

In order to create the impression of blazing bonfire at night, a combination of a far-off flashlight and a golden reflector is adopted to create the illusion of a bonfire blazing in the distance. Flashlight No.1 and a shade are used to supplement light for the coser's front and silhouette. Candlelight nearby is also applied to embellish the picture and make it more authentic and rich in content. The entire scene of the picture resembles the quality of a movie.

Magi: The Labyrinth of Magic
"Kassim" cosplayed by Red Master
"Alibaba Saluja" cosplayed by Feiyan

Camera: Canon 5D MARK II
Focal length: 100mm
Focal length: f/2.8
Shutter speed: 1/30
ISO: 800
Color temperature: 6800K

● Advanced lighting: three or more lights for outdoor shooting

The risk of producing defected photos in shootings with more than three lights is alarmingly higher than the previous two situations, yet the reward of making excellent photos is also much higher. Carefully arranged lights is what it takes to represent the extraordinary moments of cosplaying roles and to bring the planar world into realistic scenes. This is what makes cosplay photography so fascinating.

Waiting for the arrival of darkness

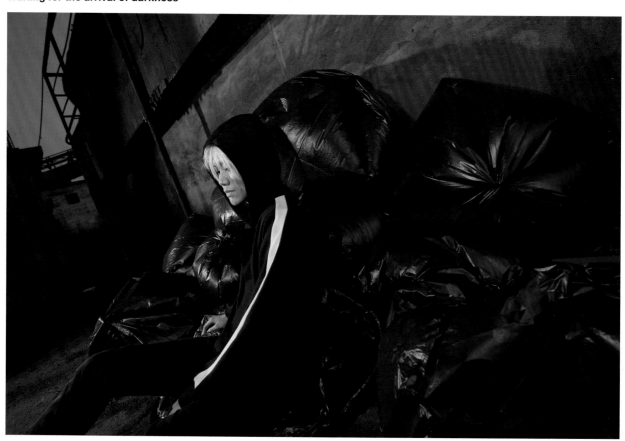

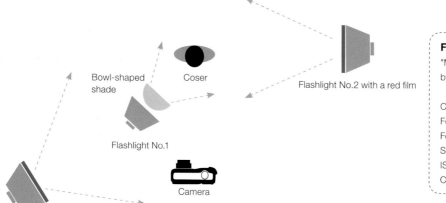

Bowl-shaped shade

Coser

Flashlight No.1

Flashlight No.2 with a red film

Camera

Flashlight No.3 with a blue film

Fate/Zero
"Matou Kariya" cosplayed by Shang Ye

Camera: Canon 5D MARK II
Focal length: 19mm
Focal length: f/5.6
Shutter speed: 1/25
ISO: 200
Color Temperature: 6900K

Our hero, Matou Kariya, is a pathetic man enduring the chewing of signet worms and smothering himself in the bitterness of revenges, yet the bottom of his heart still aspires for a happy life with his beloved. This photo refers to a scenario in the opening song of *Fate/Zero*. Here, flashlight No.3 is used as the main ambient light, emitting gentle "moonlight". Flashlight No.2 is placed to the right side of the coser to serve as supplementary light and adjust the contrast between warm and cool of the entire picture. At the same time, it can also pass for light projecting out from a window of a nearby building, which sets off the pathetic inner feelings of the hero. Flashlight No.1 mainly helps lighten up the coser's face, attracting viewers' attention to his expressions at first glance.

Japanese lifestyle

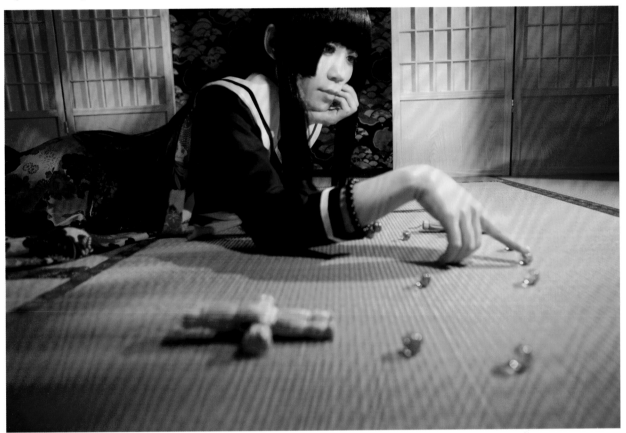

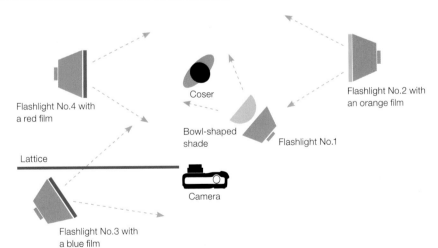

Flashlight No.4 with
a red film

Coser

Flashlight No.2 with
an orange film

Bowl-shaped
shade

Flashlight No.1

Lattice

Camera

Flashlight No.3 with
a blue film

Hell Girl

"Ai Enma" cosplayed by Sakina

Camera: Canon 5D MARKII
Focal length: 24mm
Aperture: f/3.2
Shutter speed: 1/50
ISO: 100
Color temperature: 5800K

Miss Ai Enma lives in a place with constant sunset, blooming Higanbana (or resurrection lily) and surrounding mountains. This photo desires to convey her daily life. There are three lights for environment, and a flashlight No.4 on the left side with a red film that highlights the scene. Flashlight No.2 at the right with an orange film is used for mimicking the sunset. Flashlight No.3 with a blue film is set in the front left, or in front of the lattice, creating an impression of moonlight at dusk. Flashlight No.3 plays an essential role in adjusting the general tone of the photo. Flashlight No.1 with a shade is finally added as a fill light for the coser's face.

V. Stage Performance

1 Basics of stage performance

A short cosplay performance can be the culmination of years of committed endeavors on, off and behind the stage. To understand the complexity of this fascinating hobby, let's take a look at all the various aspects of the stage performance that is called "cosplay"!

1) Preliminary preparation

First, set up an appropriate subject or theme and framework.

Secondly, brainstorm ideas to form a detailed list so all costumes, props and roles needed are compiled, and form a specific schedule for proper timing of arrangements, preparations, organizations and practices.

Stage performance of cosplay is a finely tuned art. Having alternative plans is essential to being fully ready for any unexpected events.

2) Skills in performing

Cosplay, at its core, is defined as a "demonstrative performance" that encompasses stringent requirements for modeling, expressions, standing postures, walking demeanors and other physical acts.

• Expression

An essential part of a performance is the natural and accurate facial expressions. With practice, you can convey happiness, joy, anger and sorrow along with a myriad of other emotions and expressions with different levels of exaggeration. Record your expressions for fine adjustments.

• Standing posture

Stand up straight with your back, heels, calves, shoulders and head pressed firmly against a wall. This exercise naturally strengthens your core and reinforces control of your entire body. While standing up, place a piece of paper between your thighs to reinforce your stability and control of the leg and inner thigh muscles. It is imperative to remain calm and concentrated on keeping your breath regular and controlled throughout the entire training session.

• Pose

Since performers appear to be tiny against the grand stage, it is advised that each and every move be exaggerated to the fullest extent while maintaining coordination with the body. The training method is to stand still in front of a mirror in a defined pose for 30 seconds before you start another pose.

• Catwalk

The catwalk serves as the most fundamental way of "movement" in cosplay stage performance. Starting from a standing posture with feet together, move your left foot before the right one. While walking, hold your head high, lower your shoulders and focus your eyes and chin directly forward. Never move your arms back and forth or lean your head down toward your chest. At certain distance, stand firm with the last step and present "the pose". Not even the slightest movement is ever permitted at this perfectly posed moment. In daily practices, place a book on top of your head. This helps fortify control of your head and your capability in maintaining equilibrium while you are in motion.

3) Expressiveness on the stage

Constant and consistent practice and imitation enables you to learn and hone your expressiveness on stage. Patience and understanding is required in terms of costumes, props and their details. Attention to period pieces and wardrobe such as styles of ornaments, materials of clothing, and colors of wigs is essential to the success of your performance. Observe more plays and dramas, take note of excellent performances and from your newfound knowledge develop your own sense of style. When details are fine-tuned, push yourself and boost your confidence!

2 Dos and Don'ts in competitions

Solo, duet and team competitions each pose various and unique challenges. Here are some important tips not to forget!

1) Dos and Don'ts in Solos

The core of a solo competition relies on the coordination between the solo coser, the props and the setting. It is important to remember the solo performer is the sole focus in terms of the performance. This creates extra pressure for the performer and the choreography should be extraordinarily accurate.

Even the best cosplay performers need an alternative or "Plan B". This plan can set you apart from the other performers' stage performances, especially in times of rival roles.

2) Dos and Don'ts in Duets

Keep in mind that the best effect is accomplished through creative schematics and the element of surprise. Here we'll introduce a few tips for better stage effects.

• Flashback

A flashback means using a brief yet dazzling episode that provides a glimpse into the past to depict the plot. Flashbacks may be brief, however, if supported with carefully managed musical tempo and tone, they can easily create the mood and convey the story to the audience.

• Scene setting and props

For duets it is important to devote your attention to scene setting to make up for the emptiness on the stage. Smooth transition between the scenes also add points to the overall design of the show.

Furthermore, duet competition can include more than two characters through the engagement of small apparatuses, machines and puppets.

• Dance and martial arts

Dances or martial arts are important for duets as they are often used in the scenario of flashbacks. Keep in mind that one should never compose a dance or martial arts scene for its own sake, but should integrate it into the performance with a purpose. These beautiful choreographed elements can truly and uniquely add fascination to your plot.

• On-stage costume changing

Costume changing on the stage can be a tricky business.

A common practice is to layer costumes and make sure the outer layer can be effectively removed. You may also incorporate the changing in compatibility with the change of scenes or wear a costume that personifies different styles on the front and the back. Remember, on-stage costume changing is only necessary when it contributes to the overall visual impact and understanding of the stories' scenarios.

3) Dos and Don'ts in team competitions

Cosplay with more than five cosers can be called a team performance. Preliminaries for the organization of a cosplay team performance are arduously complicated, warranting coordination of many parties and high cooperation of all involved. Professional expertise on music, script, large-sized props, stage art, lighting and performance are also highly involved. Here we summarize all preparations and tips for a cosplay team.

• Plan the script

Team performances are usually classified into two categories: "catwalk" and "stage drama". Catwalk mainly orientates on "demonstration", including costume, props show and talent show, among which choreography, formation and music are key points. Catwalks usually last for around 15 minutes.

Stage dramas are classified into dramas, tragedies and comedies with comparatively intricate scripts. Dialogues, musicals and actions are the most common forms. Always remember not to violate the meaning of the original intent, because cosplay is a loose "imitation" and "representation" of original roles, not their world views.

Stage dramas center around plots, and they usually last 15 to 30 minutes. It is optimal to introduce the main story when people are still attentive. Avoid standing still, but use gestures and the music to move the story forward. In designing the plots, be sure to plant ups and downs to attract audience attention.

• Design the music

Original animation or original music of games is most advised to be applied at the opening and ending, which enhances the sense of immersion and affinity on the audience's part. In case of special requirements, you can also substitute it with music of similar styles. Make the transition from one piece of music to another natural. Keep in mind, audio source files may vary in both format and size, which warrants a unification adjustment in advance. Also remember that repetitive adjustment and saving of the original audio production results in the deterioration of sound quality.

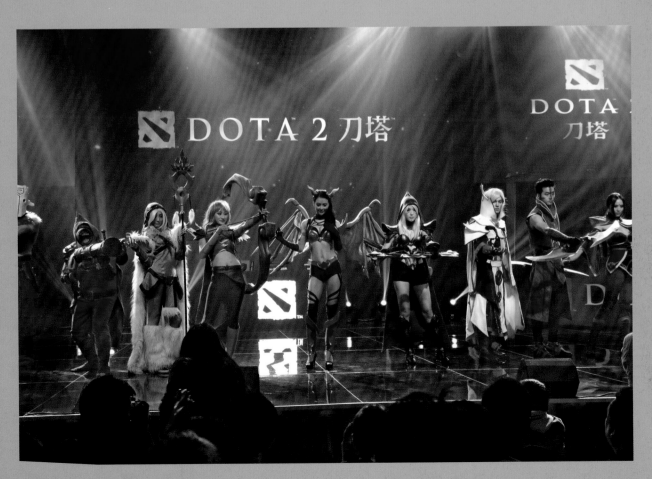

• Overall planning and team coordination

Scheduling, planning and management of personnel are essential in cosplay group performances. A team leader can divide members into several "divisions" and the head of each division will in turn take charge of their team members. Leaders should conduct valuable, regular team meetings and rehearsals. When it comes to the assignments or roles, it is imperative to factor in such responsibilities as rehearsal time, role similarity, economic affordability and personal commitment to the role.

• Observe performance etiquette

On the judge's checklist for cosplay performance, there is always an additional mark, which assesses factors such as punctuality, discipline observation, no over-time, no use of dangerous props, no vulgar content and so on. All these are referred to as performance etiquette. Performers should also remember that no foul language is permitted, no tossing of hard objects down the stage, and no projectile props should be used. After the show, listen carefully to judges' comments and compose your questions or disagreements in an appropriate way.

• Use the stage lighting to your advantage

The use of different lighting even on a simple stage can create the sense of space, time and seasonal concepts. This tremendously enhances the creation of the stage atmosphere, description of the environment and portrayal of the roles' psychological emotions. If possible, prepare in advance a detailed lighting script which records all the lighting effects in accordance with the timeline and correlation of the music. However, never expect or demand the lighting engineer to adjust lighting to your wishes; a safer and more respectable way to do this is to have a member from your team who has good knowledge of the play to give prompts to the engineer throughout the show following the lighting script.

• Get prepared for emergencies

In case of emergency situations, contact organizers instantly. A team should prepare itself against emergencies like common diseases and minor injuries. Do not use combustible or metal props on stage for safety reasons. Save a backup of the music in case of audio failure. If the music stops suddenly or there are equipment failures, stay calm, as uncontrollable incidents do not affect the score. Also, all cosers must take good care of their personal belongings; it is strongly advised to delegate someone responsible for the whole lot to avoid any loss.

• Manage costumes and props

As team performances involve many staff members and it is impossible for the person in charge to look after everyone's costumes, every coser must individually take good care of their own costumes. Props and costumes should be checked regularly. It is optimal to have a few dress rehearsals so as to expose and eliminate deficiencies before the big day. Do not hurry to leave after the show but make sure to pick things up and check the outfit. After the performance, team props must be assigned to a dedicated staff member for disassembly and transport.

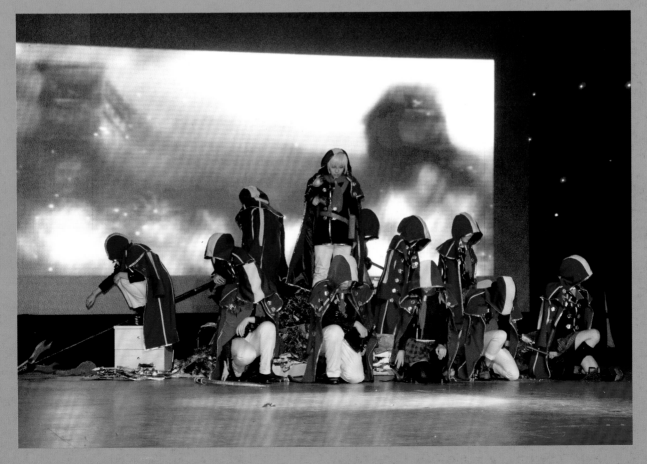

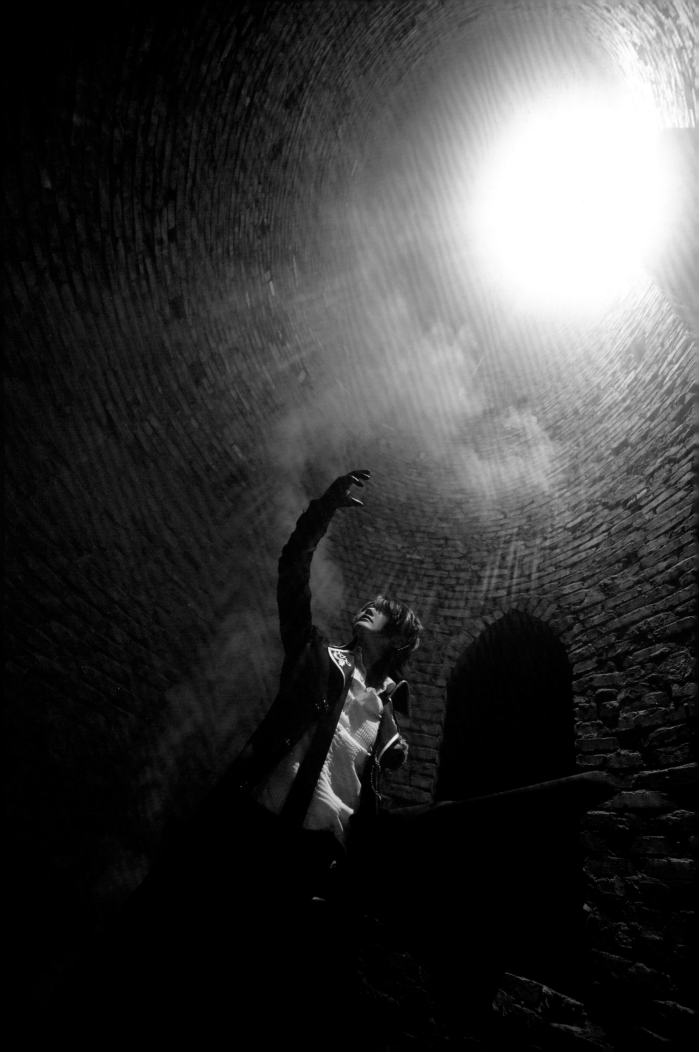

VI. Photo Sifting

The sifting of cosplay photos is the process of sorting out all the photos until we trace down to what we need. This is a prerequisite for later editing.

 First sifting

Usually there are altogether 200 to 300 photos from a photo shoot. The first sifting aims to eliminate photos with the following defects:

poor lighting

vagueness and loss of focus

inadequate facial expressions

for photos with similar pose and expressions, select two to three photos among them and delete the rest

In this process, keep an eye on the thumbnails so as to sort out pictures for all kinds of color tunes and compositions. Often after the first sifting we would narrow the photos down to around 150 photos.

 Second sifting

In the second sifting, we group the photos into sets of 10-15 according to either different costumes and poses or different facial expressions, and select the best ones from each set until we have around 40 to 50 photos left.

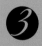 **Final sifting**

Now we group the photos according to different settings and choose two to three best ones from each set until we have decided on the finest 10 to 15 photos.

VII Retouching

Case study I: cosplay of *Genesis of Aquarion*

The following tutorial is prepared by Lala II.

· Target: turn day into night to render the photo with a sense of magic fantasy.

· Role: Mykage

· Coser: Lala II

· Photographer: Shuguo Rourou

· Software: Photoshop CS4

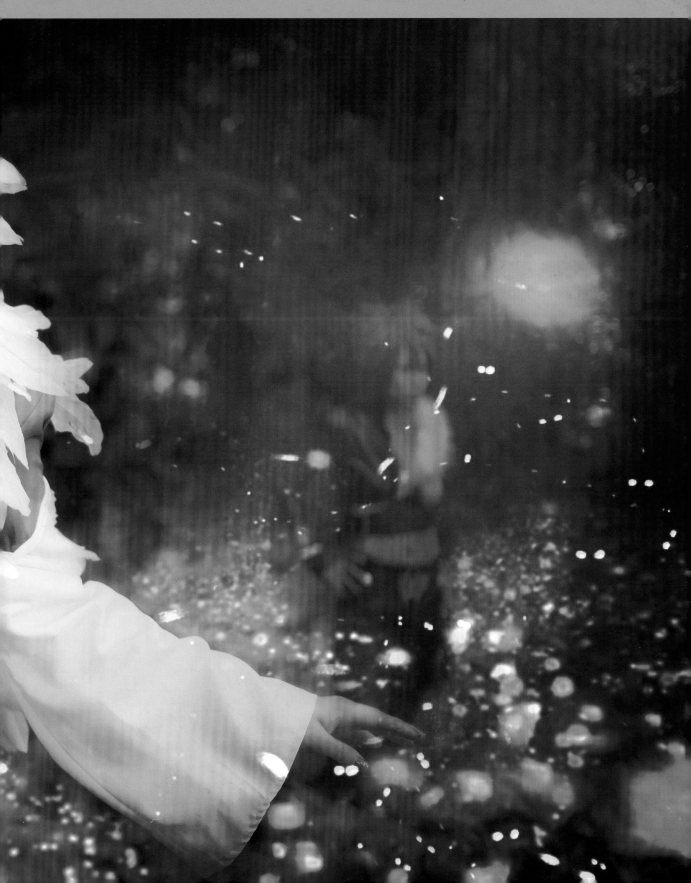

Original photo

Photos shot in the daylight features sunlight and warm light with a strong contrast. The main source of light lies directly above, which makes all objects in the picture dazzling and bright. During the night, there's moonlight and cold light with weak contrast, creating a dim and vague background. Smoke and fog may add to the photo a mystical feel.

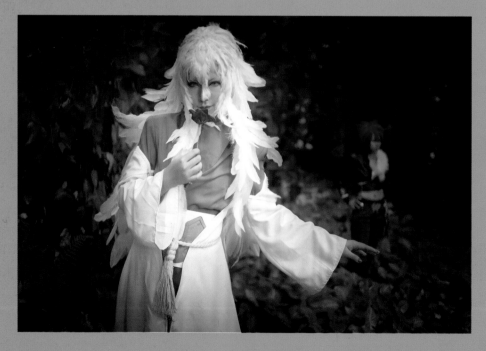

01 Add a new layer and smudge dark colors such as black or blue to haze the surrounding environment so as to render the main subject more prominent, but not too distinct because it is still night.

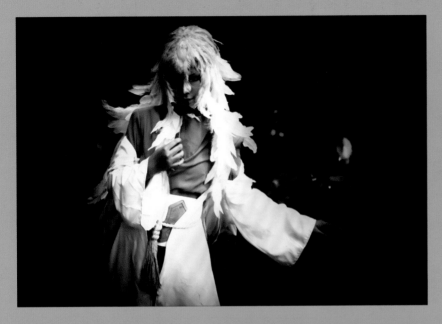

02

To enhance this contrasting effect, copy the original photo to a new layer above the layer created in step 1, select "Filter – Filter Gallery – Sketch – Conte Crayon" to obtain the desired effect. Pay attention to set the filter as shown above. Set the mode of this layer to "Multiply".

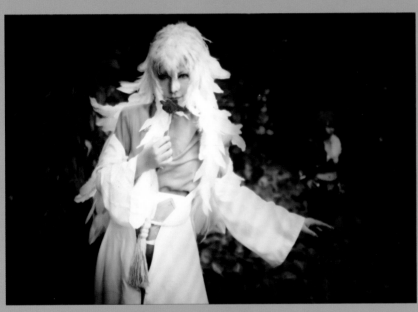

03

Copy the original photo to get another layer, choose "Filter – Filter Gallery – Distort – Diffuse Glow". Set its grain size at 0, luminous quantity at 1 and removal degree at 15. This would achieve the visual effect of a luminous subject within the darkness. You may adjust the level of each parameter according to your needs.

04

Repeat previous steps to achieve the desired effect.

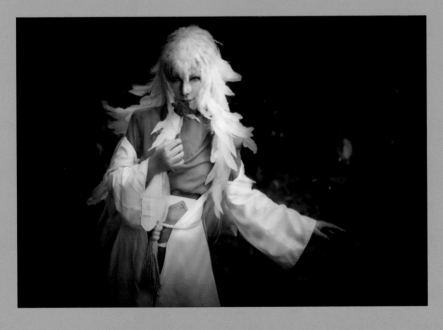

Source material photos

05

To enhance the luminous effect in the background, here a few photos of fireflies are selected as source material.

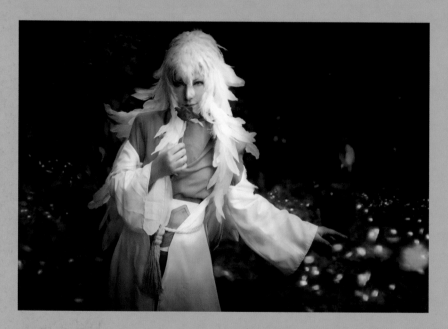

06

Place the source material images above all the layers and set this new layer to "Linear Dodge" mode. Add more source images if needed.

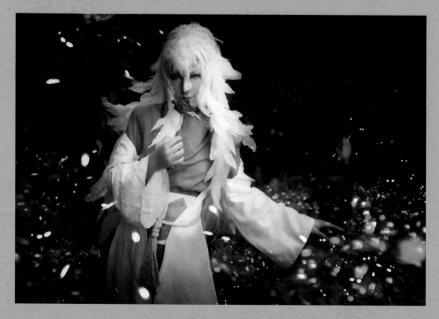

07

This is the result after adding three source images. Apart from "Linear Dodge", "Color Dodge" and "Color Filter" are equally applicable. Choose the right model to meet your own requirements.

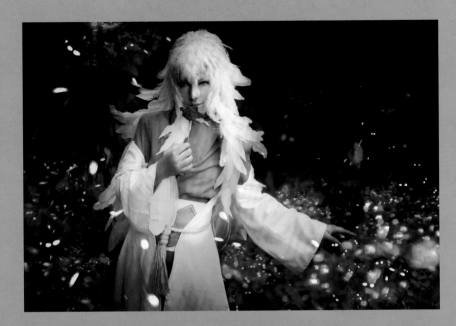

08

The light emitted by the fireflies should be able to change the tone of the surroundings. To make the picture more natural, create a new layer in the "Overlay" mode, then use the brush with turquoise and a tint of blue to paint the dark part of the picture.

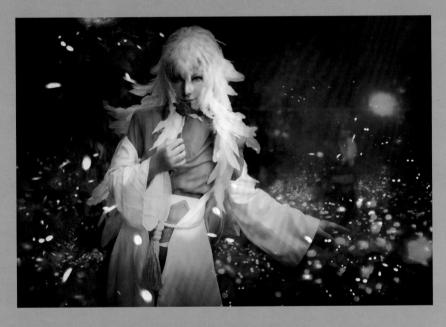

09

In order to add a soft halo around the figure as if in the moonlight, use the same method as stated in step 8, paint the new layer with iron blue, and then set the transparency of the layer to 10%-20% or even less.

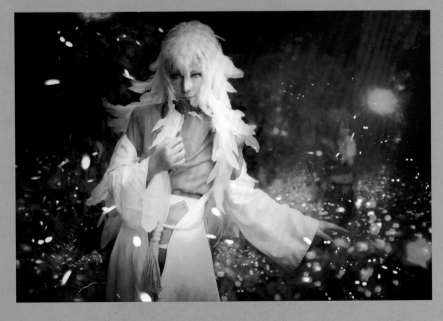

10

Repeat step 9 to achieve the desired contrast effect for the figure in the moonlight. However the iron blue haze will cast a shadow on the main figure. To solve this problem, first merge all layers, then select "Image – Adjust – Curve" and adjust the overall brightness of the photo.

This tutorial is prepared by JILL.

·Target: add subtle adjustment to the face; compose the background and envelope the picture with the sense of a dark fairy tale.

·Role: Alice
·Coser: JILL
·Software: Photoshop CS6

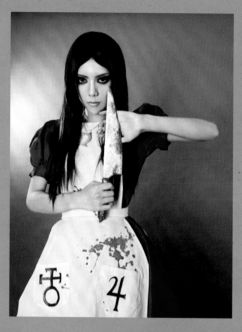

Reference images

Using reference images to define the pattern and style for the final outcome, then examine your photos and determine the target of the retouch process and the details that need to be adjusted.

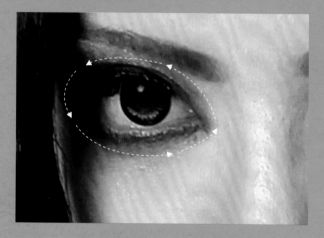

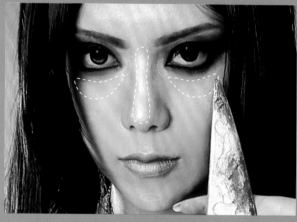

01 Use the "Stamp Tool" to remove all blemishes on the face such as moles. Alice's eye makeup should be distinctive and stands out in the facial area. In order to offset the reflective lights in her eyelids, apply the "Burn Tool" to fill in the eye line.

02 Since the lighting in the film studio was not very bright, Alice's face needs to become more prominent. To create contrast and partially brighten her face, use "Dodge Tool" on her lower lip and the area beneath her eyes.

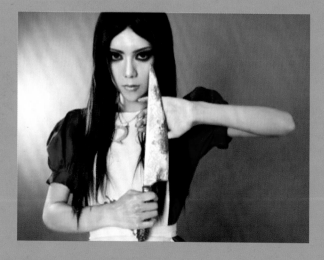

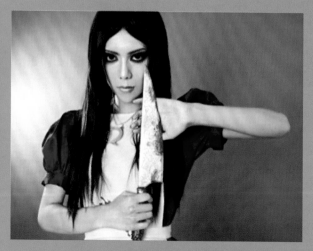

03 Adjust the overall contrast degree. Since it is a Gothic style piece of work, a tinge of chilliness can be applied.

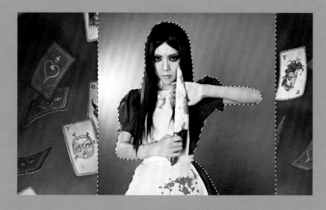

04 Choose a background picture with high pixels and the same direction of light. Put Alice's photo on top of the background layer, and use "Pen Tool" to sketch her contour. Create a mask layer and render areas other than the figure invisible.

05 Refine the trimming of the edges of the figure. Create and a new layer on top and fill in a gradient of iron blue, light on the top and dark in the bottom, then adjust the transparency degree to give Alice's face more prominence.

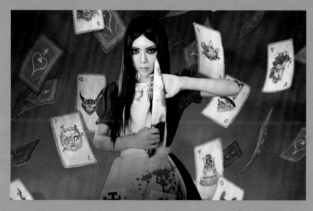

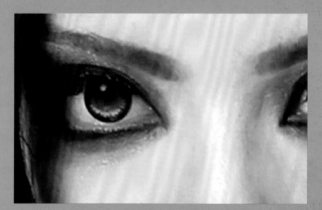

06 Use "Curve" and "Color Balance" to assimilate the figure into the background and then merge two layers into one.

07 Create a new layer to add cold green color to Alice's captivating iris, make sure her pupil is evaded. Use "Linear Dodge" for effects and adjust parameters of "Hue" and "Contrast".

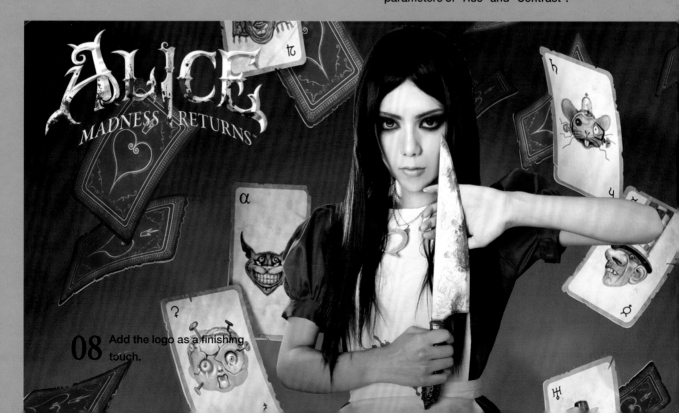

08 Add the logo as a finishing touch.

Case Study:

Cosplay of
"Lord Shen" from
Kung Fu Panda 2

In cosplay of objects without a humanly form, the creation process would undergo two stages, namely, personification and realization. Here, as an example, we'll analyze in detail the cosplay process of Lord Shen the Peacock, the formidable antagonist in *Kung Fu Panda 2*. Based on the personification in Feimo's illustration, "Lord Shen" is cosplayed by Xiaoxiao Bai.

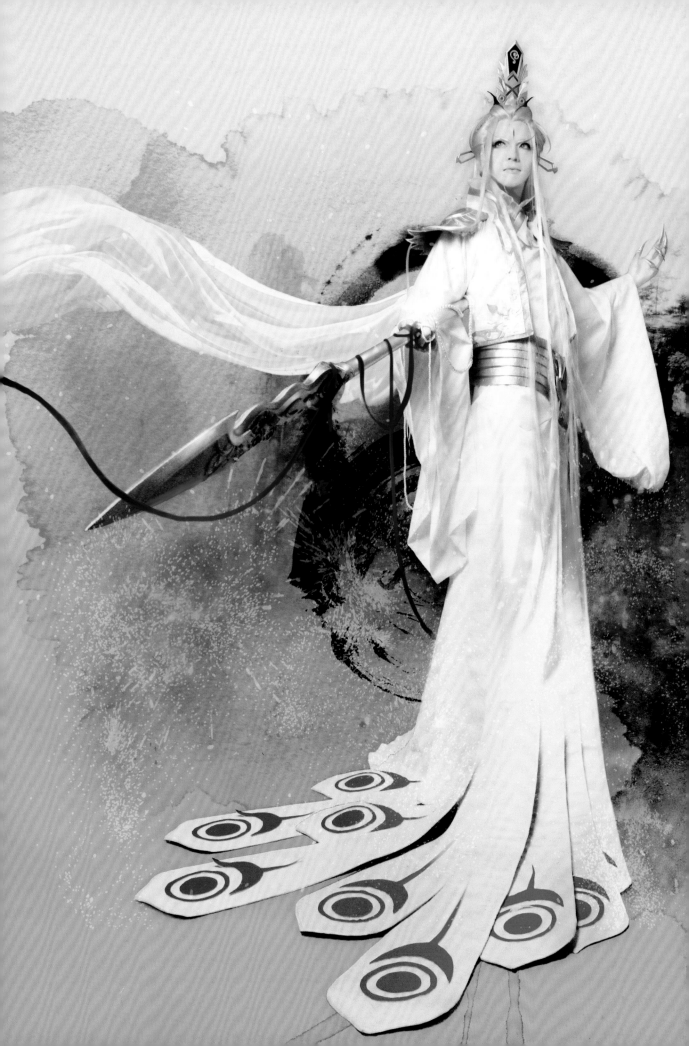

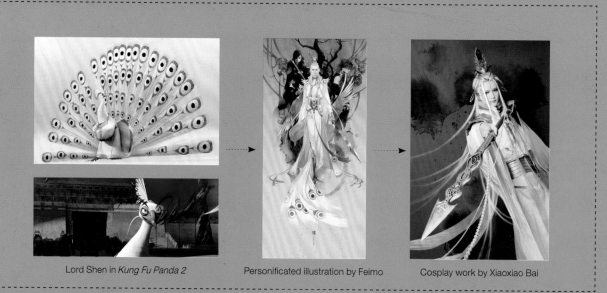

Lord Shen in *Kung Fu Panda 2* Personificated illustration by Feimo Cosplay work by Xiaoxiao Bai

• Analyze the character and features of Lord Shen

Lord Shen is not just infamous in martial arts with his daunting and deadly "Funnel Cloud and Feather Attack", but also full of craft. Lord Shen has the so-called "Sanpaku eyes", i.e. eyes in which the white space above or below the iris is visible. Roles with this feature are normally rageful and brutal. However, although evil in heart, he appears gentle and polite with soft and graceful demeanors. Therefore, he is granted the type of "tsundere" by those who are fond of the role.

· Main weapon: iron spear
· Defense weapon: peacock tail
· Concealed weapon: darts
· Ultimate weapon: cannon

Notice the entire body shape. The curves must be distinct, graceful, and, at the same time, tough. The texture of his weapons must be firm and sharp and his expressions must appear cold and merciless.

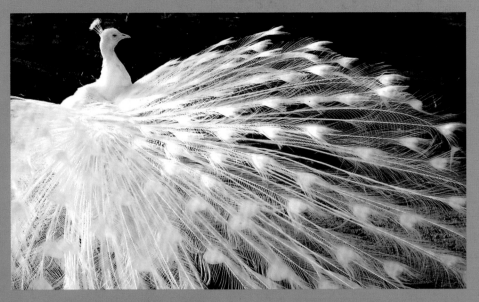

- **Refer to the prototype of Lord Shen for features in the personified image**

White peacock is an albino mutant of the human-raised wild blue peacock, rare and precious. Its entire body is pure white with reddish eyes. Its wings are underdeveloped, resulting in poor flying abilities. In breeding seasons, the male is extremely ferocious, to the extent that it even attacks its own reflection in the mirror.

Therefore, Lord Shen's facial make up must be completely white with a hint of red in the eye to reflect extreme aggression.

• Sketch the personified image

Conception and drawing of impersonated images are highly important, which directly determine the success of the final cosplay work. It is encouraged to try various expressions, movements and angles of shots at this stage to find the best combination.

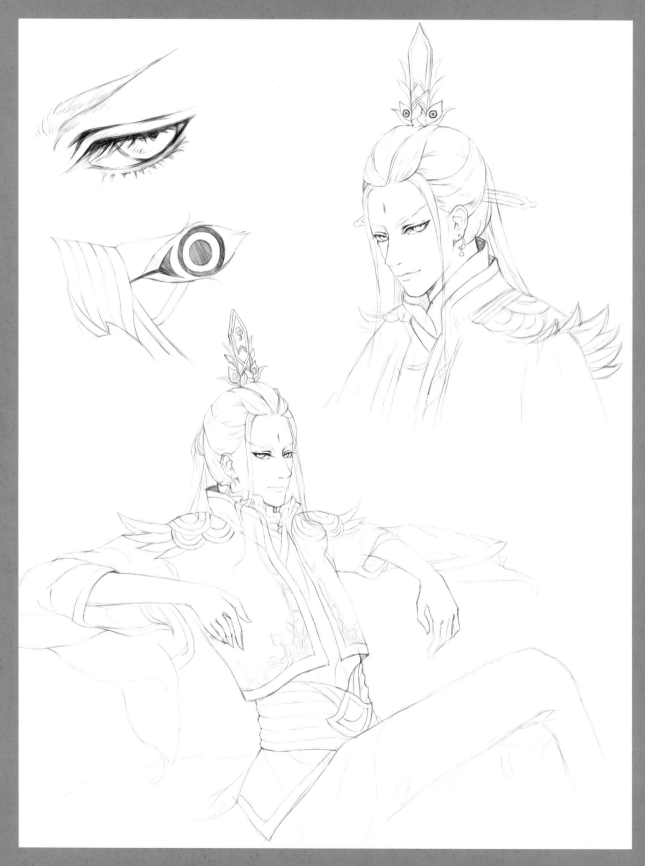

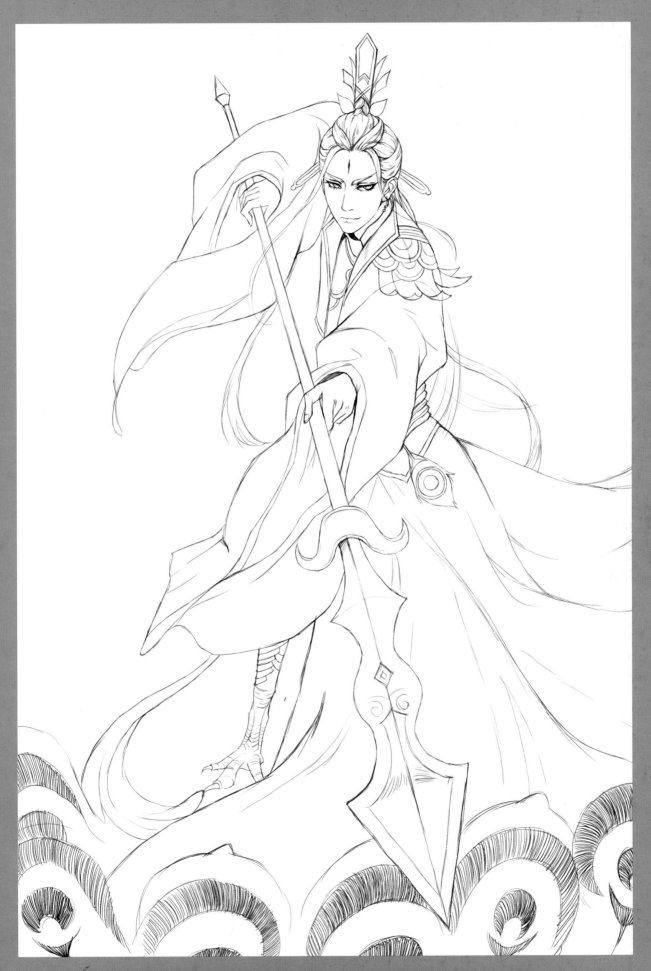

• Collect reference materials for detailed portrayal

Nail wrap, crown, costume patterns, spear, peacock feathers... the more defined the list of materials, the sooner the drawing plan will be decided. Pictures solely based on imagination would often appears stereotyped. Therefore, we need sample materials to enrich details and add to its appeal.

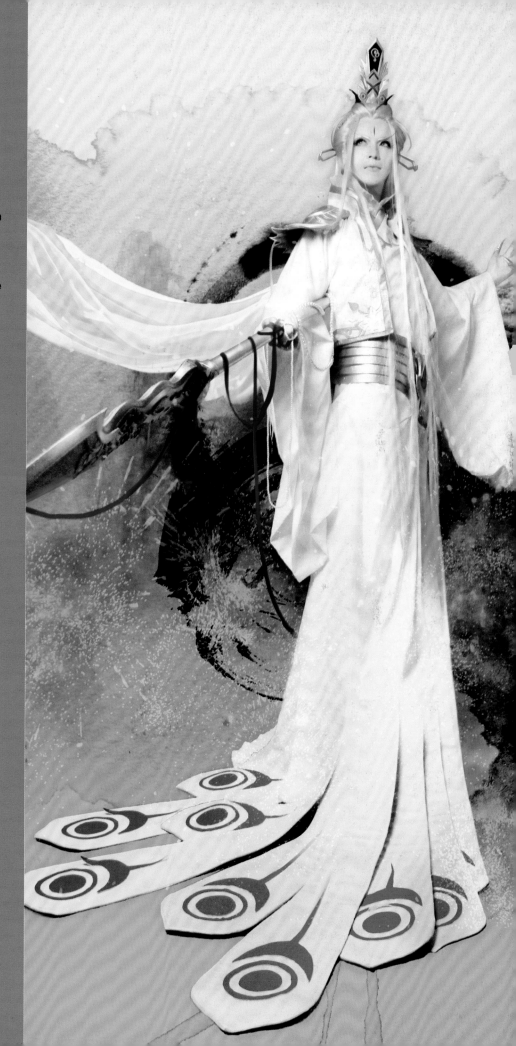

• Select materials for realization

The costume in this example comprises of upper and lower parts that require a variation in tactile materials. The belt and shoulder pieces should give the impression of golden metallic texture. Whitened facial make-up gives a sense of coldness and the sliver in the middle of the eyebrows and reddish eyes demonstrate a sense of distance.

Here is a comparison of the details of the finished work with the conceptual illustration. In the realization stage of cosplay, although adjustments still occur in special occasions – often due to material restrictions – details and refinement are always being constantly perfected.

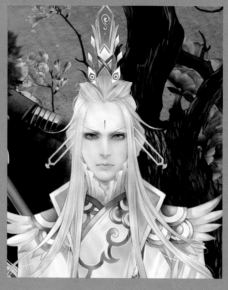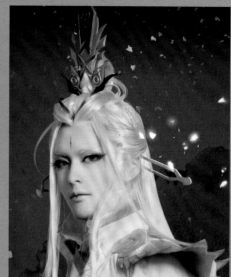

Crown, make-up and expressions

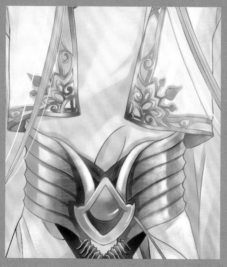

Waist belt

Tail feathers

Prop style and pattern

● Select camera angle

The camera angle marks the specific location at which a camera is placed to take a shot.

Here is a brief introduction to the function of different camera angles with reference to the "Lord Shen" cosplay photo.

① Extreme long shot:

It introduces the environment to create a certain atmosphere, such as the imposing manner of Lord Shen in his authoritative command of the world.

② Long shot:

It shows the entire figure and background, revealing the figure's shape, costume styles and identity.

③ Medium Shot:

It is the most narrative shot and the most commonly used angle in cosplay photos, highlighting the poses and the figure's relationship with the background.

④ Close shot:

It depicts details, which require the modeling to be more refined with makeup, costumes and props being more authentic. It is also the reason why the realization process demands perfect details and refined completeness.

⑤ Close up:

It conveys the subject's expressions and changes of emotion. Close ups deliver a strong compelling and appealing sense to the viewers.

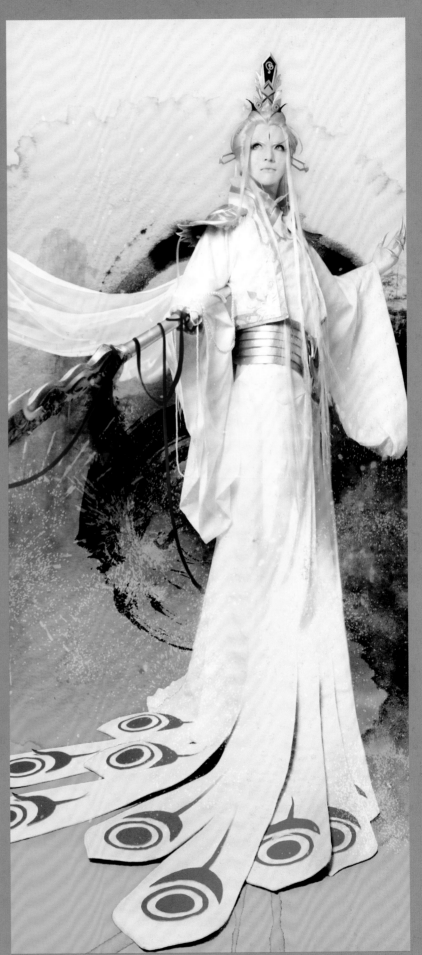

Photos on this and the next pages are medium shots, aimed at delivering emotions reflected by the coser's expressions and movements and showing readers vivid special effects such as ink patterns, shiny fragments and light rays in the background.

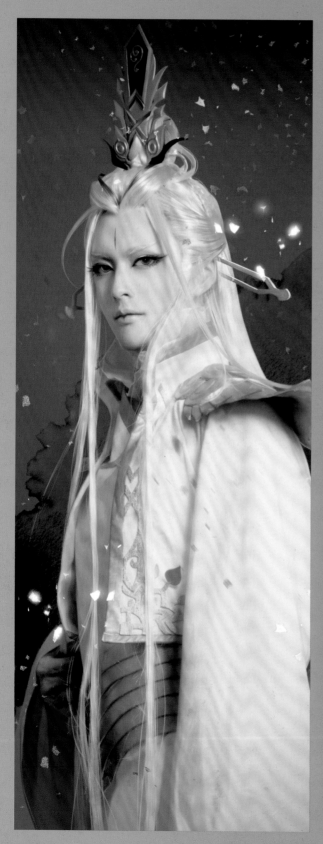

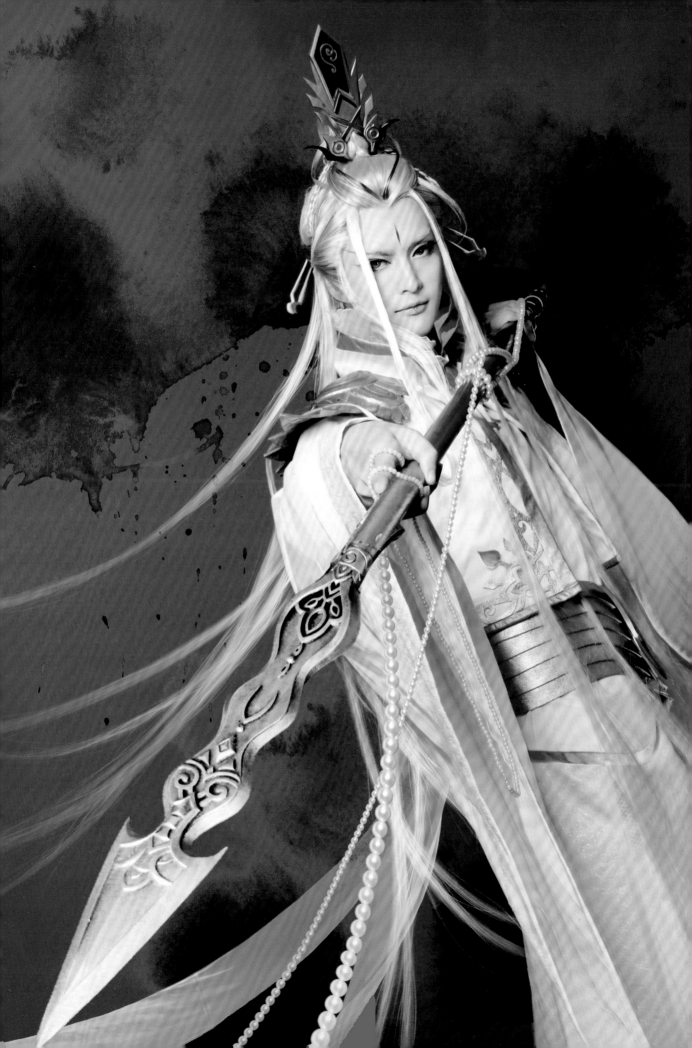

Photo Gallery

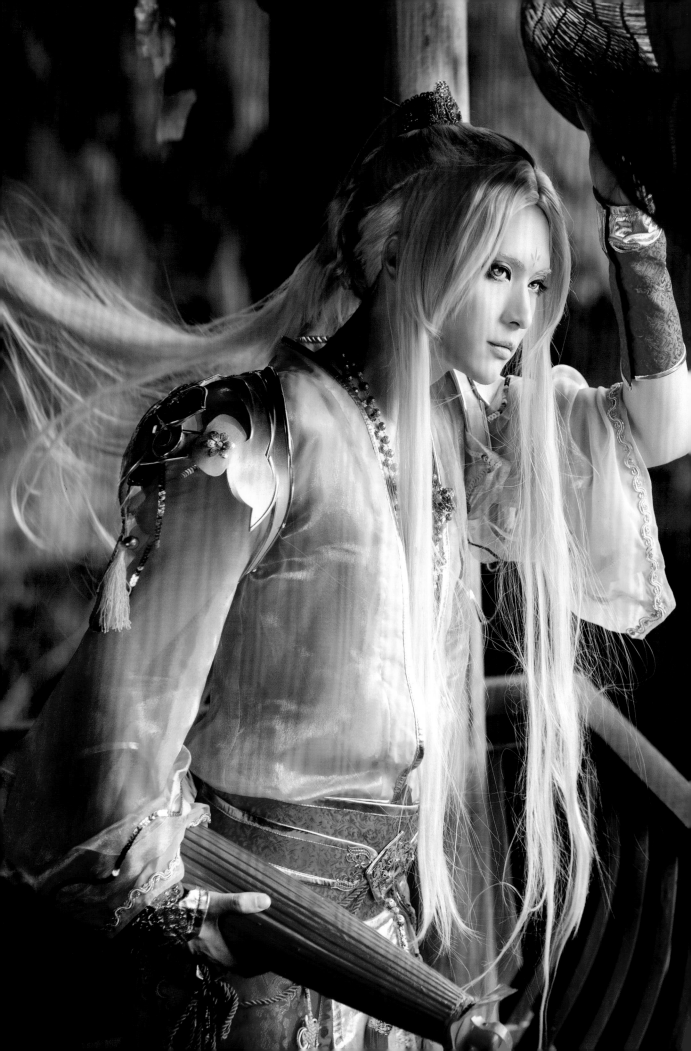

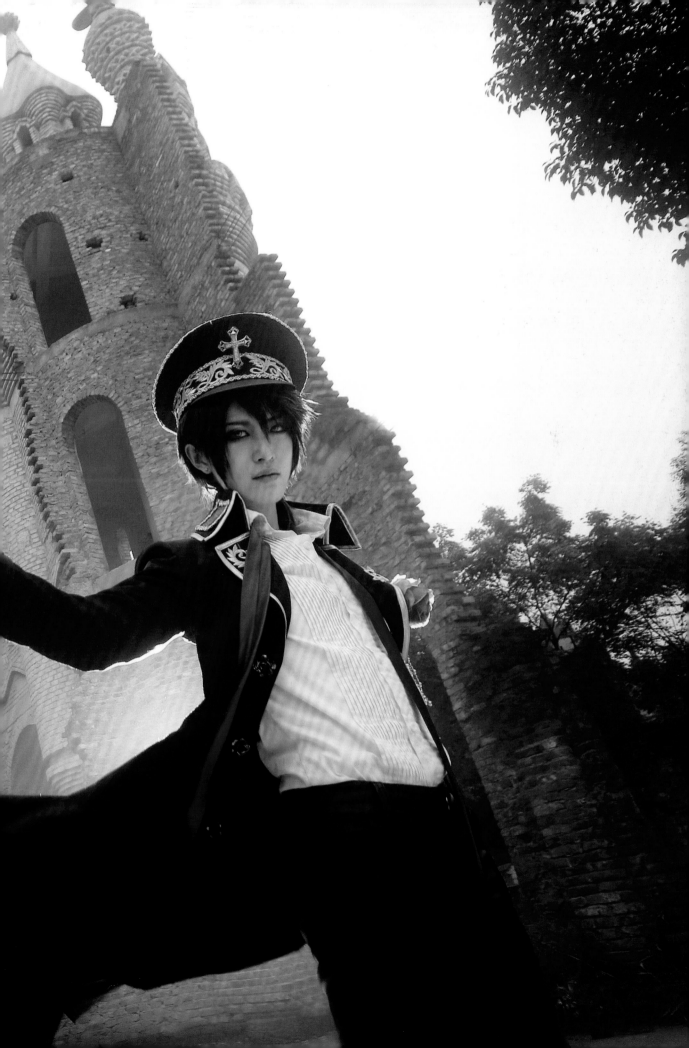

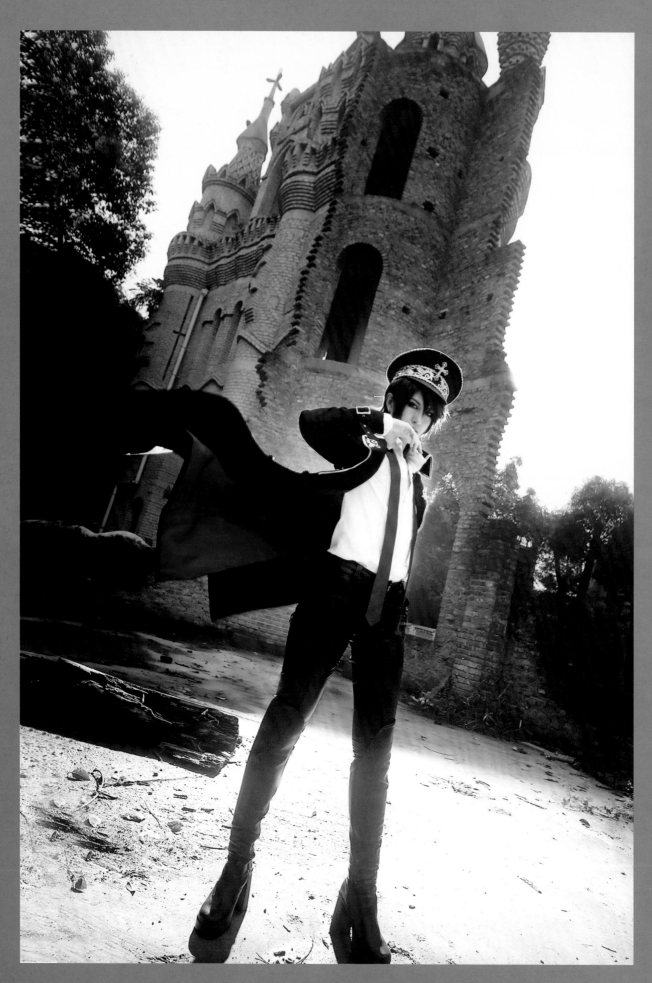

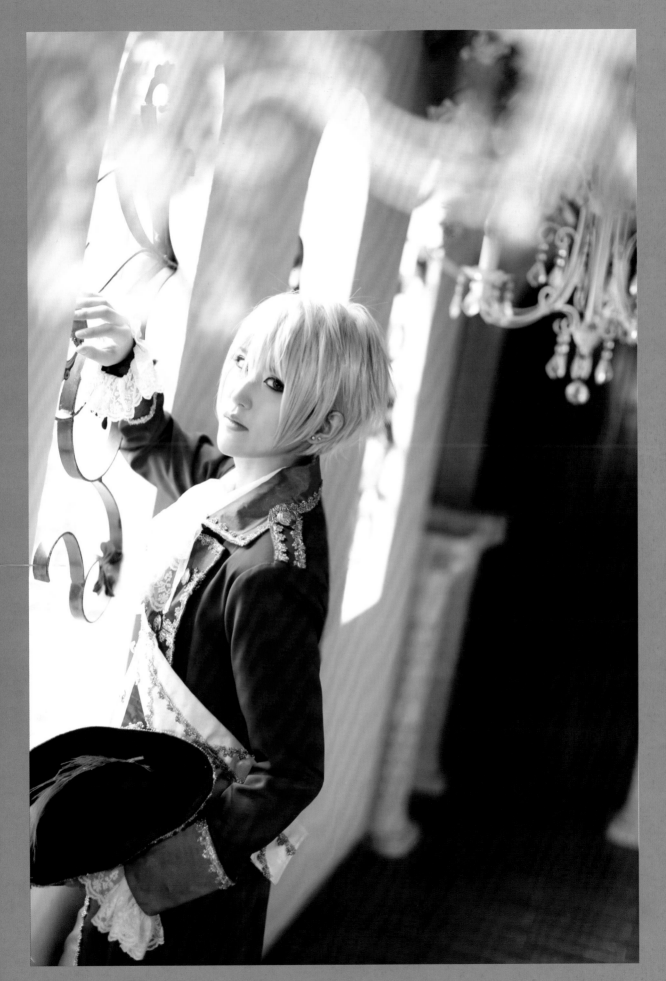

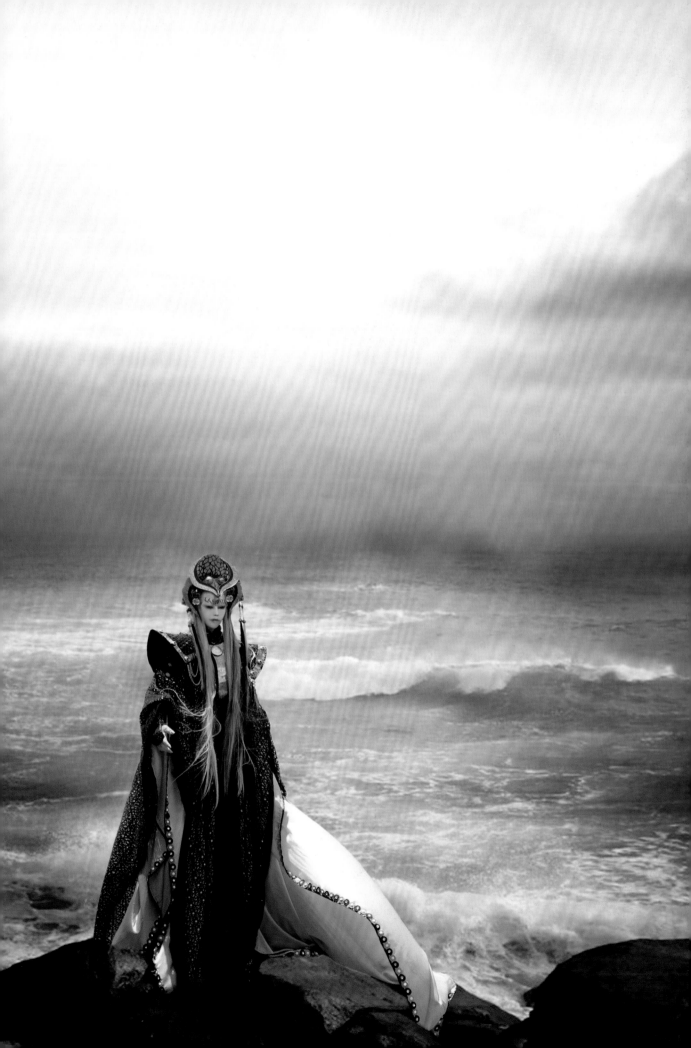

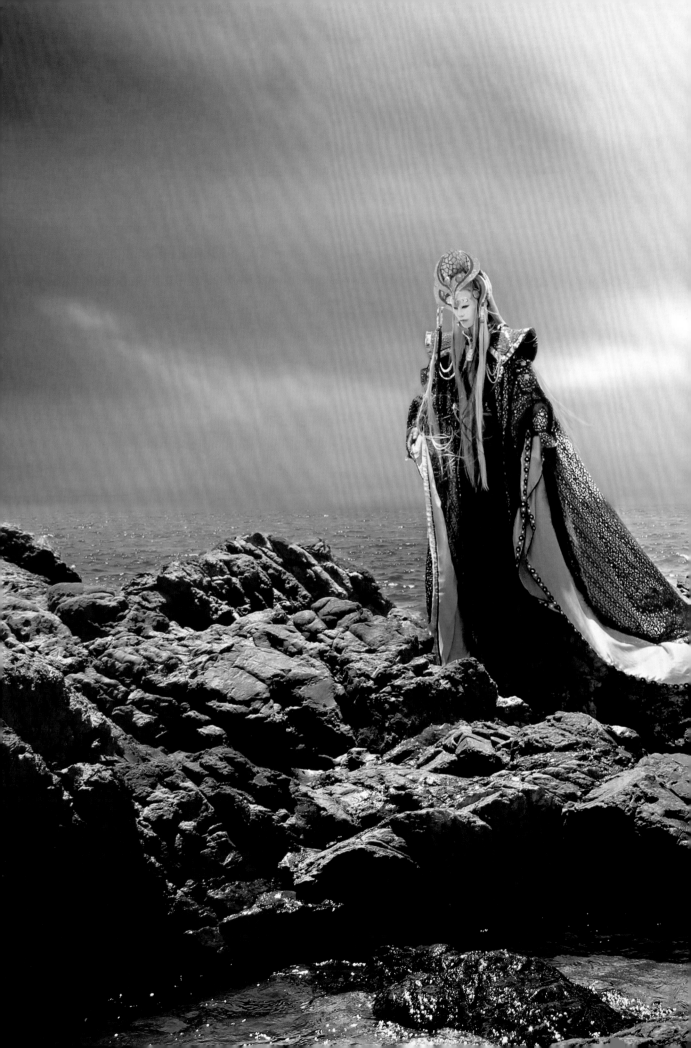

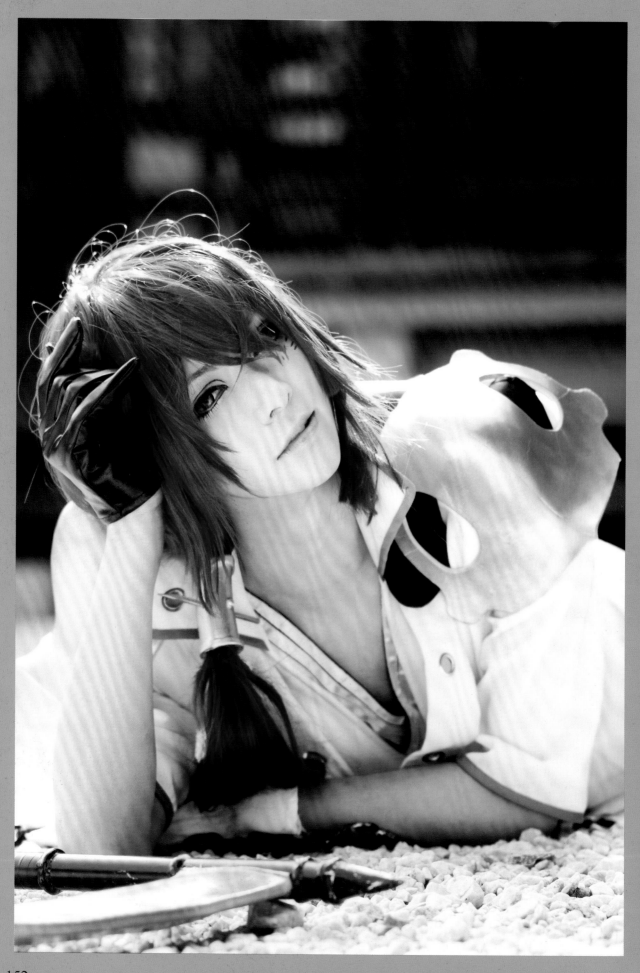

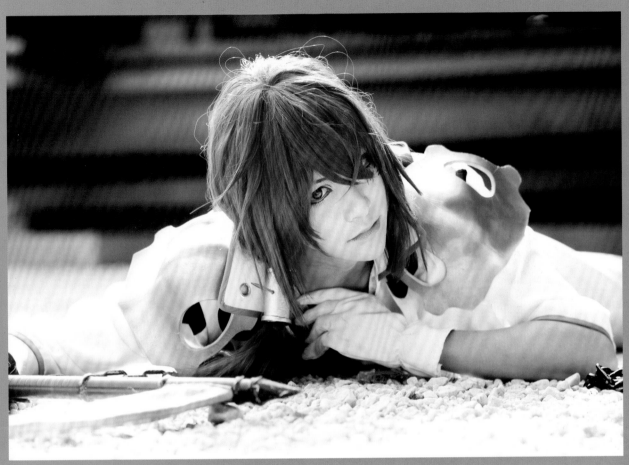

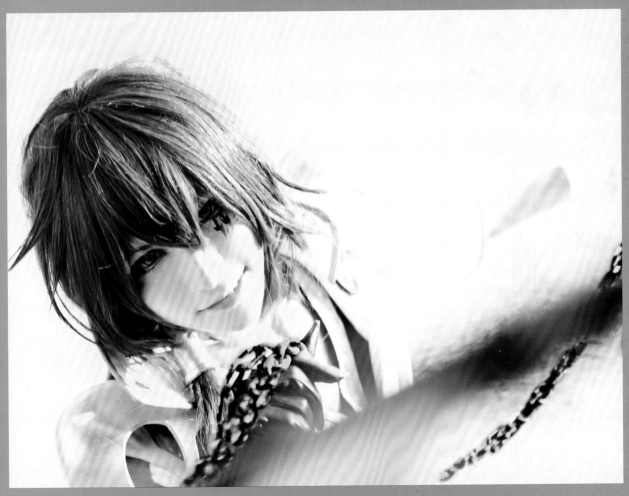

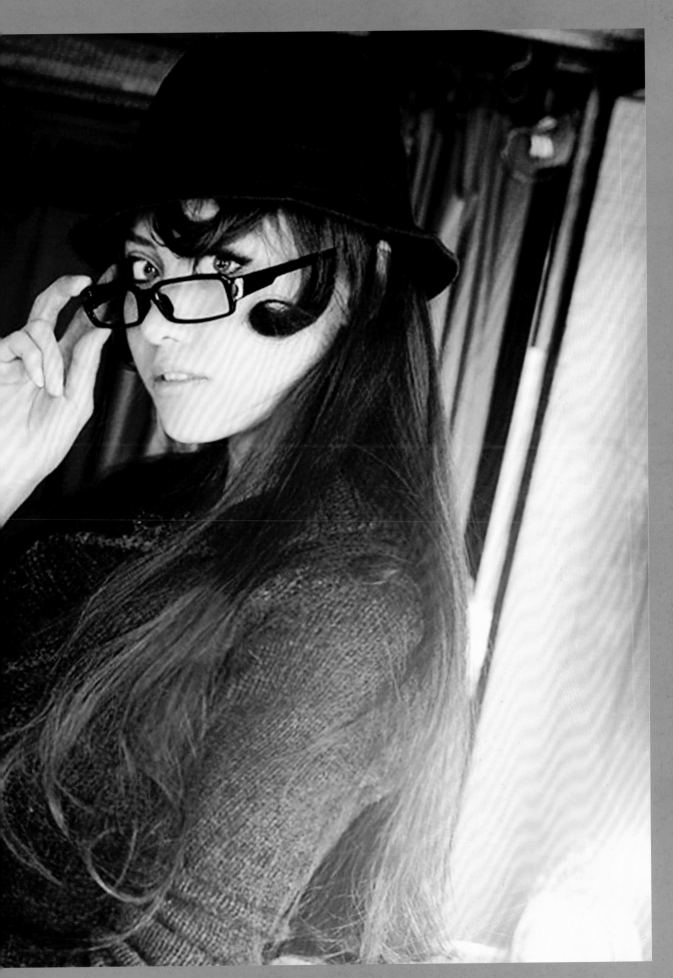

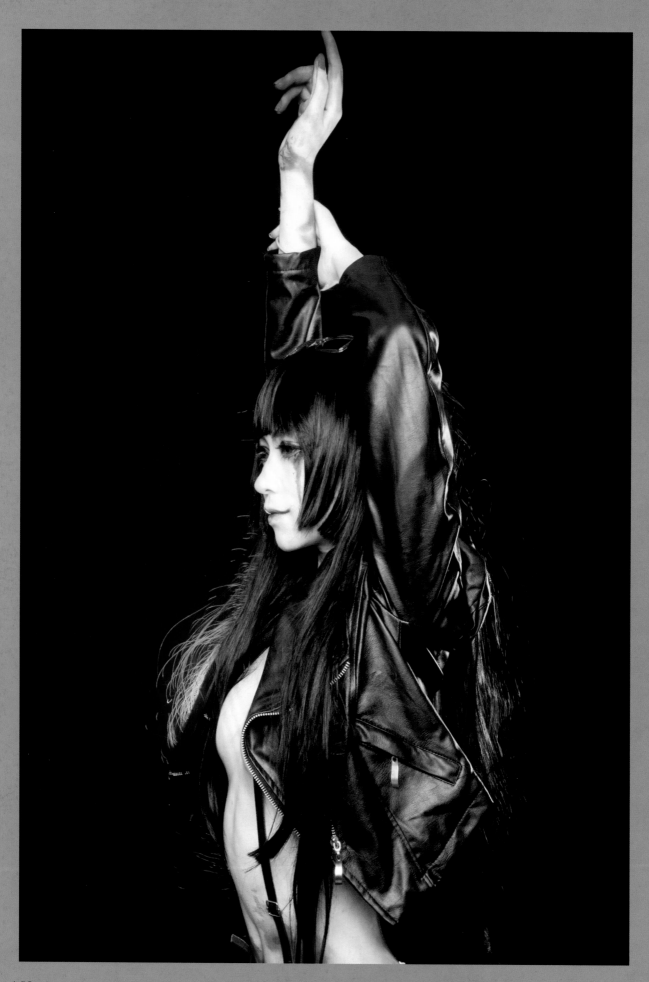

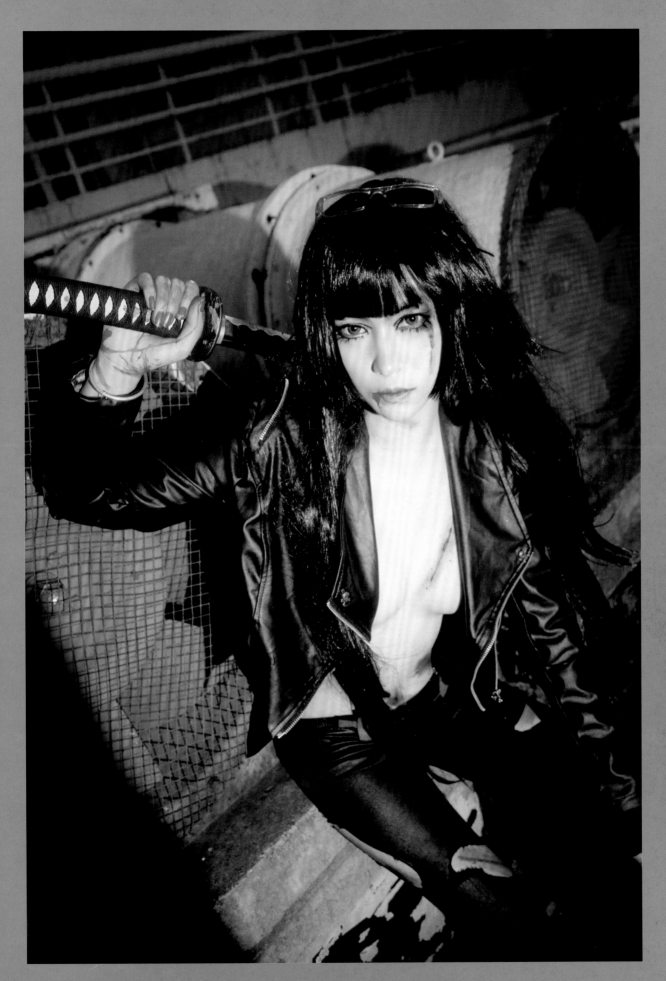

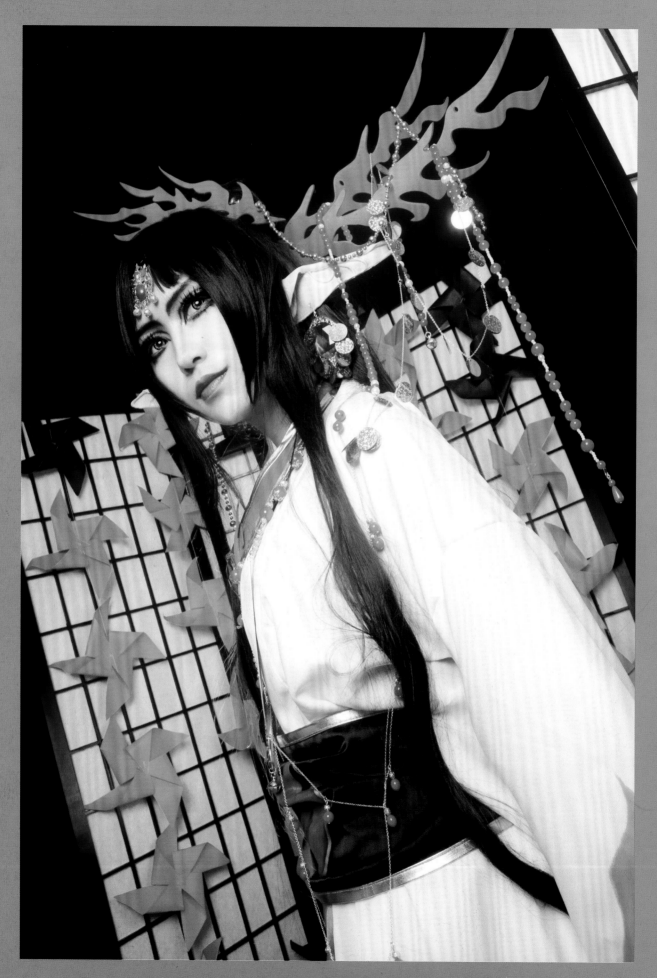

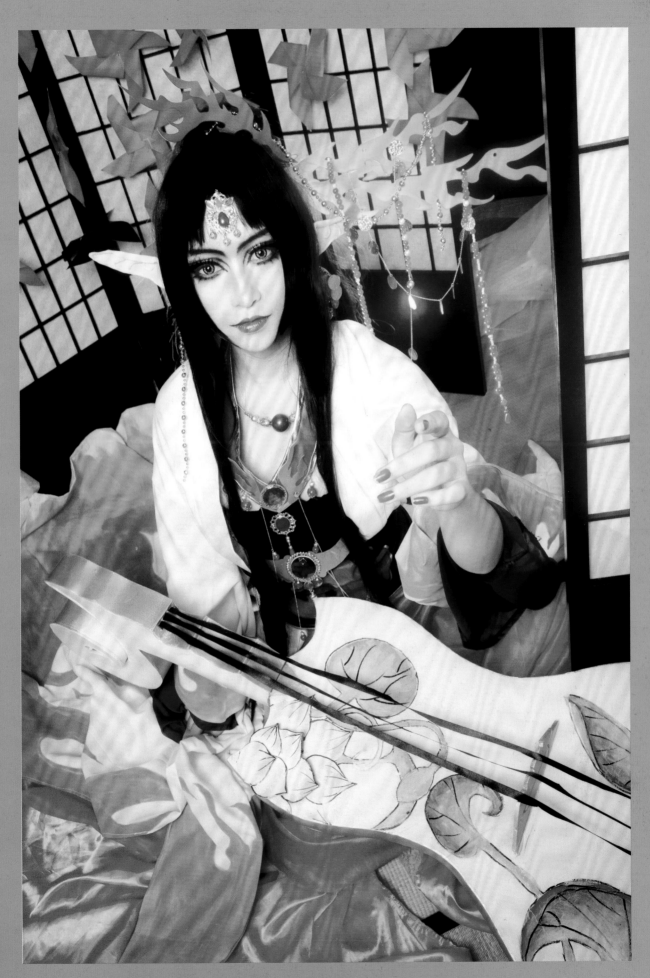

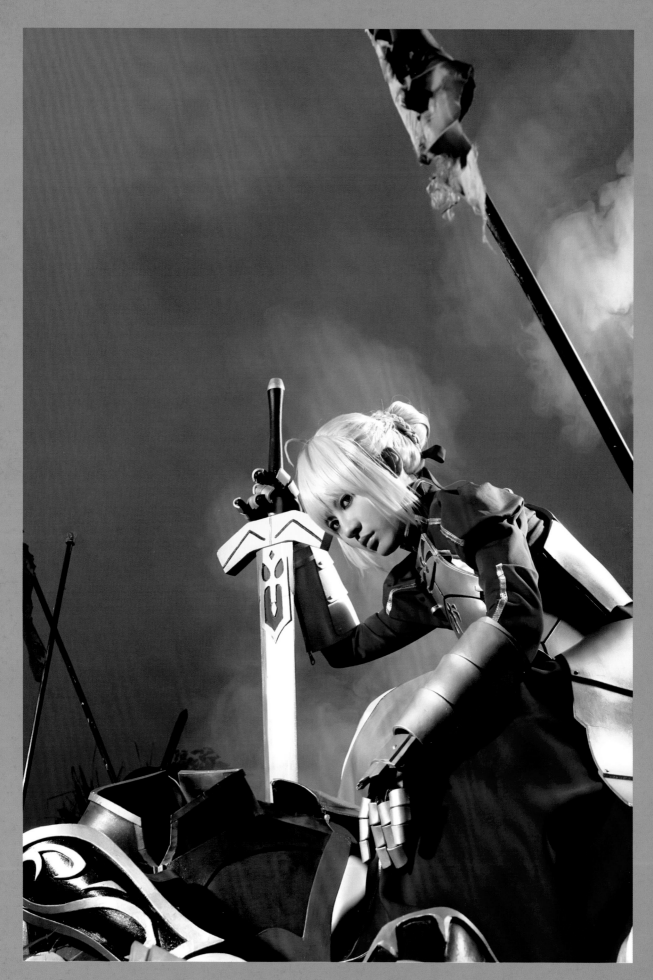

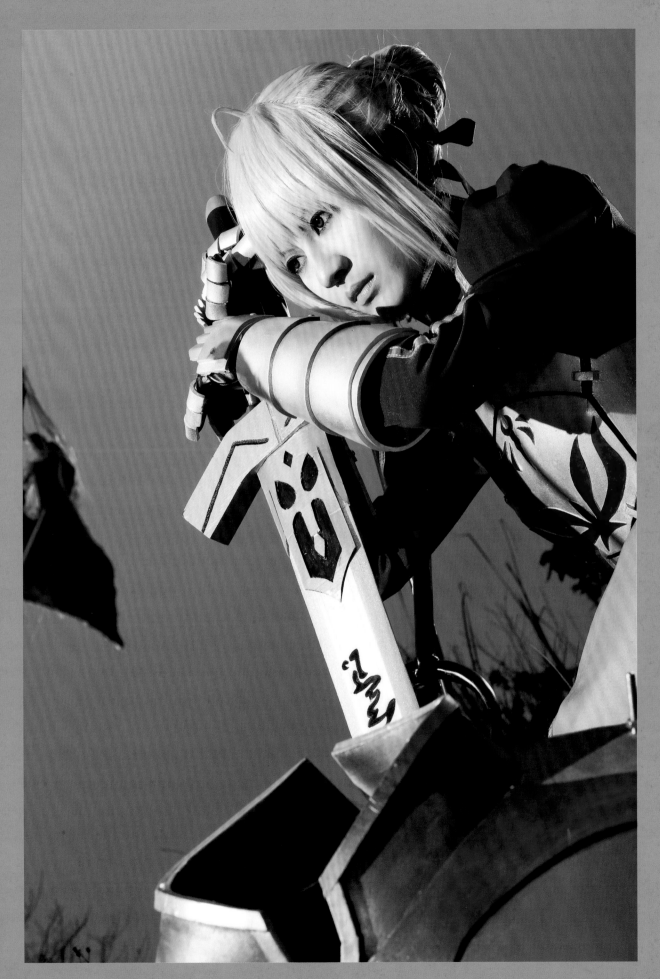

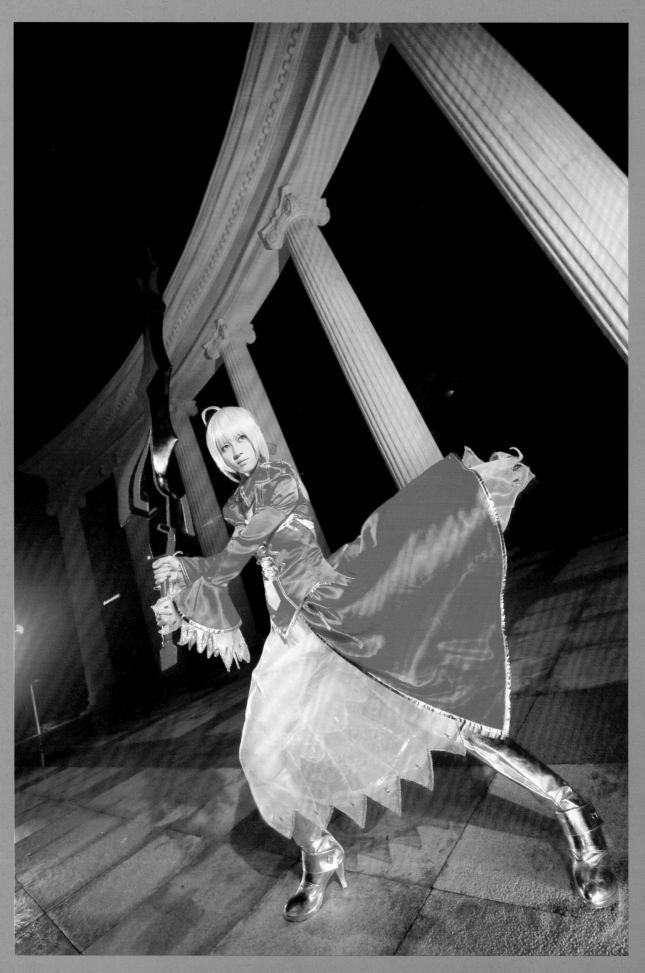

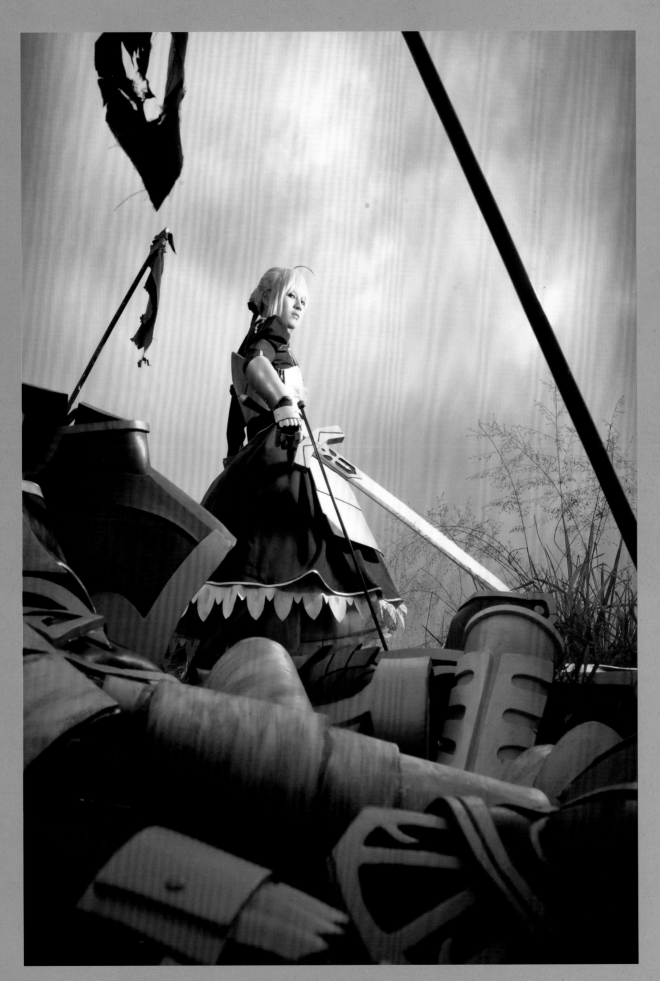

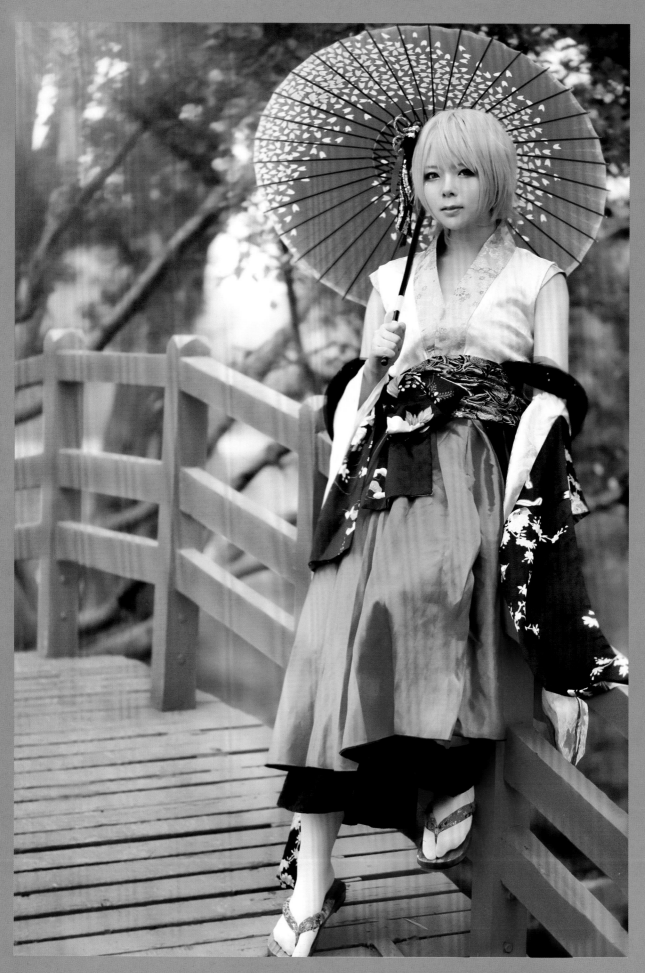

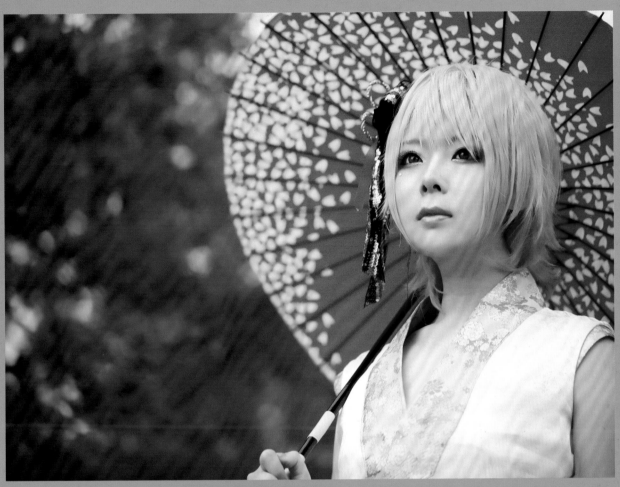

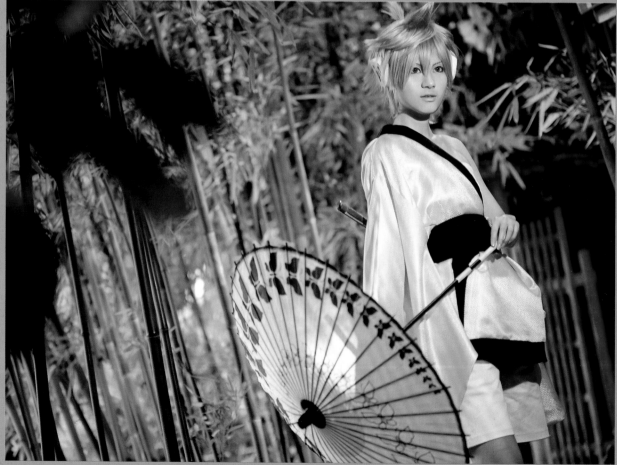

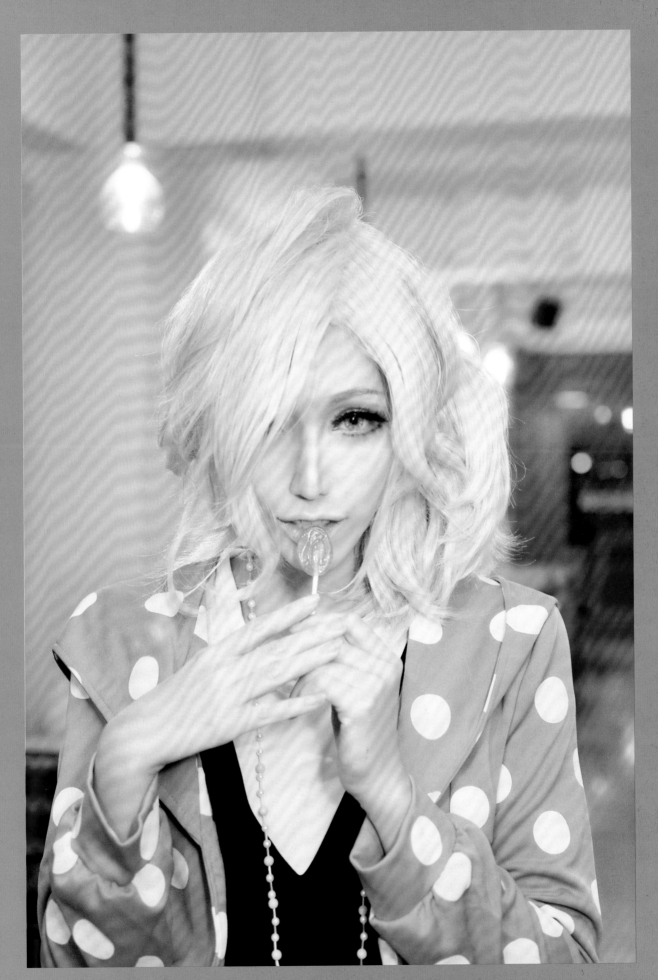

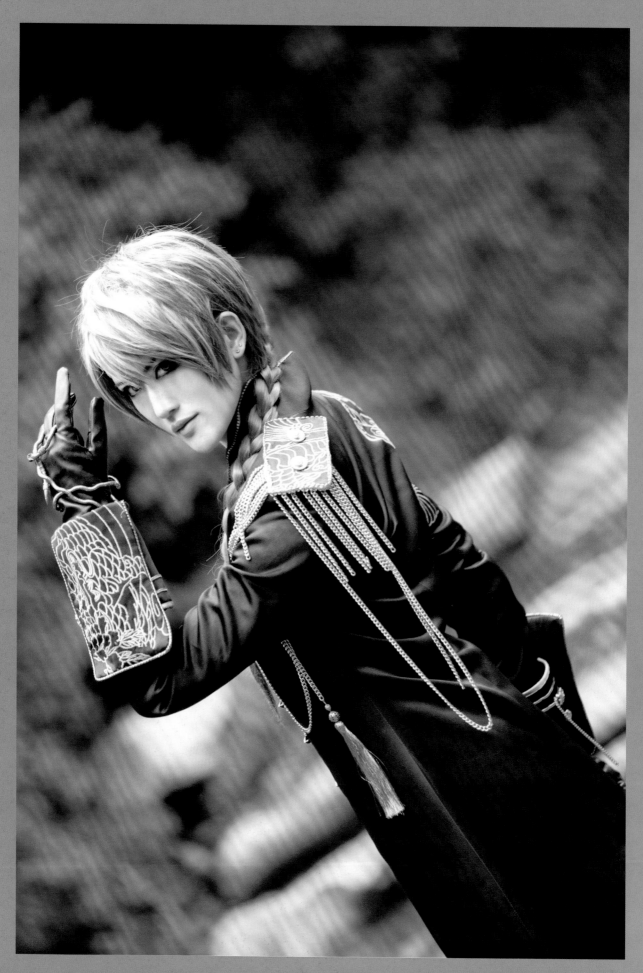

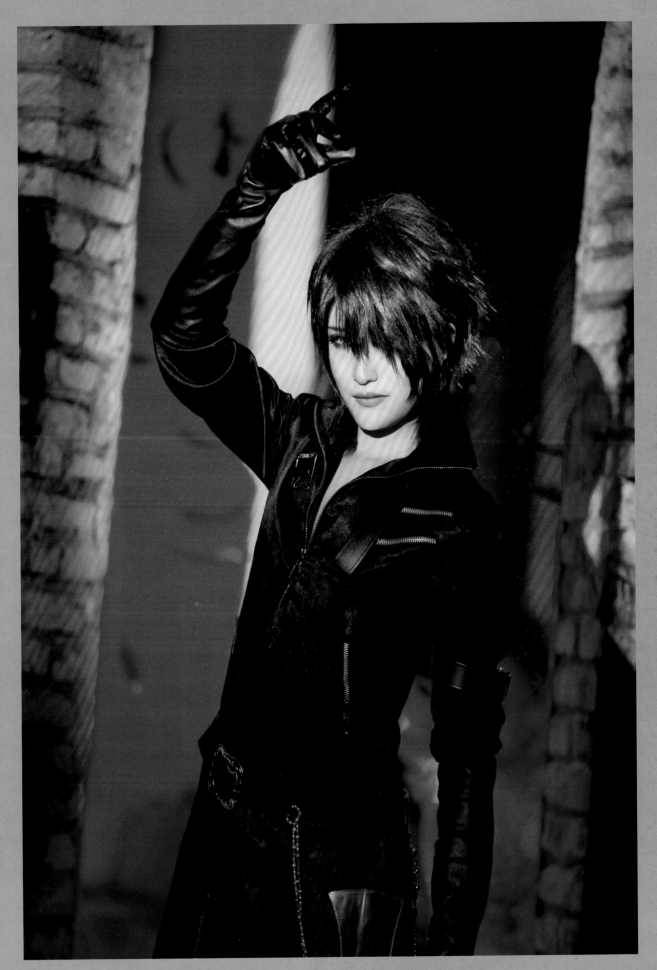

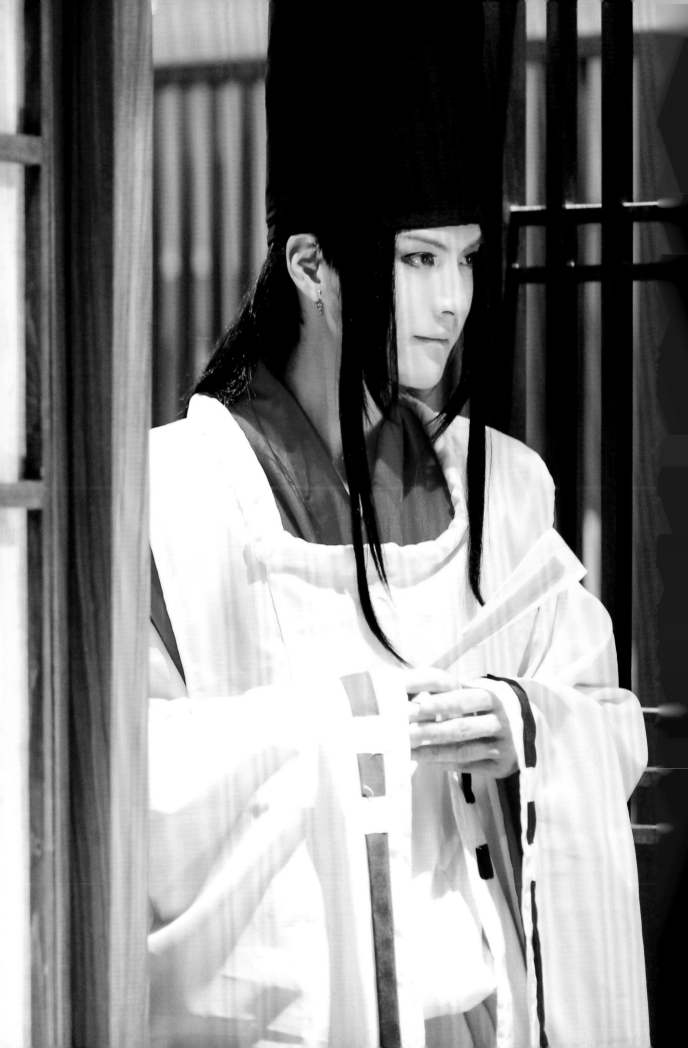

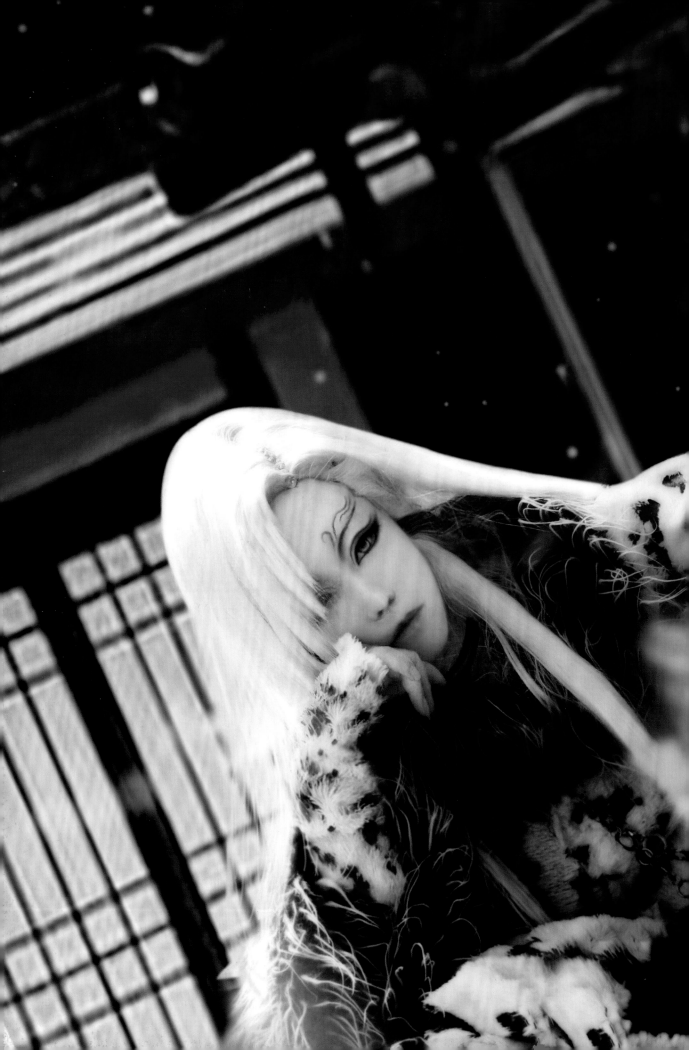

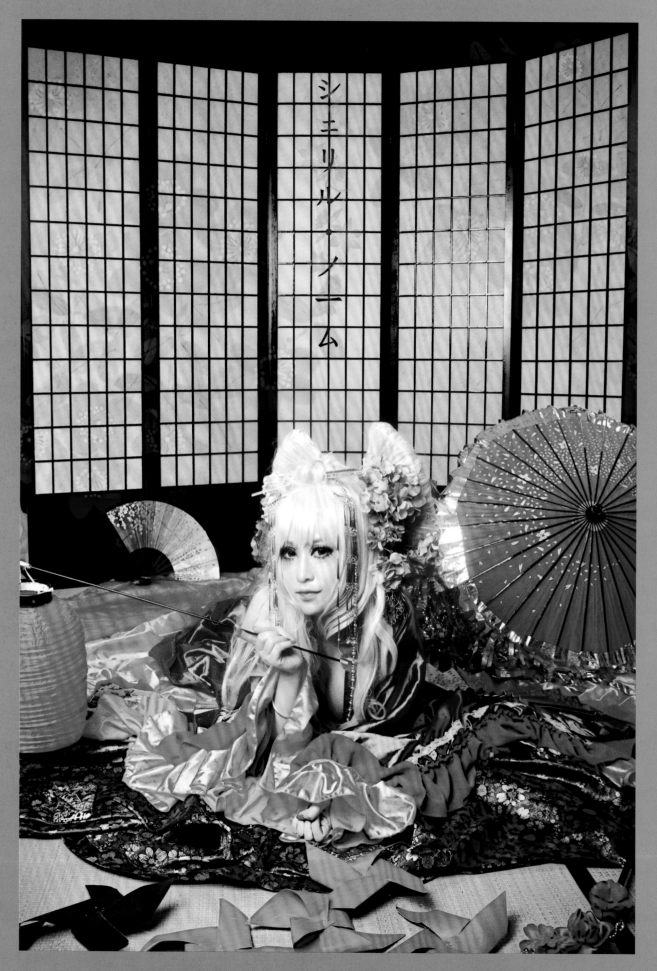

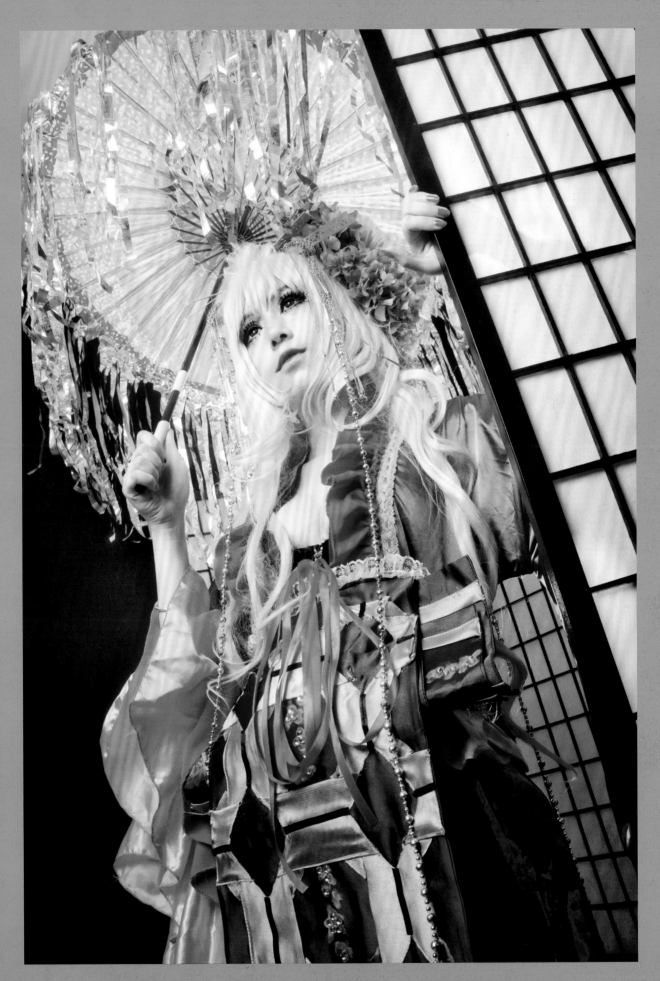

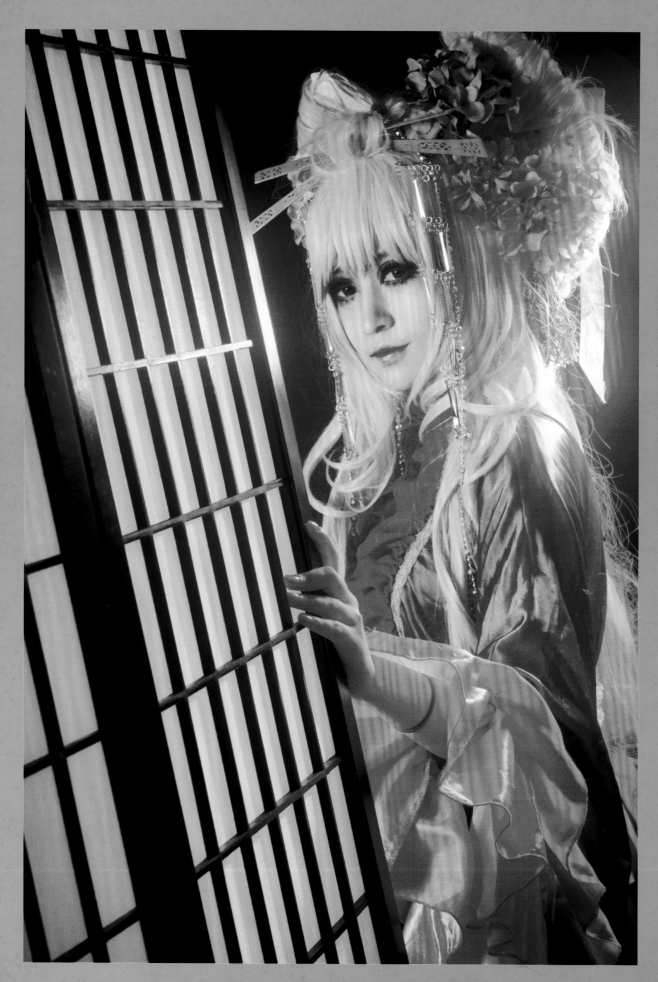

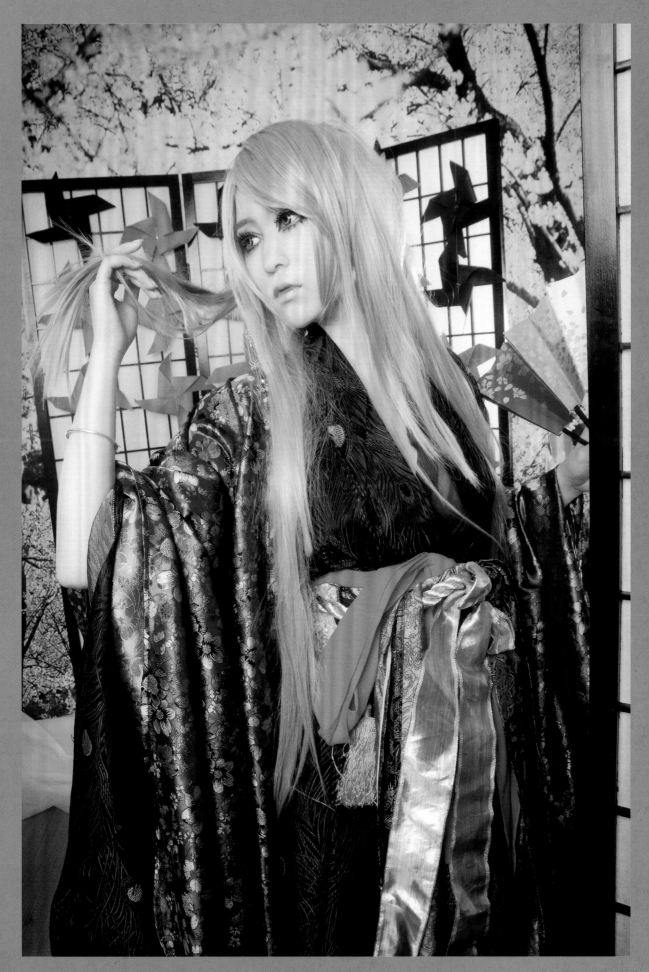

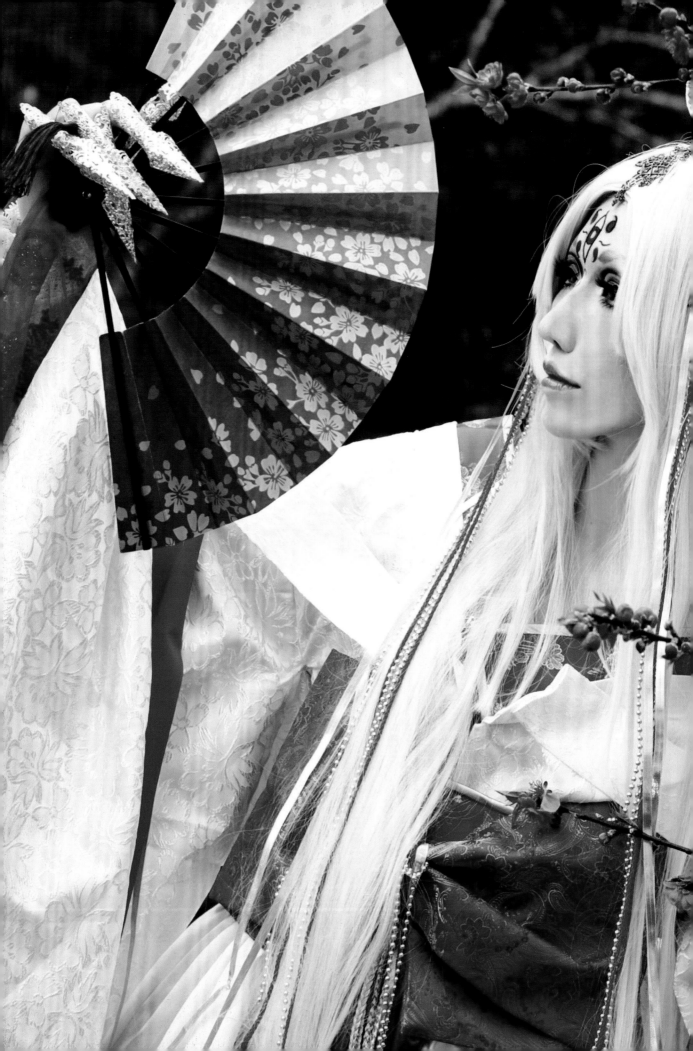

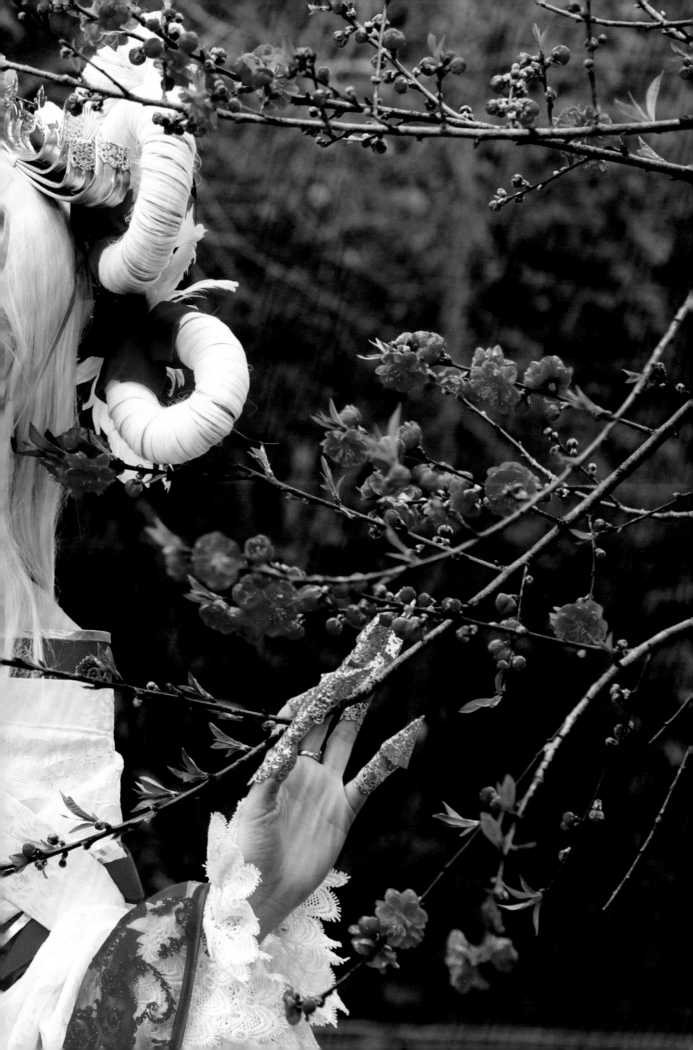

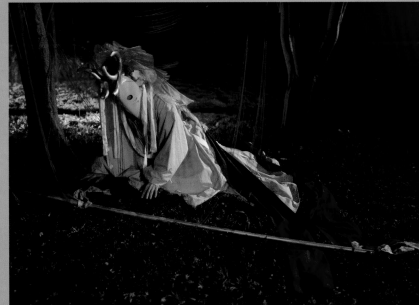

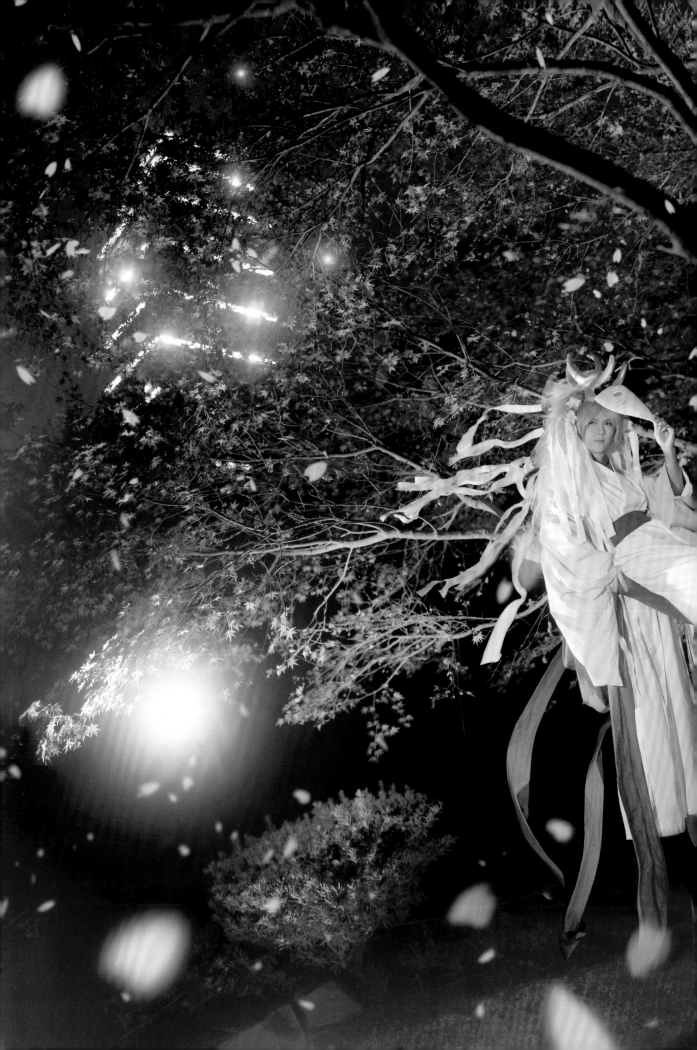

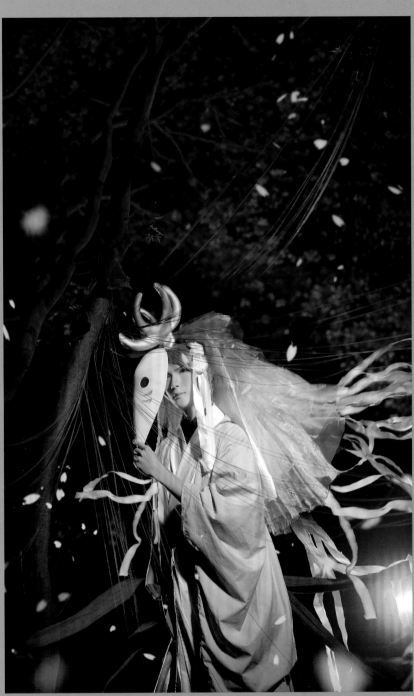

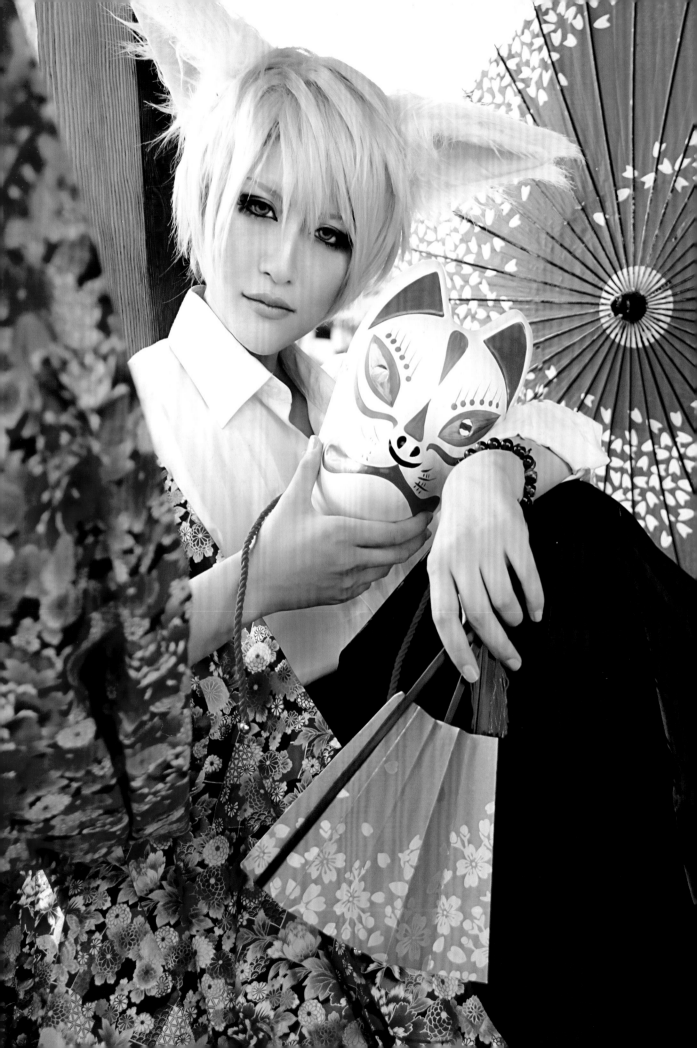

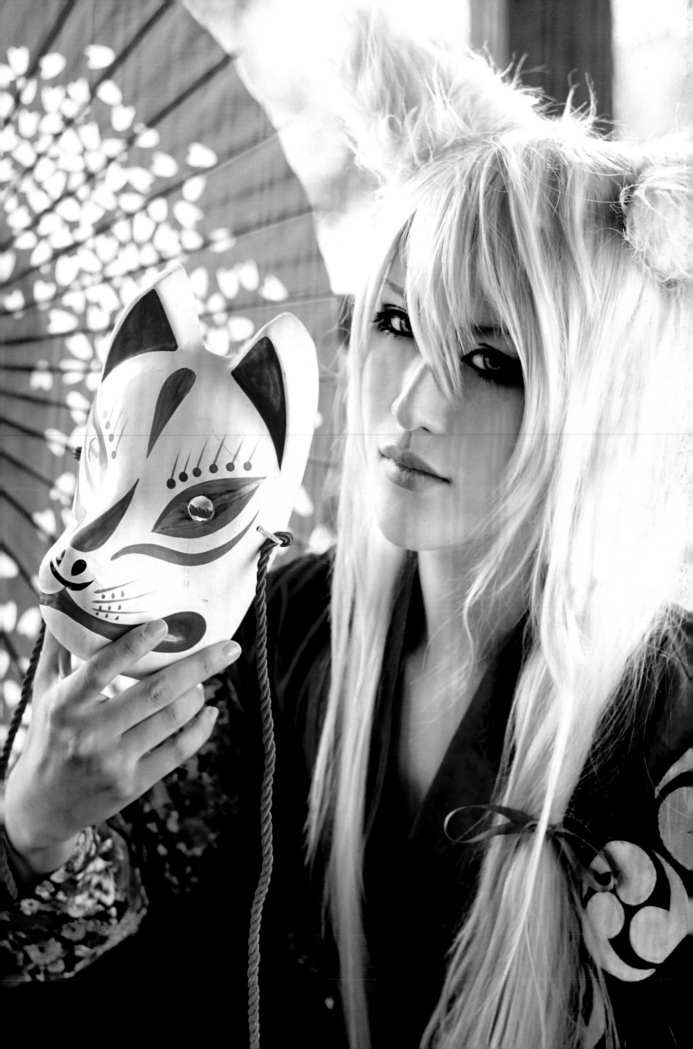

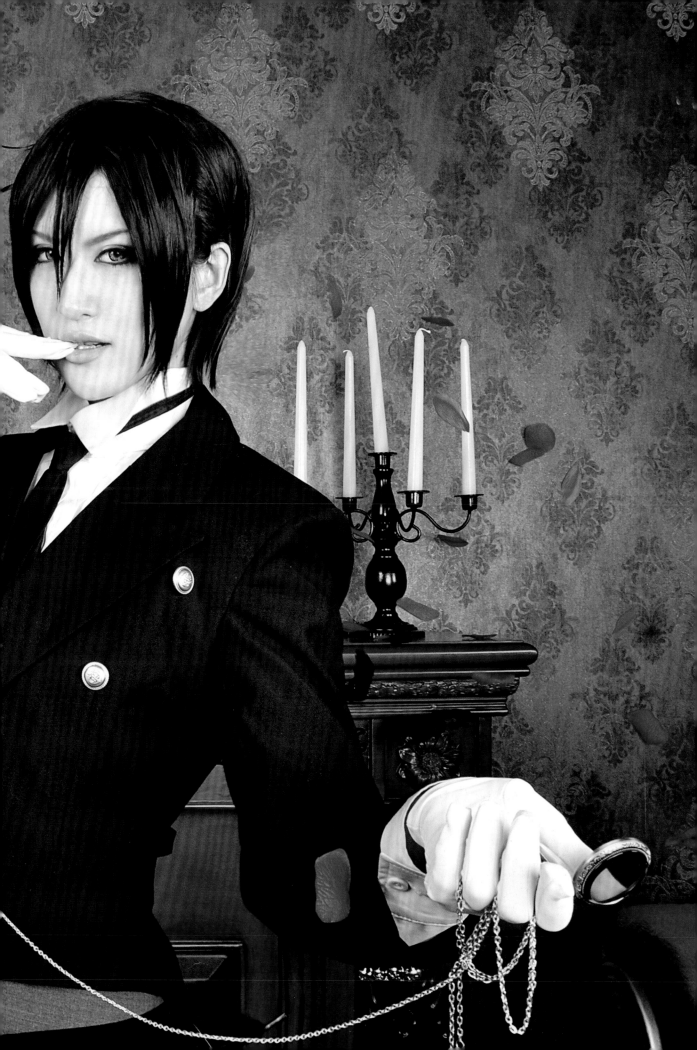

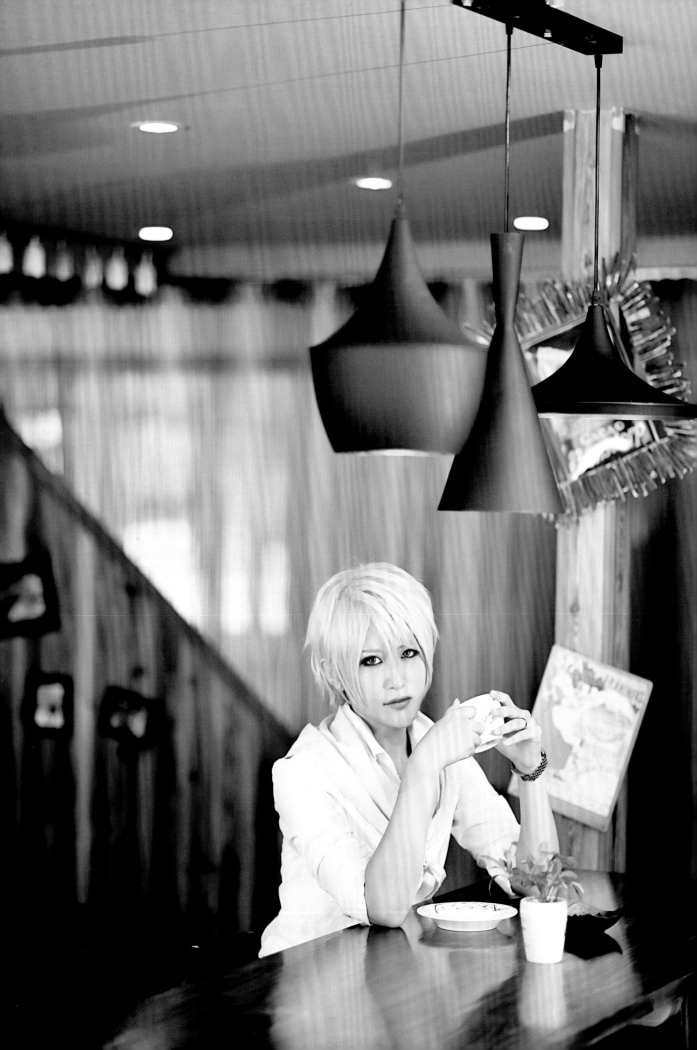

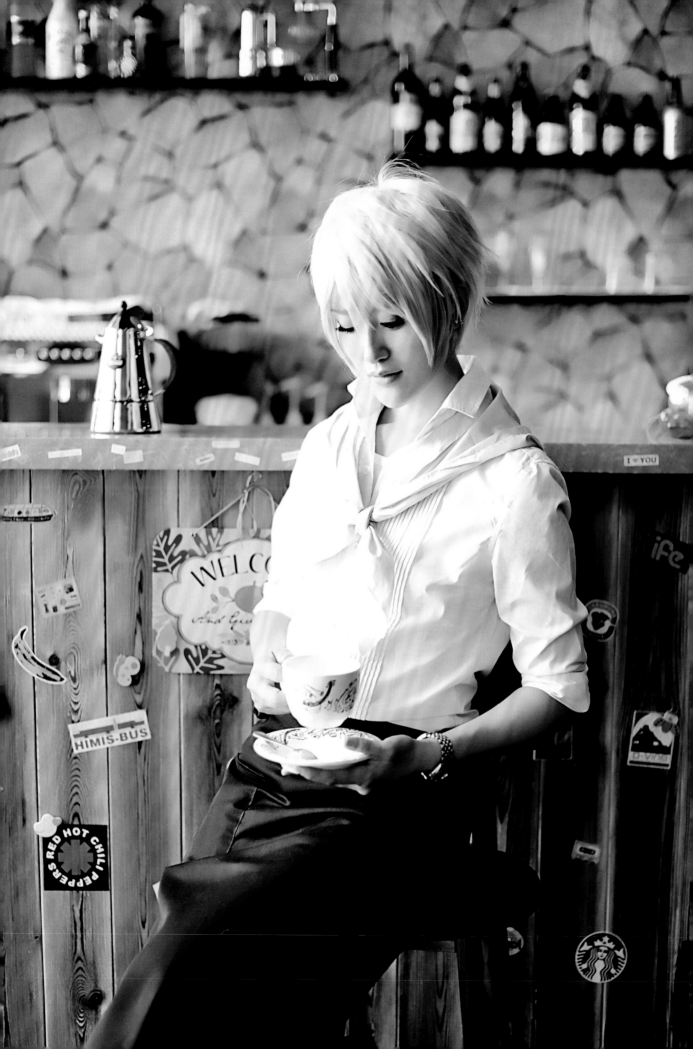

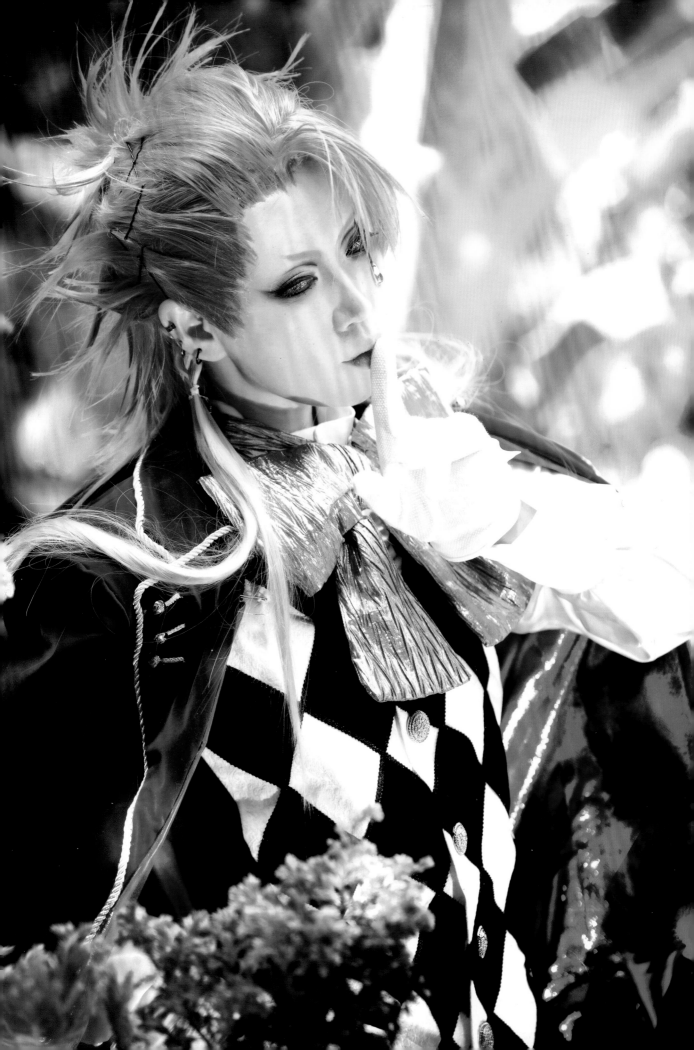

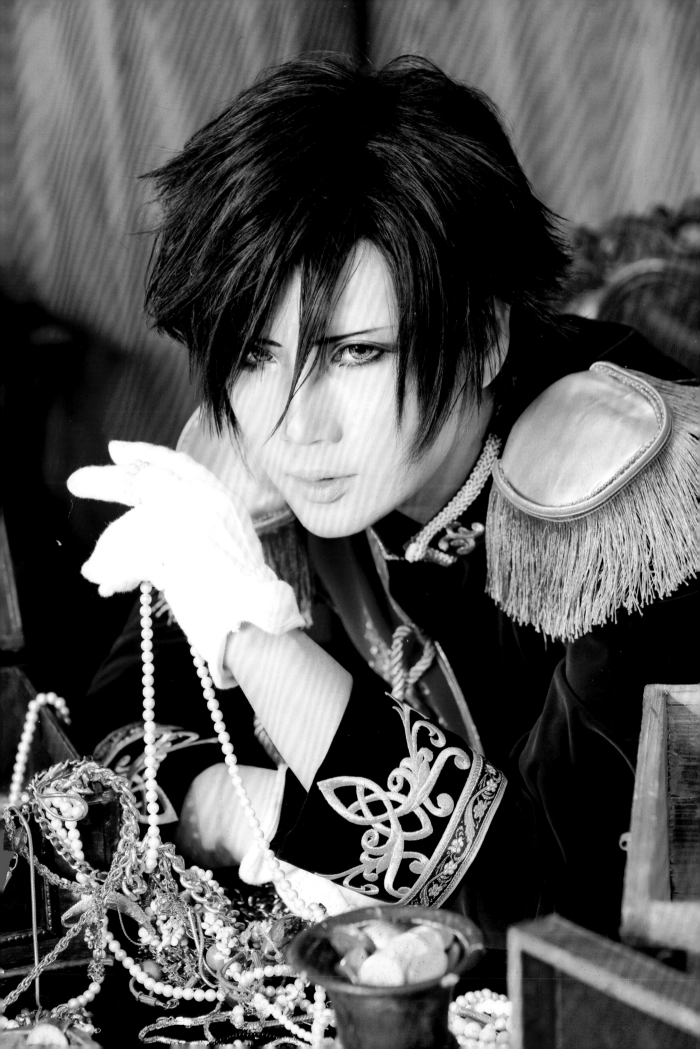

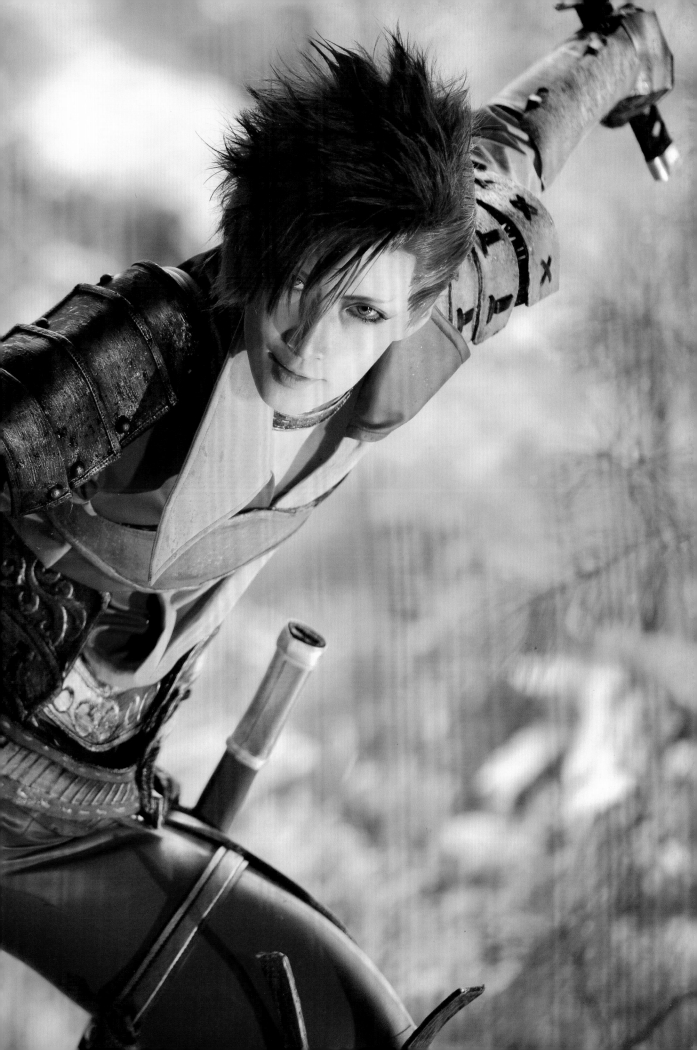

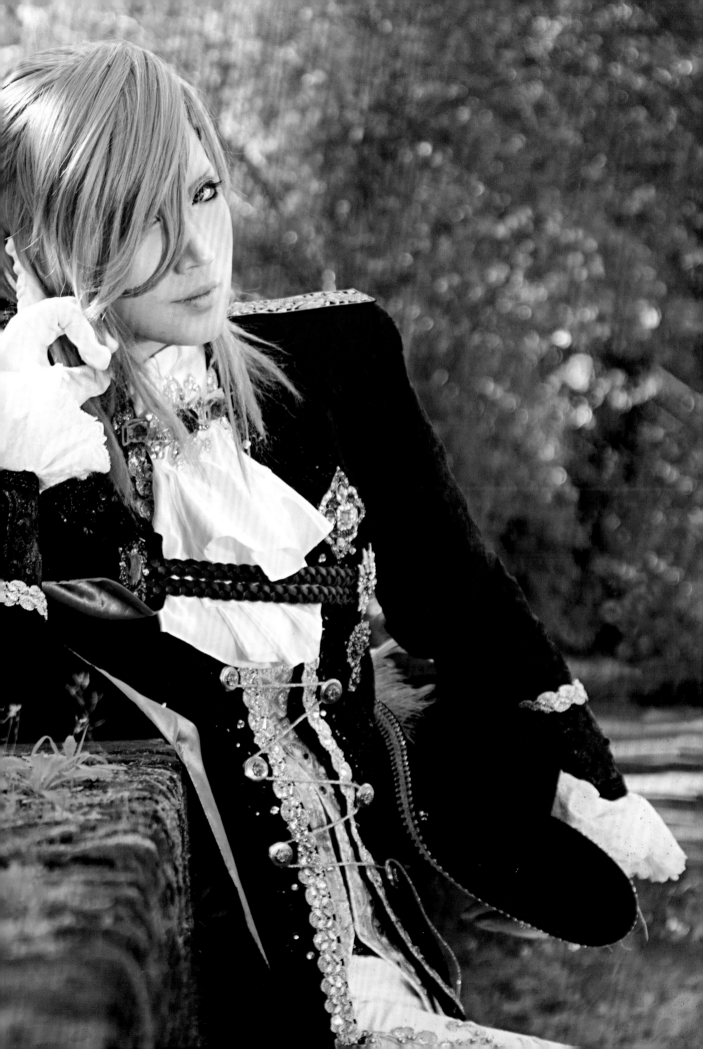

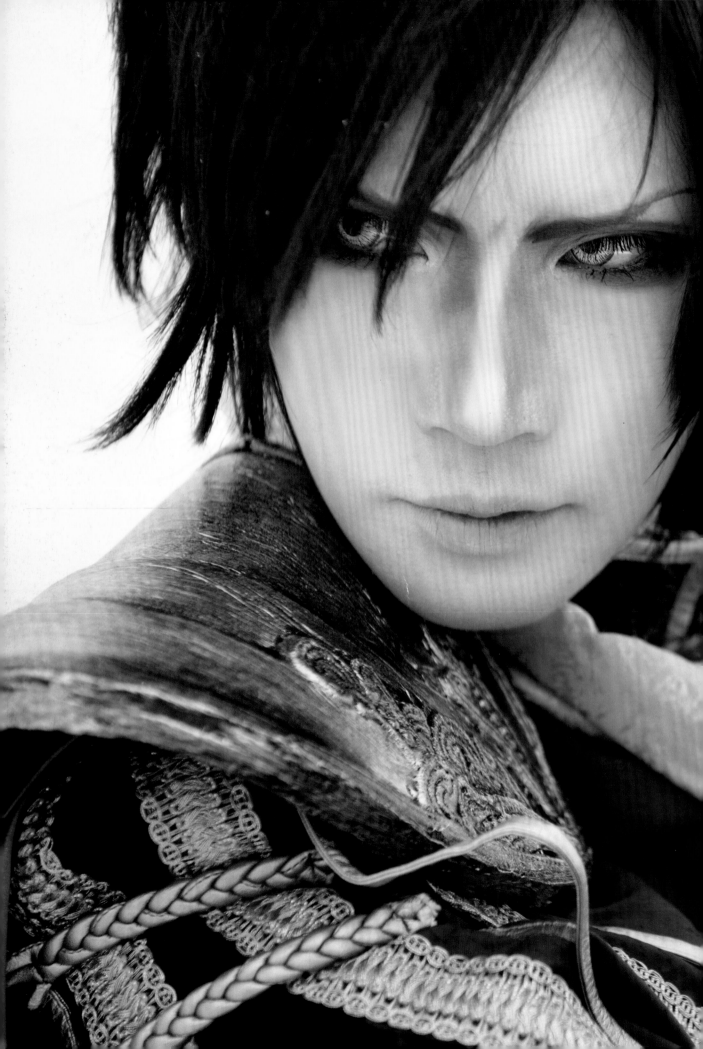

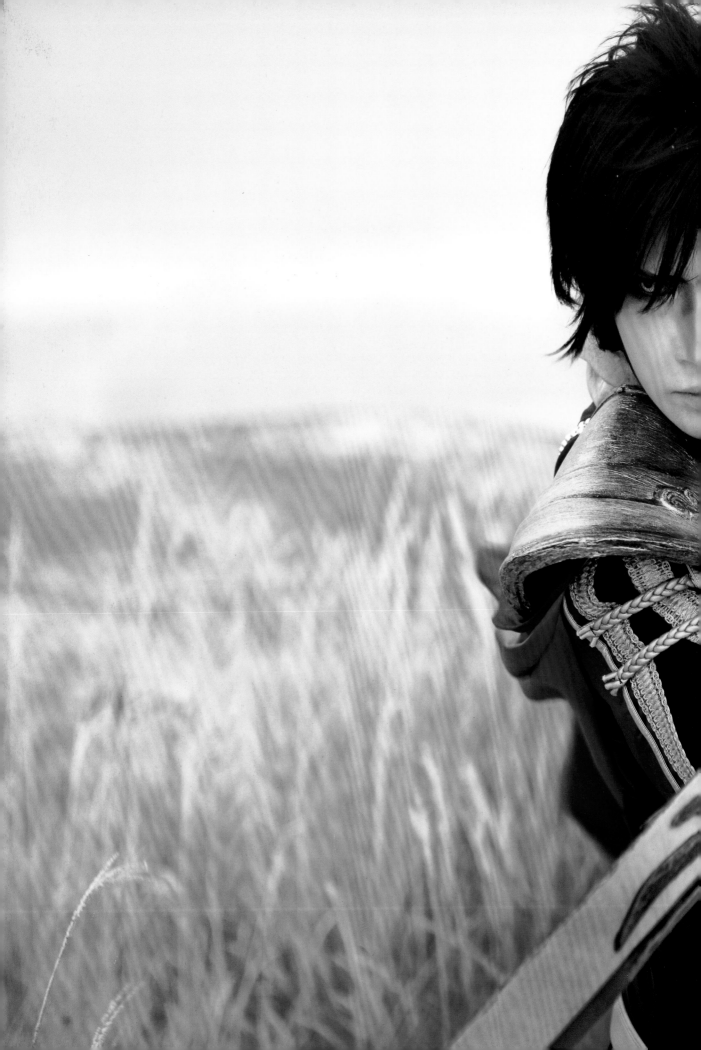

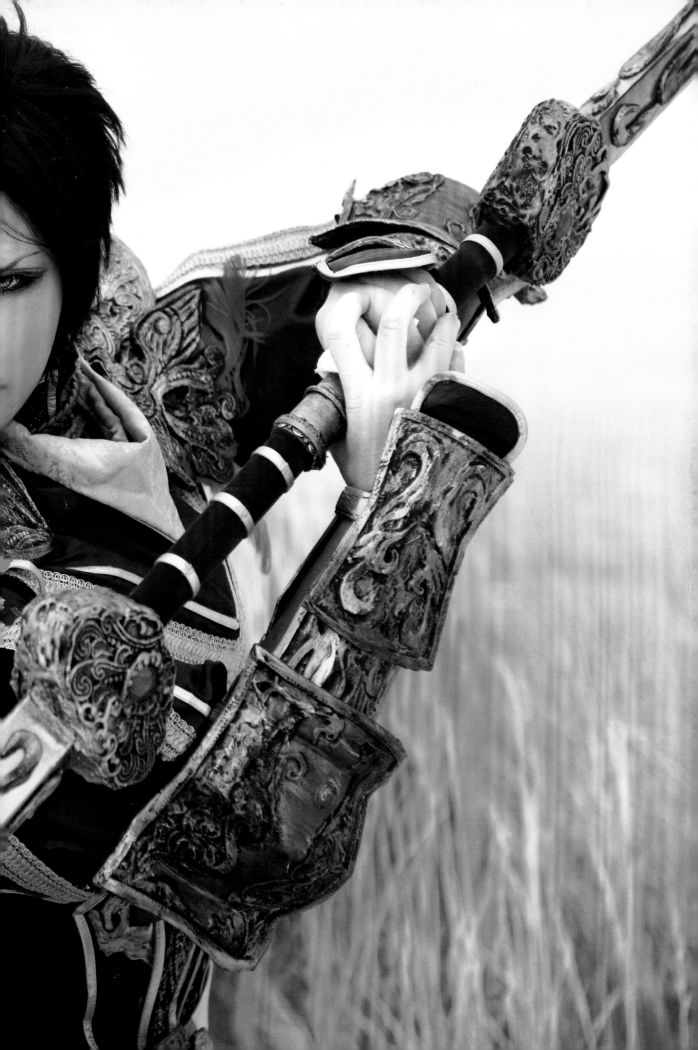

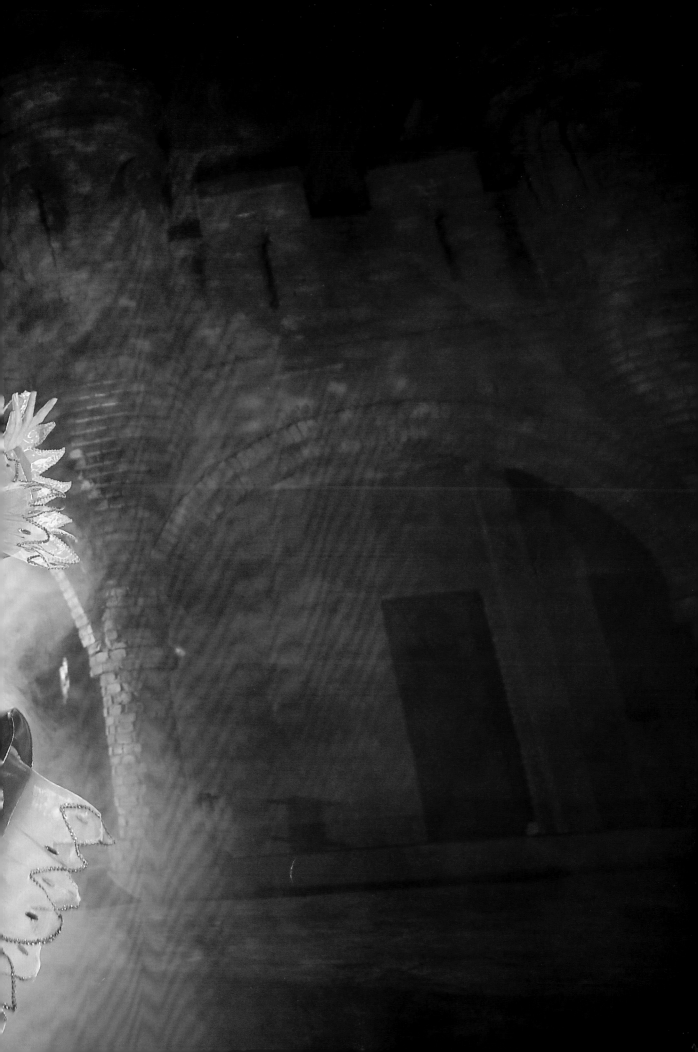

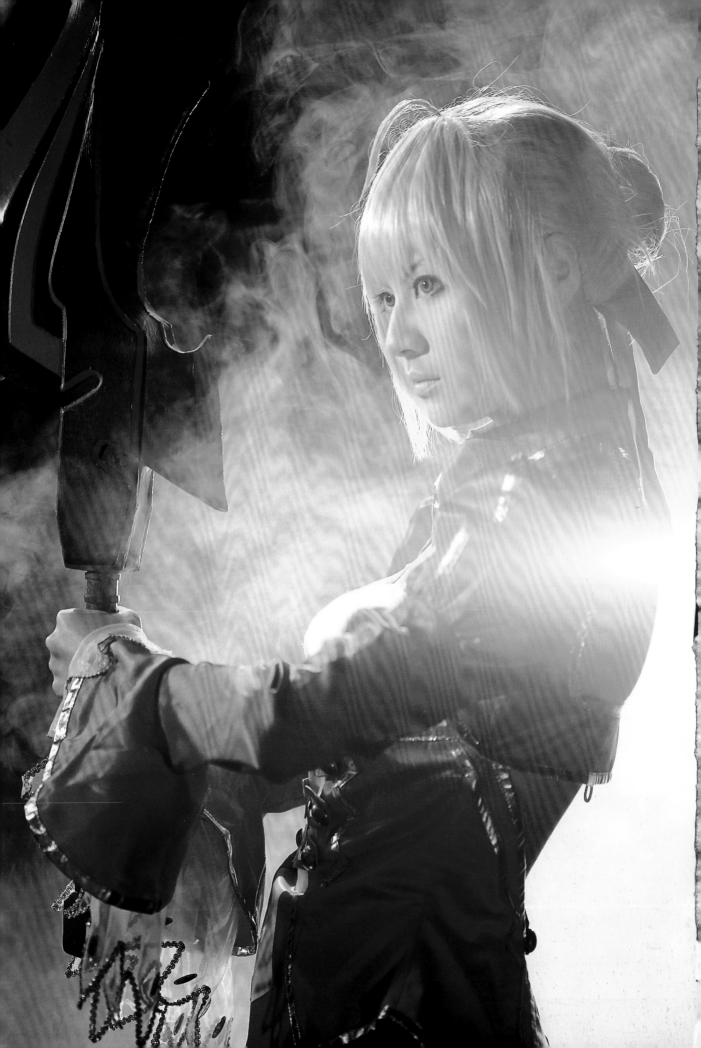